1000 SKATE BOARDS

Created by Olo Éditions
www.oloeditions.com

Editorial direction / Nicolas Marçais
Art direction / Philippe Marchand
Layout / ZS studio
Editor / Zarko Telebak
Author / Mackenzie Eisenhour
Photos / J. Grant Brittain

First published in the United States of America in 2023 by
Universe Publishing, a division of Rizzoli International Publications, Inc.
300 Park Avenue South, New York, NY 10010
www.rizzoliusa.com

For Rizzoli
Publisher / Charles Miers
Editor / Klaus Kirschbaum
Assistant Editor / Meredith Johnson
Managing Editor / Lynn Scrabis

Library of Congress Control Number: 2022948513
ISBN-13: 978-0-7893-4146-4

First printing, 2023
2023 2024 2025 2026 / 10 9 8 7 6 5 4 3 2 1

Printed in Croatia

Notes

Page 53
[1] *Jim Thiebaud wanted this graphic by Natas Kaupas to be a bold statement against racism and racist violence.*

Pages 53 and 213
[2] *Andy Jenkins drew this board during 101's string of "pushing the envelope" graphics. In '91 the crack epidemic was still in full swing and this image was about as shocking as you could get. It should be stated, the crack epidemic was no joke (and still isn't) to the communities (mostly of color) it ravaged.*

Page 58
[3] *The issue of accidental gun deaths highlighted by this '92 McKee graphic is still as relevant today as it was three decades back.*

Page 87
[4] *Blind's Reaper character by McKee took over brand identity at Blind during the late '90s. The cartoonish depiction of violence (and a noose) shouldn't be confused with the real tragedy of suicide by hanging.*

Page 118
[5] *More "gallows humor" here from Mike Sieben at Bueno. Suicide by hanging is of course a deadly serious issue. Reach out to someone if you are having a hard time.*

MACKENZIE EISENHOUR

PHOTOS BY J. GRANT BRITTAIN

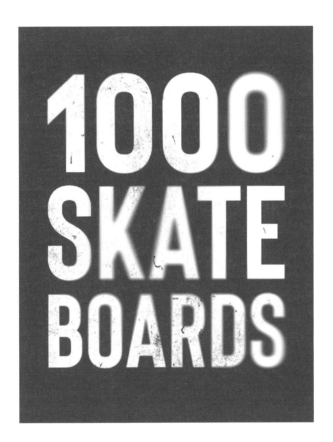

1000
SKATE
BOARDS

UNIVERSE

CONTENTS

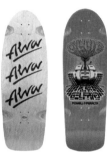

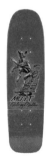

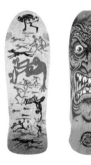

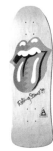
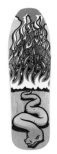
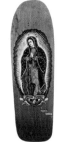

1000 SKATEBOARDS: CREATED TO BE DESTROYED

IN SEPTEMBER OF 1986, MY FATHER RETURNED FROM A BUSINESS TRIP TO FLORIDA WITH TWO SKATEBOARDS HE HAD PURCHASED FOR MY SISTER AND ME. BOTH CAME WITH GIANT BLACK, PINK, AND BLUE SANTA CRUZ "DOT" LOGOS, BRIGHT RED "SLASHER" WHEELS, AND SHINY ALUMINUM INDEPENDENT TRUCKS.

That night, our father drove us down to the Promenade des Anglais in Nice and we took our maiden voyages on the boardwalk. An unseasonably warm breeze lifted mist off the Mediterranean and carried it up across the glistening red asphalt. I was transfixed from the second I began to roll.

I was born in Belgium to an American father and Norwegian mother in '76. Prior to moving to Nice, I had spent a decade living in Oslo, Norway. All I knew about skateboarding was that it had been banned—it was illegal to even own a skateboard in Norway—in 1978–89 on grounds that it was too dangerous. All of this only heightened my interest, of course. By '86, a massive worldwide skateboard boom was underway. All the kids in my 4th-grade class at the American International School of Nice were talking about it—the Bones Brigade, Vision Street Wear, Alva, Tony Hawk, the Gonz, Natas, and onward. But on that first night, none of that mattered. I ventured out alone ahead of my sister and parents and felt something I had never felt before. I got hooked on the feeling—that gliding fluid motion. I got hooked on the freedom; there were no teammates, no rules, no referees—only gravity, inertia, and cold, hard cement.

Thirty-six years later, I'm a 45-year-old lifelong skateboarder living in Los Angeles. I have spent the last three decades writing for *Skateboarder Magazine*, then *Transworld SKATEboarding*. I am spending more time riding my skateboard now than ever. I have boxes and boxes of old skateboards stacked up in my parents' basement in France as well as closets full of boards and memorabilia hidden away in every corner of my apartment in LA. Almost every long-term friend in my life I met through skateboarding. I have broken countless bones in my body (currently nursing a fractured wrist and sprained knee as I write this). I have met and skated with almost every hero I had as a child. I have ridden on some of the most historic schoolyards, skateparks, and "spots" on the planet. And I still can't get enough.

❝ NOTHING IS STATIC. EVERYTHING IS ALWAYS IN FLUX. SKATEBOARDING IS NO DIFFERENT. I LOOK AT IT LIKE BUILDING A PYRAMID. THEY [IN THE '60S/ '70S/ '80S] PUT DOWN THE FIRST BUILDING BLOCKS. THEN PEOPLE IN THE '90S WOULD USE THOSE SAME BLOCKS TO KEEP BUILDING. IT KEPT GOING AND KEPT GOING. WE'RE ALMOST AT THE CAPSTONE NOW AND DUDES ARE JUST KIND OF HANGING OUT AT THE TOP. ❞

MARC JOHNSON

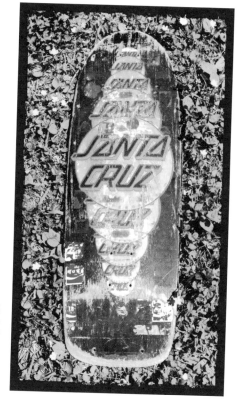

My first skateboard deck. The Santa Cruz R/S 10 Series Multi Logo team board I was given by my father, Charles, in 1986.

The skateboard my father brought me in 1986 set my life on a completely new course. It was the single most important moment, perhaps outside of the birth of my children or marriage to my wife. The biggest question, then: what is the allure of skateboarding? Clearly, it is far more than the simple piece of wood landlocked surfers nailed roller-skate wheels to back in the '50s. It is far more than a toy or a passing fad. Far more than ornate graphics silkscreened on plywood. Far more than the Olympic sport it became in Tokyo 2021. Far more than the roughly $5 billion skateboard industry that supports it. To me, to us, the true believers—skateboarding is our religion. All the while being something that we feel so deeply, but can never quite find the words.

Through this book's iconic graphics and artists, through a breakdown of our history, anatomy of our equipment, overview of our industry, our most celebrated practitioners, most beloved brands, and our worldwide collection of legendary spots and our defining ethos—this book aims to illuminate our religion. It represents my best efforts at describing this thing that transformed my normal life into one of perpetual motion all those years ago.

Mackenzie Eisenhour

SKATEBOARD GRAPHICS

BEYOND THE ACT OF RIDING A SKATEBOARD, ONE OF THE FIRST THINGS THAT LURED ME INTO THE SKATEBOARDER LIFESTYLE WAS THE COLORFUL AND ELABORATE GRAPHICS SILKSCREENED ON THE BOARDS THEMSELVES.

Skateboard graphics are a central visual representation of the counterculture they inhabit—a canvas meticulously designed and illustrated only to be torn to shreds on cement, wood, and metal. Much like album covers at the peak of the record industry, an entire subculture exists of artists, collectors, and fans devoted to their archiving. When I saw the Corey O'Brien Reaper graphic by Jim Phillips in a Norwegian *Variety* magazine article in the late '80s, I knew that I was seeing something unlike any other "team sport." I saw pure rebellion.

While the earliest mass-produced skateboards in the '60s adopted either toy-like designs or smaller signature labels, and boards in the '70s stuck to minimal (yet still sometimes intricate) artwork, by the '80s—specifically, after 1980 when Santa Cruz released the Steve Olson Checkerboard graphic—complex full-color designs covering the entire bottoms of skateboard decks became the norm.

"Top Graphics," meanwhile, usually repurposed some smaller theme from the bottom design and more often than not listed the board company name and pro on the topside of the board. Over the past forty-five years, an infinite creative universe has been formed, with graphics depicting anything from crack pipes and full-frontal nudity all the way to Cubism, oil paintings, and minimalist graphic design. This book showcases one thousand of what I see as our best creations.

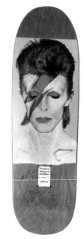

Jason Lee's tribute to David Bowie (Aladdin Sane) for his 1991 Blind board. A grail for many board collectors. Signed and dedicated to me by Jason when I worked with him in the '00s.

"ALL THE GRAPHICS WERE JUST SO AMAZING TO ME AS A KID. THE EARLY DAYS OF BLIND. WORLD. 101. EVEN LIBERTY—BASICALLY EVERYTHING THAT MARC MCKEE WAS INVOLVED WITH. I LOVED IT. I STILL LOVE IT."

Pontus Alv

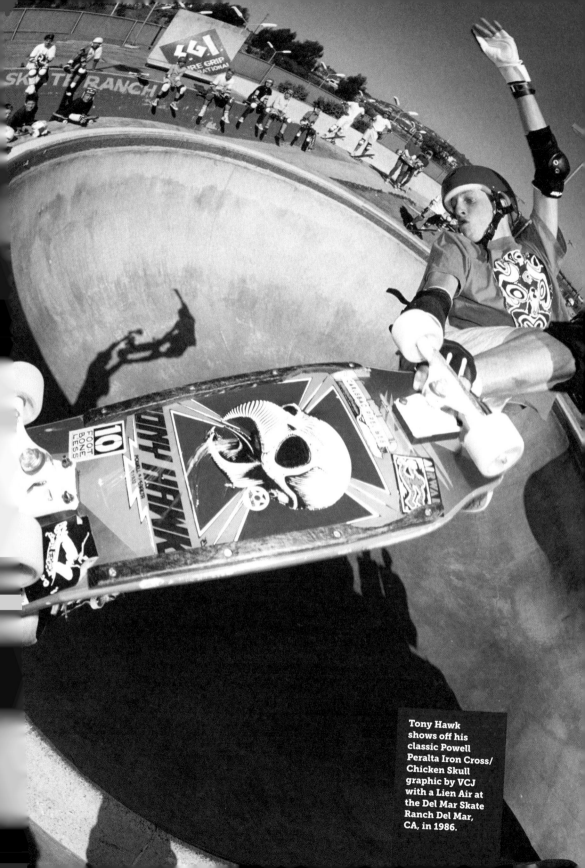

Tony Hawk shows off his classic Powell Peralta Iron Cross/ Chicken Skull graphic by VCJ with a Lien Air at the Del Mar Skate Ranch Del Mar, CA, in 1986.

THE '50S AND '60S: THE FIRST BOOM

THERE IS NO REAL RECORD OF THE FIRST SKATEBOARD. AS FAR BACK AS THE '30S AND '40S, THERE ARE SCATTERED RECORDS OF PEOPLE RIDING VARIOUS WHEELED CONTRAPTIONS. BUT BY THE LATE '50S, A PROTO-VERSION OF SKATEBOARDING EMERGED AS AN AFTER-SURF ACTIVITY IN MALIBU, HERMOSA BEACH, AND THE PACIFIC PALISADES OUTSIDE LOS ANGELES.

The first mass-produced skateboard arrives somewhere around 1956–58 in the form of the Sidewalk Swinger by Humco, Tresco's Skee-Skate (which makes the claim of being the first in the later first issue of the *Skateboarder Quarterly* in '64), or possibly the Roller Derby by the Roller Derby Skate Corporation in 1959. Others point to Carl Jensen, who built skateboards and sold them under the Greg Noll Surfboards stamp through Noll's surf shop in Hermosa Beach, or the Chicago Roller Skate Company in the '50s. While no conclusive consensus has been reached, all of these skateboards were extremely rudimentary and came with steel or clay wheels on roller-skate-manufactured trucks.

Moving into the '60s, the first signature skateboard appears in the form of pro surfer Phil Edwards's via his model for Makaha in '63. A small '60s skateboard boom ensues with notable milestones like the release of Jan and Dean's hit song "Sidewalk Surfin'" in '64 and the short film *Skaterdater* in '65. Written and directed by Noel Black, the film won the Palme d'Or at Cannes for Best Short and was nominated for an Academy Award. *Surf Guide* magazine begins heavy promotion of the pastime and the *Skateboarder Quarterly* becomes the first dedicated title—printing magazines from '64 through '65.

Following a high-water mark with the '65 International Skateboard Championships held in Anaheim, California, skateboarding all but dies—almost as quickly as it arrived—due to declining popularity, citywide bans, negative press, and safety concerns. Still, in a sign of things to come, Vans Shoes are born in '66, and Skip Engblom, Jeff Ho, and CR Stecyk III begin planting the seeds for Zephyr in Santa Monica in '68.

Top: Patti McGee on the cover of *Life* magazine and *Skateboarder Magazine*, 1965.
Bottom: Children riding skateboards in New York City in the '60s.

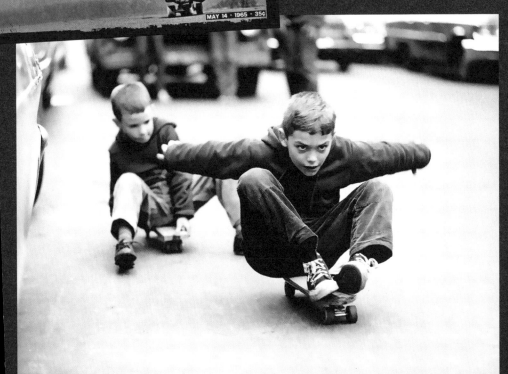

HUMCO
Sidewalk Swinger,
1956

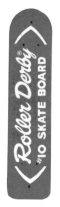

ROLLER DERBY
Roller Derby,
1959

MOEN-PATTON
Flying Ace,
Road Surfer, 1957

SPORT FUN
Black Knight,
1960

UNION SURFER
Monster,
Team Deck, 1960

MAKAHA
Phil Edwards,
1963

HOBIE
Super Surfer,
1963

TRESCO
Skee Skate,
1964

**COOLEY
AND ASSOCIATES**
Junior Bun Buster,
1964

SEARS
35 Inch Hang Ten
Surfer, 1965

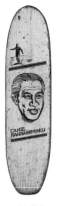

NASH
Duke Kahanamoku,
1965

METTOY-PLAYCRAFT
Batman,
1966

"I WON THE U.S. NATIONAL SURFING CHAMPIONSHIPS
IN HUNTINGTON BEACH IN '63. BECAUSE MY NAME BECAME
PRETTY WELL KNOWN THROUGH SURFING AND WINNING
THE NATIONALS, I ENDORSED A SKATEBOARD
FOR HANSEN SKATEBOARDS IN SEPTEMBER OF '64."

LJ Richards

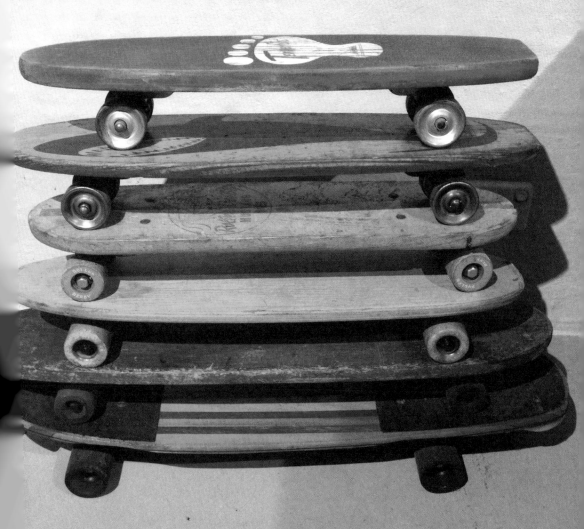

THE '70S: URETHANE CHANGES EVERYTHING

AFTER THE LATE '60S SLUMP, SKATEBOARDING BEGINS TO RISE IN POPULARITY AGAIN IN THE '70S. THIS IS THANKS IN PART TO THE INTRODUCTION OF THE "KICKTAIL" BY LARRY STEVENSON IN '69 (PATENTED IN '71) AND IS REVOLUTIONIZED WHOLESALE IN '73 WITH THE INTRODUCTION OF FASTER AND GRIPPIER URETHANE WHEELS (BY FRANK NASWORTHY AND HIS CADILLAC WHEELS).

These two massive improvements in functionality coincide with the birth of modern trucks in '73 via Bennett Trucks (providing turning capabilities) and the arrival of precision bearings in '75 (providing faster and more reliable rides) via Road Rider Wheels. Picking up on these advancements, the Zephyr team in Santa Monica brings a new aggressive mode of skateboarding to a host of banked schools in West LA and later, empty swimming pools—all captured by the lens and words of CR Stecyk III for the relaunched *Skateboarder* magazine (the second run of the magazine covers '75–'79).

Distributed across the world as a near skateboard bible, the magazine makes superstars of Tony Alva, Jay Adams, Stacy Peralta, and others while shifting the pastime away from a wholesome beach fad to a more rock 'n' roll–style counterculture. Peralta and Alva became the first paid skateboarders by Vans in '76, and the graphics of the era, notably by Stecyk himself (who coins the term "Dogtown") and artists like Wes Humpston match the new harder edge.

By the late '70s, a second industry boom leads to skatepark construction worldwide with massive cement snakeruns, bowls, and banks springing up overnight. Santa Cruz's parent company NHS (Novak, Haut, Shuirman) is born in '73 and joins Fausto Vitello to launch Independent Trucks in '78. Scores of other companies are born along with contest circuits and national skateboard associations. Vertical skateboarding leads to major advances—Tony Alva and George Orton are credited with the first "airs" around '77 and Alan "Ollie" Gelfand invents the ollie in '78.

As the decade ends, skateboarding again takes a plunge in popularity and rising insurance rates and low attendance cause all but a few of the skateparks to close. *Skateboarder* magazine rebrands to *Action Now*, then later ceases publication for a second time around the turn of '80.

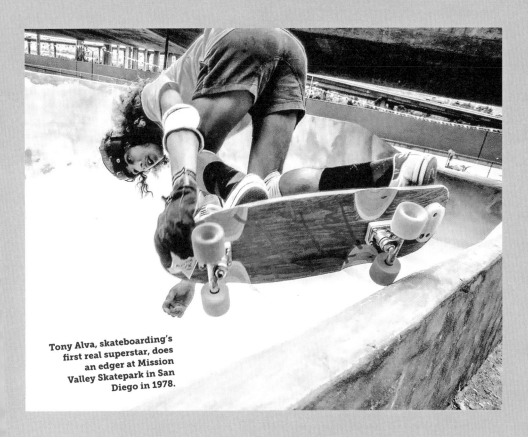

Tony Alva, skateboarding's first real superstar, does an edger at Mission Valley Skatepark in San Diego in 1978.

"IN THE '70S THERE WERE LIKE THESE HUGE REVOLUTIONS AND INNOVATIONS GOING ON. SO THAT RIGHT THERE MADE IT DIFFERENT. IT WENT FROM CLAY TO URETHANE WHEELS, LOOSE BALL BEARINGS TO PRECISION BEARINGS. THOSE WERE HUGE CHANGES—WARP TAILS AND REGULAR PLIES, BLOCK TAILS, NARROW BOARDS, THEN THE WIDE BOARDS. IN THE '70S, EVERYTHING WAS LIKE BRAND-NEW AND HAPPENING."

Steve Olson

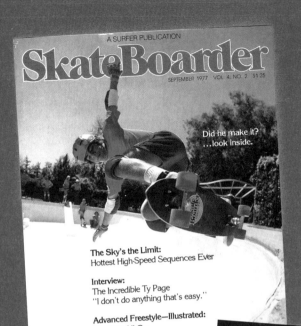

From top left:
Paul Hackett on the cover
of the Sept. 1977 issue of
Skateboarder. Photo: Bolster.
An ad for Road Rider Wheels
from the mid-'70s. The first
wheels to incorporate
precision bearings.
Eric Dressen Park Rider
Wheels ad at Fountain Valley
Skatepark, Fountain Valley,
CA, Oct. 1977.

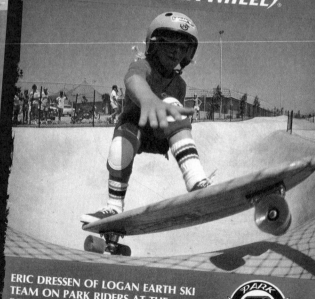

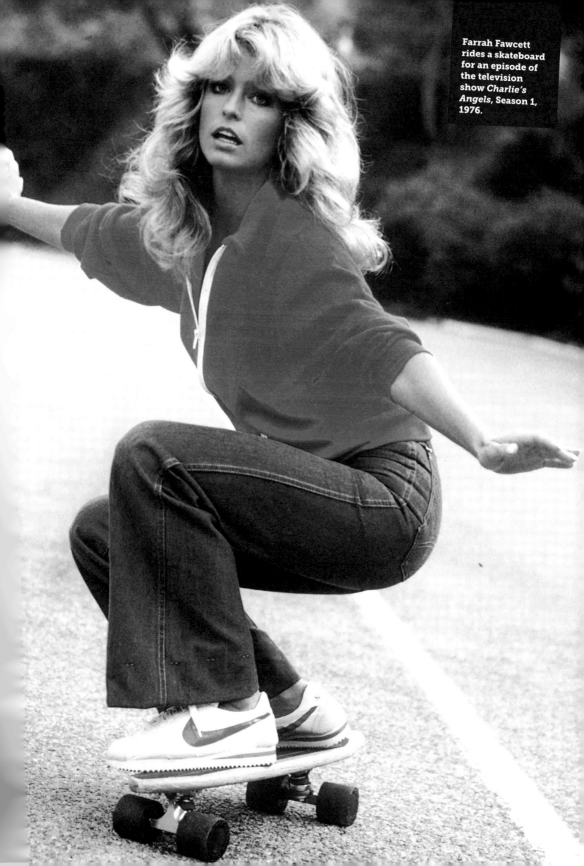

LOGAN EARTH SKI
Torger Johnson,
1974

Z-FLEX
Jay Adams,
Multi-color, 1974

HOBIE
Skitch Hitchcock,
World's Champion model,
1974

ALVA
27 inch,
Team Deck, 1975

BAHNE
24 Inch Hotdog,
Team Deck, 1975

MAHARAJAH
27 inch,
Team Deck, 1976

Z-FLEX
Jay Adams,
Z-Woody, 1976

LOGAN EARTH SKI
Robin Logan,
DuraLite, 1976

SIMS
Superply,
Team Deck, 1976

BADLANDS
Pool Tool by Roy Hunt,
1977

SANTA CRUZ
Fiberglass 28,
Team Deck, 1977

SIMS
Quicktail 84cm,
1977

ALVA
Tri-logo,
Team Deck, 1977

VARIFLEX
Team Deck,
1978

DOGTOWN
Bigfoot by Wes Humpston,
1978

DOGTOWN
Bob Biniak, Rocket
by Wes Humpston,
1978

DOGTOWN
Paul Constantineau,
-tap by Wes Humpston,
1978

ALVA
Leopard,
Team Deck, 1979

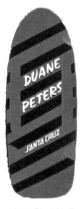

SANTA CRUZ
Duane Peters 5,
1979

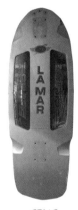

SIMS
Bert Lamar,
1979

POWELL PERALTA
Brite-Lite, 1979

DOGTOWN
Shogo Kubo,
Airbeam, 1979

ZORLAC
Snub Nose,
Team Deck, 1979

KANOA SURF
Bobby Valdez,
Tri-Beam, 1979

THE '80S: FROM THE UNDERGROUND TO THE THIRD BOOM

AS THE '80S KICK OFF, SKATEBOARDING IS AGAIN SIDELINED TO THE DEDICATED FEW. BACKYARD WOODEN HALFPIPES FILL THE VOID OF THE EXTINCT SKATEPARKS.

Dismayed at the disappearance of *Skateboarder*, Fausto Vitello (Independent Trucks) launches *Thrasher* in '81. As a response to *Thrasher's* "Skate and Destroy" ethos, *Transworld SKATEboarding* is created by Larry Balma (Tracker Trucks) and Peggy Cozens to "Skate and Create."

Rodney Mullen adapts the ollie to flatground in '82 and over the next decade, it revolutionizes street skating. In '84, the recently formed Powell Peralta releases the first official skate video, *The Bones Brigade Video Show* by Stacy Peralta and CR Stecyk III. With VHS quickly spreading videos (by the time *The Search for Animal Chin* is released in '87 nearly every company needs at least one team video a year) throughout the world, a new explosion in popularity begins by the mid-'80s with Powell Peralta, Vision, Santa Cruz, Schmitt Stix, and Sims leading the industry. Airwalk and Visions Street Wear shoes join Vans as the skate footwear brands of choice.

The NSA (National Skateboard Association) headed by Frank Hawk (Tony's father) organizes an international contest circuit and Tony Hawk, Christian Hosoi, Steve Caballero, Mark "Gator" Rogowski, and many more become vert superstars. Meanwhile, street-skating stars emerge in the form of Natas Kaupas, Mark Gonzales, Tommy Guerrero, Eric Dressen, and Mike Vallely. By the late '80s—with boosts from mainstream films like *Back to the Future*, *Police Academy 4*, *Thrashin'*, and *Gleaming the Cube*—pro skaters are taking home over $100,000 per year.

The first pro model skate shoe is released by the French company Etnies for Natas Kaupas in '89 and the Vans Steve Caballero pro shoe is released only months later. Kaupas and Gonzales unlock handrails, stairs, and wallrides—expanding skateboarding's playing field dramatically. Board shapes and graphics produced during the late '80s are some of the most bizarre. The decade closes with a worldwide recession and skateboarding shrinks (again).

"A LOT OF THE NEON '80S SHIT WAS A JUST LIKE A VISION BRAINWASH. LIKE BRAD DORFMAN TRYING TO RAPE PEOPLE'S MINDS WITH THIS DAY-GLOW CRAP. WE WERE JUST LIKE, 'THIS AIN'T MADONNA, THIS IS AC/DC, BITCH.'"

Craig Johnson

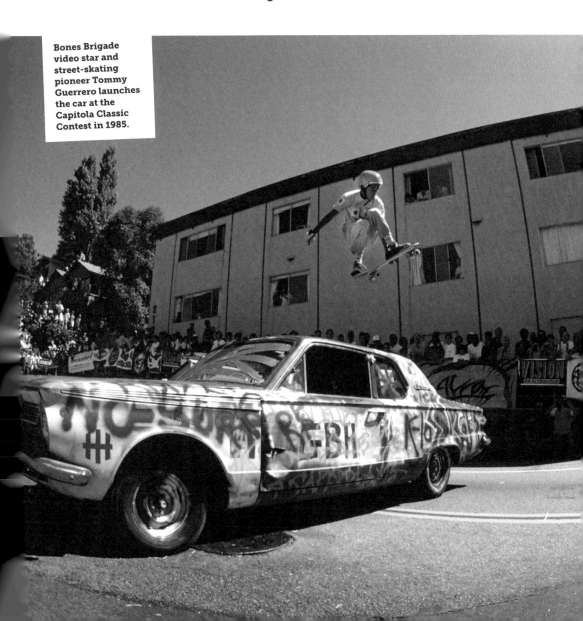

Bones Brigade video star and street-skating pioneer Tommy Guerrero launches the car at the Capitola Classic Contest in 1985.

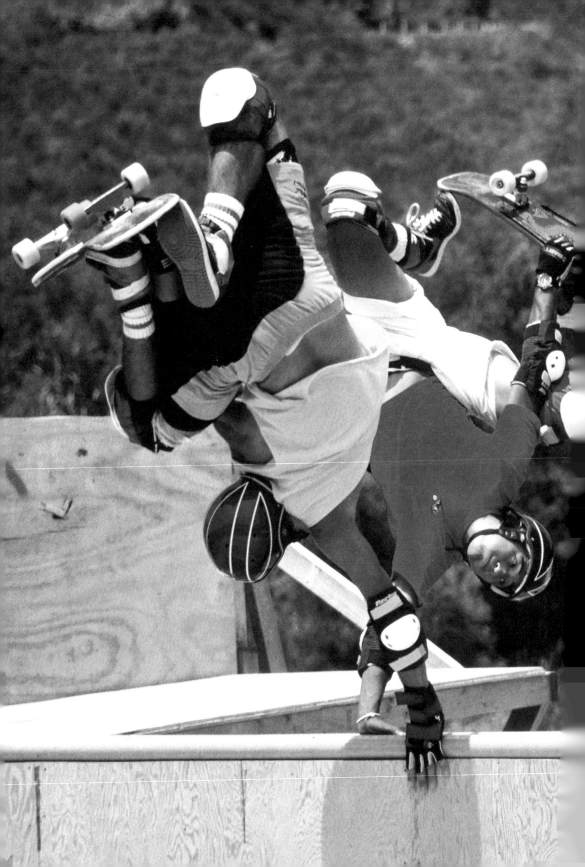

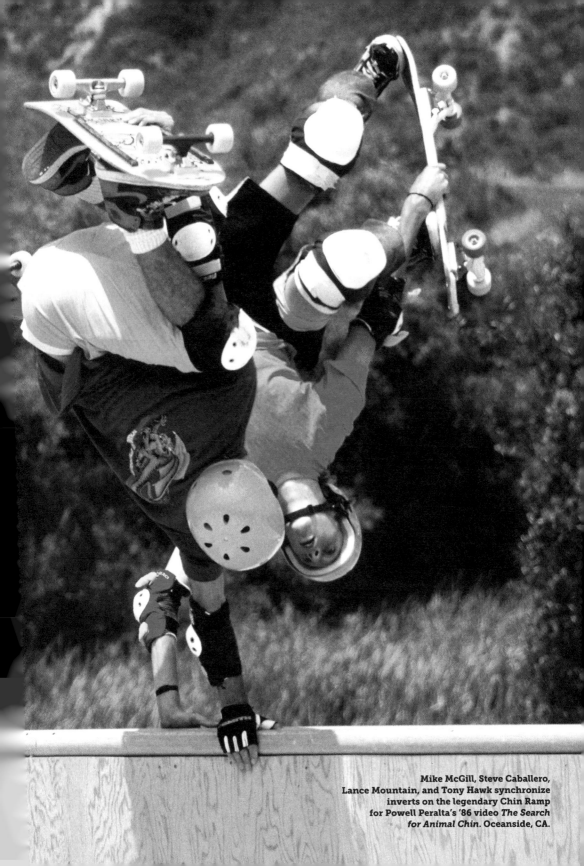

Mike McGill, Steve Caballero, Lance Mountain, and Tony Hawk synchronize inverts on the legendary Chin Ramp for Powell Peralta's '86 video *The Search for Animal Chin*. Oceanside, CA.

SANTA CRUZ
Steve Olson, Circle Logo
on Checkerboard,
1980

POWELL PERALTA
Steve Caballero,
Dragon 6-Ply,
1980

VARIFLEX
El Gato,
1980

POWELL PERALTA
Alan Gelfand,
Ollie Tank by VCJ, 1980

DOGTOWN
Jim Muir,
Triplane, 1980

POWELL PERALTA
Jay Smith,
1980

POWELL PERALTA
Rat Bones,
Team Deck, 1980

SANTA CRUZ
Salba Bevel,
1980

SIMS
Brad Bowman,
Superman, 1981

SANTA CRUZ
Jammer,
Team Deck, 1981

SIMS
Bert Lamar,
1981

POWELL PERALTA
Rodney Mullen,
Mutt Freestyle,
1981

SIMS
Brad Bowman, Digital FE-Series,
1981

VARIFLEX
Allen Losi 3 Times,
1981

ZORLAC
Street Machine,
Team Deck,
1981

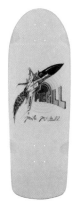

POWELL PERALTA
Mike McGill,
Jet Fighter 6-Ply,
1982

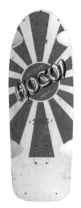

SIMS
Christian Hosoi,
Rising Sun,
1982

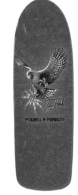

POWELL PERALTA
Tony Hawk,
1982

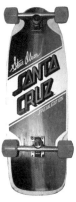

SANTA CRUZ
Steve Olson
Special Edition,
1982

VARIFLEX
Lance Mountain,
1982

ZORLAC
Big Boys,
Band Deck, 1983

ALVA
Dagger Tail,
Team Deck, 1983

TOWN + COUNTRY
Burst,
Team Deck, 1983

MADRID
Explosion,
Team Deck, 1983

DOGTOWN
DT Pig,
Team Deck, 1983

SIMS
Lester Kasai,
Splash, 1983

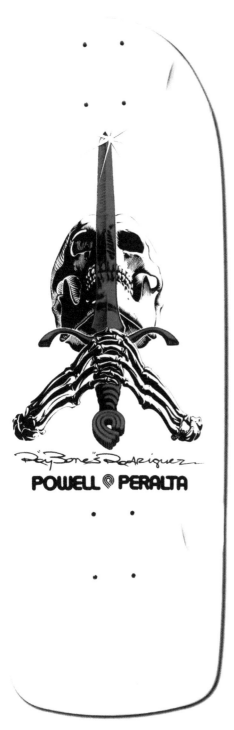

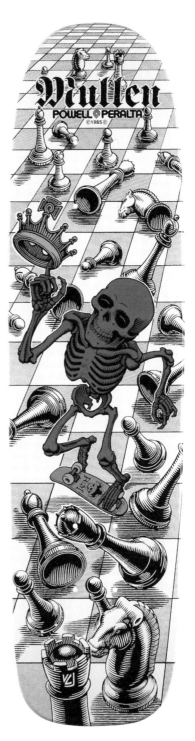

POWELL PERALTA
Ray "Bones" Rodriguez,
1982

POWELL PERALTA
Rodney Mullen, Chess Freestyle,
1983

G+S
Jim Gray,
Ska, 1983

POWELL PERALTA
Steve Steadham,
Spade, 1983

POWELL PERALTA
Tony Hawk,
Iron Cross by VCJ, 1983

UNCLE WIGGLEY
Tony Magnusson,
Epoxy, 1983

VISION
Agent Orange,
Band Deck, 1984

ALVA
Christian Hosoi,
1984

G+S
Billy Ruff,
Chalise, 1984

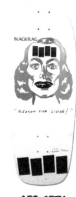

RIP CITY
Black Flack,
Band Deck, 1984

TITUS
Claus Grabke,
Clock Fiberglass,
1984

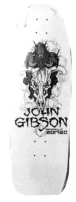

ZORLAC
John Gibson,
Cow Skull, 1984

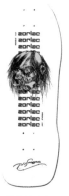

ZORLAC
Double Cut,
Team Deck, by Pushead,
1984

SANTA CRUZ
Duane Peters 2,
1984

POWELL PERALTA
Mike McGill,
Skull, 1984

MADRID
Mike Smith,
Duck, 1984

POWELL PERALTA
Per Welinder,
Nordic Skull Freestyle,
1984

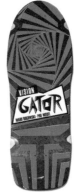

VISION
Gator Swirl,
1984

**SANTA MONICA
AIRLINES**
Natas Panther 1,
1984

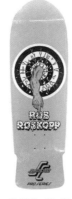

SANTA CRUZ
Rob Roskopp,
1 Arm, 1984

SIMS
Steve Rocco,
Freestyle, 1984

**SANTA MONICA
AIRLINES**
Jay Adams,
1984

G+S
Neil Blender,
Snake and Lattice,
1984

SOS
Steve Olson,
Splatter, 1984

ZORLAC
Craig Johnson,
Voodoo Doll,
1984

POWELL PERALTA
Tommy Guerrero,
V-8 Dagger,
1984

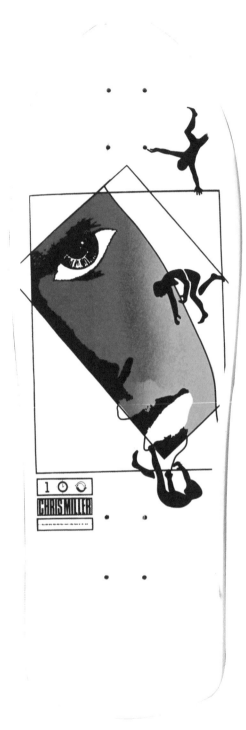

G+S
Chris Miller, Face by Miller,
1985

ALVA SKATES
Hammerhead,
1985

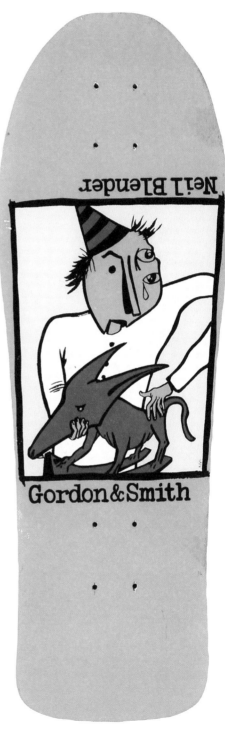

POWELL PERALTA
Lance Mountain, Future Primitive 1,
1985

G+S
Neil Blender, Rocking Dog,
1985

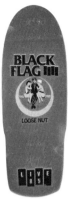

RIP CITY
Black Flag,
Loose Nut, Band Deck,
1985

POWELL PERALTA
Kevin Harris, Canadian
Mountie Freestyle,
1985

MADRID
Bill Danforth,
Nomad, 1985

SANTA CRUZ
R/S 10 series,
Multi Logo (third), 1985

POWELL PERALTA
Steve Caballero,
Full Dragon, 1985

HOSOI
Christian Hosoi,
Hammerhead, 1985

ZORLAC
JFA,
Band Deck, 1985

MADRID
John Lucero,
X-Teamrider, 1985

ALVA SKATES
Fish by Mondo,
1985

VISION
Mark Gonzales 1,
1985

**SANTA MONICA
AIRLINES**
Natas Panther 2, 1985

SIMS
Jeff Phillips,
Bust Out, 1985

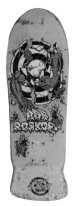

SANTA CRUZ
Roskopp 3,
1985

SANTA CRUZ
Keith Meek,
Slasher, 1986

VISION
Aggressor,
John Grigley, 1986

ALVA
John Thomas,
1986

G+S
Neil Blender,
Coffee Break, 1986

SANTA CRUZ
Jeff Kendall,
End of the World,
1986

SANTA CRUZ
Rob Roskopp,
Face, 1986

POWELL PERALTA
Tommy Guerrero,
Flaming Dagger,
1986

HOSOI
Christian Hosoi,
Sun 1 Vert, 1986

SKULL SKATES
Dave Hackett,
Street Sickle, 1986

TRACKER
Lester Leaf,
1986

ALVA
Fred Smith,
Loud One, 1986

WALKER
Mark Lake,
Nightmare, 1986

SIMS
Pierre Andre,
Street, 1987

BBC
Bad Boy Club,
Team Deck, 1987

SIMS
Eric Nash,
Bandito, 1987

G+S
Neil Blender,
Faces, 1987

G+S
Neil Blender,
Picasso, 1987

SANTA CRUZ
Jeff Grosso,
Demon by Jim Phillips,
1987

SANTA CRUZ
Jeff Grosso,
Toybox by Jim Phillips,
1987

POWELL PERALTA
Per Welinder,
Nordic Skull XT by VCJ,
1987

VISION
Mark Gonzales,
Coloring Board by Gonz,
1987

POWELL PERALTA
Steve Caballero,
Dragon Bats,
1987

SCHMITT STIX
John Lucero,
Street Thing 1,
1987

SCHMITT STIX
Joe Lopes,
Barbeque, 1987

HOSOI
Christian Hosoi,
Street Flag, 1987

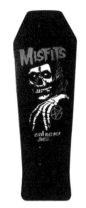

PLAN 9
Misfits, Evil Never Dies,
Band Coffin Deck,
1987

SCHMITT STIX
Rip Saw,
Team Deck, 1987

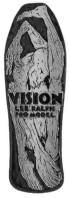

VISION
Lee Ralph,
1988

DOGTOWN
Eric Dressen,
Pup Size, 1988

DOGTOWN
Aaron Murray,
1988

SCHMITT STIX
Bryce Kanights,
Gargoyle and Shield,
1988

VISION
Mark Gonzales,
Gonz and Roses,
1988

SANTA CRUZ
John Lucero,
Red Cross, 1988

**SANTA MONICA
AIRLINES**
Natas Kaupas Panther 2
by Wes Humpston, 1988

**SANTA MONICA
AIRLINES**
Natas Kaupas Panther 3
by Jim Phillips, 1988

VISION
Aggressor 2, John Grigley,
1988

H-STREET
Ron Allen,
1988

POWELL PERALTA
Tony Hawk 7-ply, Chicken Skull by VCJ,
1988

**SANTA MONICA
AIRLINES**
esse Martinez, Handshake
by Doug Smith, 1988

SANTA CRUZ
Corey O'Brien,
Reaper by Jim Phillips,
1988

VISION
Mark Gonzales III,
Man and Woman,
1988

SANTA CRUZ
Jason Jessee,
Sun God by Jim Phillips,
1988

ALVA
Eddie Reategui,
Warrior by Mark Rude,
1988

SANTA CRUZ
Jeff Grosso,
Coke, 1988

**SANTA MONICA
AIRLINES**
Steve Rocco,
Think Crime, 1988

**SANTA MONICA
AIRLINES**
Steve Rocco 1,
1988

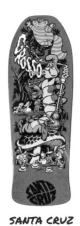

SANTA CRUZ
Jeff Grosso,
lice in Wonderland
y Jim Phillips, 1989

POWELL PERALTA
Ray Barbee,
Ragdoll by Sean Cliver,
1989

WORLD INDUSTRIES
Mike Vallely,
Barnyard, 1989

WORLD INDUSTRIES
Mike Vallely,
Elephant 2 by Marc McKee,
1989

**SANTA MONICA
AIRLINES**
Natas Evil,
Cat, 1989

H-STREET
Danny Way,
Giant, 1989

AIRBOURNE
The Rolling Stones
Steel Wheels Tour,
Band Deck, 1989

SANTA CRUZ
Ross Goodman,
Gravedigger,
1989

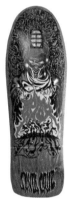

SANTA CRUZ
Tom Knox,
Ghoul by Kevin Marburg,
1989

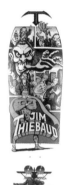

**SANTA MONICA
AIRLINES**
Jim Thiebaud, Joker
by Jim Phillips, 1989

WORLD INDUSTRIES
Jef Hartsel,
Globes, 1989

POWELL PERALTA
Tony Hawk,
Claw, 1989

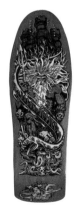

SANTA CRUZ
Jason Jessee,
Mermaid by Jim Phillips,
1989

POWELL PERALTA
Lance Mountain,
Junior by Lance Mountain,
1989

**SANTA MONICA
AIRLINES**
Steve Rocco 2,
1989

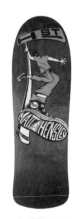

H-STREET
Matt Hensley,
Pole Spin by Obradov
1989

VISION
Mark Gonzales, Fat Face,
1989

SCHMITT STIX
Chris Miller, Faces by Miller,
1989

SANTA CRUZ
Eric Dressen, Celtic Rose,
1989

THE EARLY '90S: BACK TO THE STREETS

IN WHAT HAS NOW BECOME A FAMILIAR CYCLE, SKATEBOARDING'S POPULARITY AND THE INDUSTRY DEPENDENT ON THAT POPULARITY CRUMBLES FOR A THIRD (AND IN SOME WAYS FINAL) TIME.

As the vertical superstars from the '80s lose everything overnight and the few remaining skateboarders make street skating the only viable terrain, a number of tragedies shake the skateboarding community: the first, Mark "Gator" Rogowski rapes and murders Jessica Bergsten in '91 and is sentenced to life in prison; the second, the death of Jeff Phillips from suicide in '93.

A former Sims pro freestyler, Steve Rocco launches World Industries with the help of Skip Engblom after being fired by Sims/Vision. He quickly topples the "Big Five," stealing away Mike Vallely and Rodney Mullen from Powell Peralta, then Natas Kaupas and Mark Gonzales from SMA and Vision (who start 101 and Blind, respectively) to create a new wave of "skater-owned" companies. Following suit, Tony Hawk leaves Powell Peralta to birth Birdhouse Skateboards in '92. Stacy Peralta leaves Powell not long thereafter and Vision quickly shrinks from a multimillion-dollar company to nearly nothing overnight.

As *Thrasher* and *Transworld* struggle to stay afloat, Rocco creates *Big Brother* magazine headed up by Jeff Tremaine, Sean Cliver, and Spike Jonze. Rocco's empire and videos all but take over with a more urban, subversive, and technically cutting-edge street skating. Having released the first successful double kicktail board with the Vallely Barnyard in '89 (shaped by Mullen), by '92 Rocco's influence leads skateboards to thin down from 9 inches to the 7-inch "popsicle" shape along with a short run of "everslick" bottoms. Wheels follow suit and shrink from around 60mm in the late '80s to almost 40mm by '92.

These changes result in a technical explosion of extremely complicated tricks on curbs, stairs, and handrails. Tricks are invented nearly overnight and documented in videos. From '91 through '93 some of the most influential videos of all time are released including *Video Days* in '91 by future Academy Award winner Spike Jonze, and starring Mark Gonzales, Jason Lee, Guy Mariano, and the rest of the Blind team, and Plan B's era-defining video *Questionable* in '92.

Hip-hop and rap influences complete skateboarding's divorce from its surfing-centric beach roots and skateboarding becomes nearly ubiquitously associated with cities. Still small compared to the '80s high point, and shunned by the mainstream, modern skate culture is incubated during these early '90s years. By the time it is depicted in Larry Clark's *Kids* in '95, skateboarding exists as an entirely different pastime than during the three decades prior. Supreme skateshop opens in New York in '94.

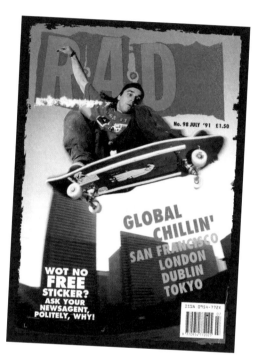

"THE PROGRESSION WAS CRAZY FOR THOSE YEARS ['91–'93]. IT MOVED SO FAST TRICKS WOULD BE OUT OF DATE BY THE TIME YOU LEARNED THEM. WHEN PRESSURE FLIPS CAME OUT IN '92 I LEARNED THEM—THEY WERE ALREADY GONE. LIKE I FINALLY FIGURED IT OUT EVERY WHICH WAY AND THEN IT WAS LIKE, 'NOPE. THOSE ARE OUT.'"

Guy Mariano

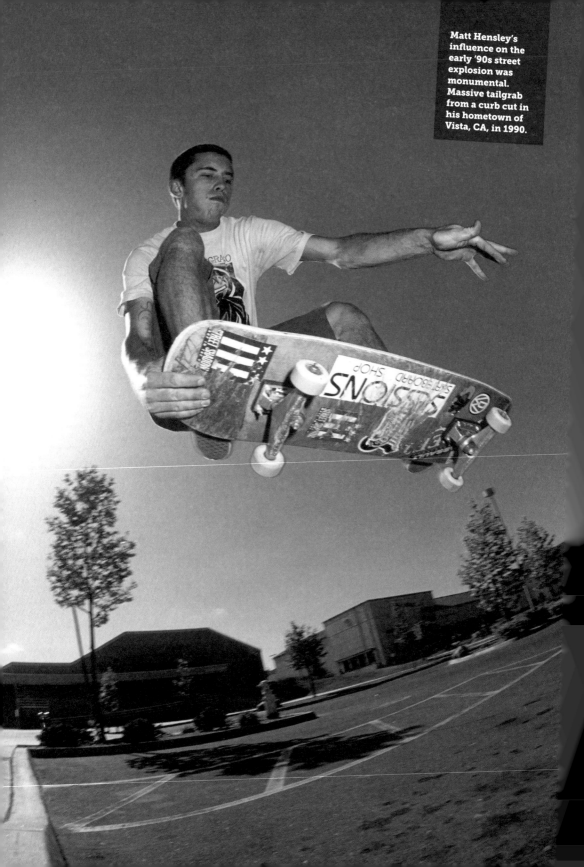

Matt Hensley's influence on the early '90s street explosion was monumental. Massive tailgrab from a curb cut in his hometown of Vista, CA, in 1990.

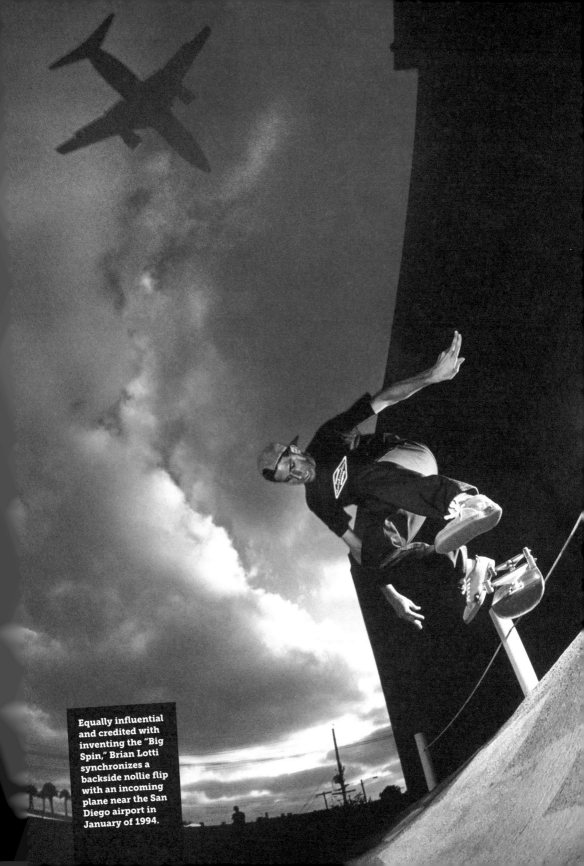

Equally influential and credited with inventing the "Big Spin," Brian Lotti synchronizes a backside nollie flip with an incoming plane near the San Diego airport in January of 1994.

LUCERO
John Lucero,
12XU, 1990

SANTA CRUZ
Jeff Kendall,
Atom Man, 1990

POWELL PERALTA
Steve Caballero,
Cab Iron Dragon,
1990

SCHMITT STIX
Chris Miller,
Cat Bird, 1990

SKULL SKATES
Dead Guys,
Team Deck, 1990

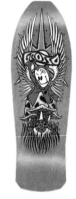

LUCERO
Jeff Grosso,
Devil Angel, 1990

SANTA CRUZ
Bod Boyle,
Everslick, 1990

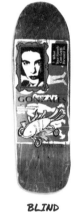

BLIND
Mark Gonzales,
Fish Collage,
1990

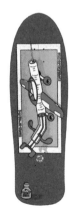

**SANTA MONICA
AIRLINES**
Julien Stranger,
Syringe, 1990

**SANTA MONICA
AIRLINES**
Mike Conroy,
1990

BBC
Jeff Phillips,
Devil, 1990

ZORLAC
Metallica 2,
Band Deck, by Pushe
1990

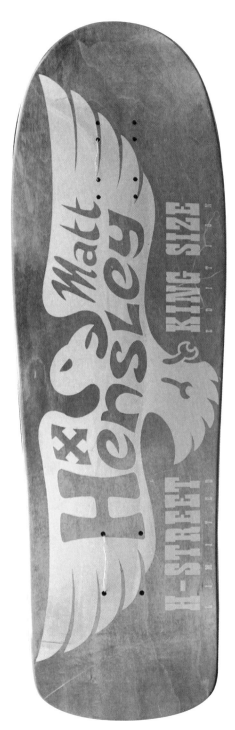

FOUNDATION
Tod Swank,
1990

H-STREET
Matt Hensley,
Kingsize by Albertini,
1990

PLANET EARTH
Buster Halterman,
1990

WORLD INDUSTRIES
Ron Chatman Experience,
1990

H-STREET
Sal Barbier,
Hands, 1990

WORLD INDUSTRIES
Jef Hartsel,
Banzai Tree, 1990

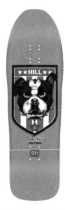

POWELL PERALTA
Frankie Hill,
Bulldog, 1990

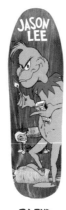

BLIND
Jason Lee,
Grinch, 1990

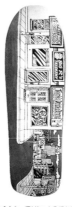

WORLD INDUSTRIES
Stick-o-rama,
Team Deck, 1990

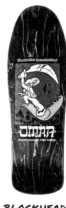

BLOCKHEAD
Omar Hassan,
Arabian Nights
by Ron Cameron, 199

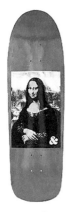

G+S
Mona Lisa,
Team Deck, 1991

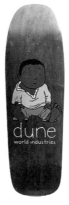

WORLD INDUSTRIES
Chris Pastras,
Dune Baby, 1991

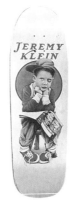

WORLD INDUSTRIES
Jeremy Klein,
Black Eye, 1991

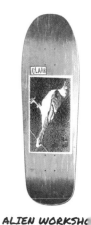

ALIEN WORKSHO
Steve Claar,
Blue Bird, 1991

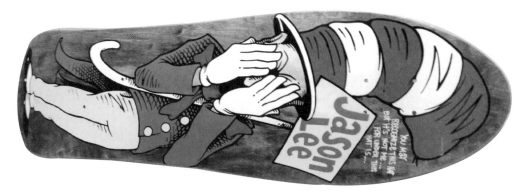

BLIND
Jason Lee, Cat in the Hat by Andy Jenkins,
1990

WORLD INDUSTRIES
Mike Vallely, Snake,
1990

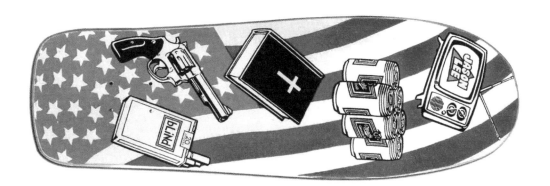

BLIND
Jason Lee, American Icons,
1991

ALIEN WORKSHOP
Duane Pitre, Olives,
1991

101
Gabriel Rodriguez, Jesus,
1991

NEW DEAL
Andy Howell, Kid,
1991

BLIND
Jason Lee,
Burger, 1991

LIFE
Sean Sheffey,
1991

WORLD INDUSTRIES
Randy Colvin,
1991

LIBERTY
Todd Congelliere,
1991

REAL
Henry Sanchez,
Crayon, 1991

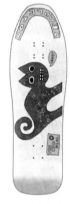

NEW DEAL
Ed Templeton,
Cat, 1991

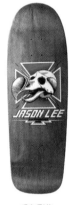

BLIND
Jason Lee,
Dodo by Marc McKee, 1991

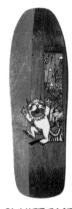

PLANET EARTH
Brian Lotti,
Wild Things, 1991

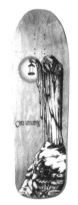

H-STREET
Chris Livingston,
1991

SANTA CRUZ
Jason Jessee,
Guadalupe, 1991

ZORLAC
Metallica,
Spider, 1991

WORLD INDUSTRIES
Rodney Mullen,
Street, 1991

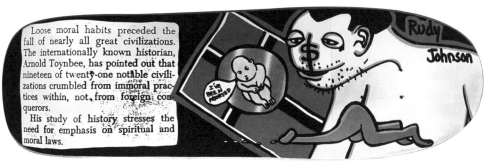

BLIND
Rudy Johnson, Aborted,
1991

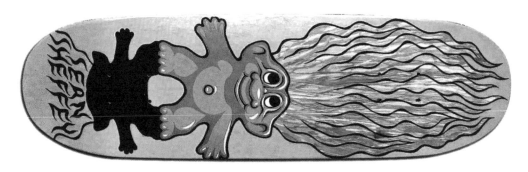

PLAN B
Sean Sheffey, Troll,
1991

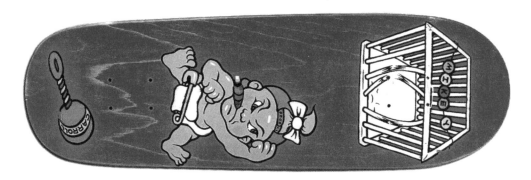

PLAN B
Mike Carroll, Baby by Sean Coons,
1991

ALIEN WORKSHOP
Rob Dyrdek, Little Rob by Neil Blender,
1991

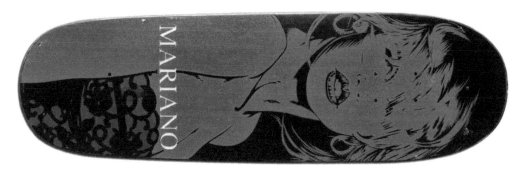

BLIND
Guy Mariano, Claudia Schiffer by Sean Cliver,
1991

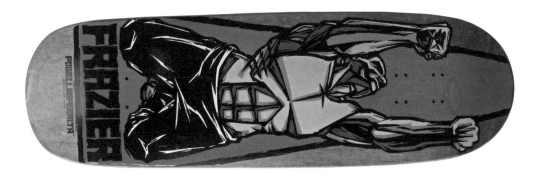

POWELL PERALTA
Mike Frazier, Yellow Man by Sean Cliver,
1991

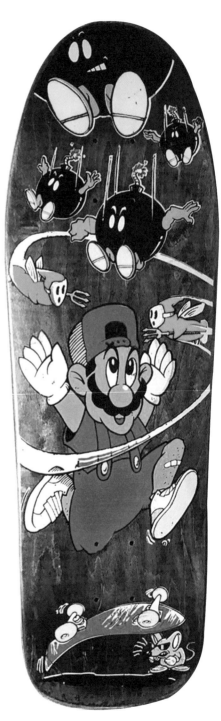

BLIND
Mark Gonzales,
1991

WORLD INDUSTRIES
Jeremy Klein,
Mario, 1991

BLIND
Danny Way,
OC Bladerunners,
1991

101
Natas Kaupas,
Oops, 1991

101
Natas Devil,
Worship, 1991

H-STREET
Matt Hensley,
Stained-glass
by Jeff Klindt, 1991

REAL
Jim Thiebaud,
nging Klansman [1], 1991

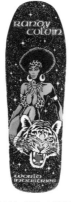

WORLD INDUSTRIES
Randy Colvin,
Velvet, 1991

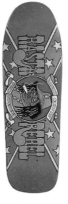

WORLD INDUSTRIES
Randy Colvin,
Rasta Rebel, 1991

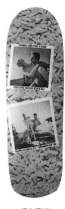

BLIND
Mark Gonzales,
Macaroni Kiss Slick, 1991

101
Natas Kaupas,
Crack Pipe [2], 1991

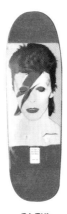

BLIND
Jason Lee,
Bowie, 1991

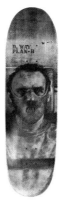

PLAN B
Danny Way,
Hannibal by Sean Coons,
1992

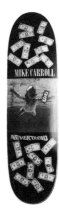

PLAN B
Mike Carroll,
Nevertrend, 1992

notes page 2.

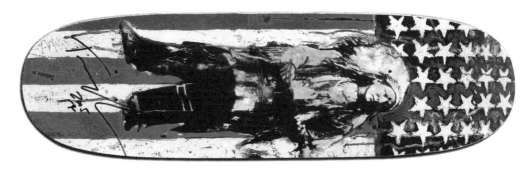

REAL
Tommy Guerrero, Native American,
1992

PLAN B
Sean Sheffey, Malcolm Slick,
1992

MILK
Ron Chatman by Ron, Jeremy Klein, and Mark Gonzales,
1992

TV
Ed Templeton,
1992

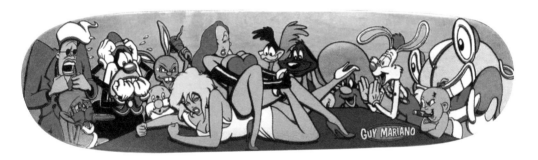

BLIND
Guy Mariano, Roger Rabbit by Marc McKee,
1992

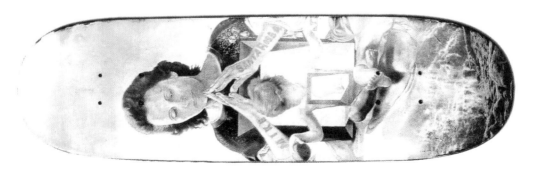

THINK
Mike Santarossa,
1992

BLACK LABEL
John Cardiel,
1992

H-STREET
Dan Peterka,
Charlie Brown,
1992

WORLD INDUSTRIES
Randy Colvin,
New Kids on the Block,
1992

**SANTA MONICA
AIRLINES**
Eric Britton,
Everslick, 1992

SANTA CRUZ
Eric Dressen,
Everslick, 1992

101
Kris Markovich,
Evel Knievel, 1992

THINK
Jason Adams,
Flames, 1992

REAL
James Kelch,
Flyer (Slick), 1992

BLIND
Guy Mariano,
High Guy
by Marc McKee, 1992

BLIND
Jordan Richter,
Jerkin' Jordan
by Marc McKee, 1992

BLIND
Rudy Johnson,
Rear End Rudy
by Marc McKee, 1992

PLAN B
Danny Way, 12 Guac
by Spike Jonze, 199

REAL
James Kelch,
Flowers, 1992

TV
Mike Vallely
by Ed Templeton,
1992

BIRDHOUSE
Jeremy Klein
by Nancy Chiang,
1992

ACME
Your Pro Model (Cat),
1992

POWELL CORP.
de Speyer, Wade Awaits
by John Keester, 1992

BLIND
Guy Mariano,
32, 1992

SANTA CRUZ
Jaya Bonderov, Bikini Girl
by Johnny Mojo, 1992

BLOCKHEAD
Jeremy Wray,
Salt Girl, 1992

BLUE
s Pastras, Knife & Fork
Andy Jenkins, 1992

PLANET EARTH
Brian Lotti,
1992

ACME
Gunshot, Team Board
by Ron Cameron, 1992

PLAN B
Rodney Mullen,
Motorcycle, 1992

BLIND
Guy Mariano, Accidental Gun Death by Marc McKee [3],
1992

BLIND
Henry Sanchez, Horny Henry by Marc McKee,
1992

101
Eric Koston, Buddha,
1993

[3] *See note page 2.*

WORLD INDUSTRIES
Chico Brenes, Orange Vendor,
1993

101
Gabriel Rodriguez, Penalizer,
1993

UNDERWORLD ELEMENT
Andy Howell,
1993

PLAN B
Rick Howard,
Han Solo, 1993

PLAN B
Sean Sheffey,
The Thing, 1993

PLAN B
Rick Howard,
Dog and Doll, 1993

PLAN B
Pat Duffy,
Primus, 1993

BLIND
Jordan Richter,
Safe Sex, 1993

BLIND
Tim Gavin,
Dogpound, 1993

101
Adam McNatt,
Bondage, 1993

BLIND
Brian Lotti,
Dancing Girls, 1993

BLIND
Tim Gavin,
Ken Doll, 1993

POWELL PERALTA
Wade Speyer,
Beavis and Butthead, 1993

101
Adam McNatt,
Peanuts Manson, 1993

BLIND
Ronnie Bertino,
Mr. Butts, 1993

REAL
Kelly Bird,
Eagle, 1993

ATM CLICK
Mark Gonzales reissue,
1993

MILK
Christian Hosoi
by Mark Gonzales, 1993

BLOCKHEAD
I (Heart) Cops,
1993

BLACK LABEL
Randy Colvin
y John Lucero, 1993

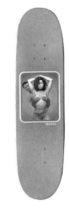

EVOL
Alphonzo Rawls,
Janet Jackson, 1993

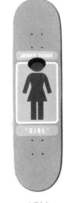

GIRL
Jovontae Turner
by Andy Jenkins, 1993

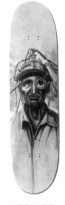

STEREO
John Deago
by Kevin Ancell, 1993

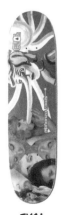

EVOL
Alphonzo Rawls,
Pinocchio, 1993

GIRL
Sean Sheffey,
Fighting Irish, 1993

SMA
Jason Adams,
Rotten by Mojo, 1993

SMA
Jason Adams,
Descendents Mojo, 1993

PLAN B
Matt Hensley, Retirement by Nico,
1993

BLOCKHEAD
Jeremy Wray, Dr. Seuss Tribute,
1993

COLOR
Jeremy Wray, Troubled Youth,
1993

PLAN B
Rodney Mullen,
Yoda by Sean Coons,
1993

BLIND
Rudy Johnson,
Spark Plug by Mark McKee,
1993

POWELL CORP.
Chris Senn
by John Keester, 1993

WORLD INDUSTRIES
Kareem Campbell,
White Devil, 1993

PLAN B
nny Way, Darth Vader
y Sean Coons, 1993

ALIEN WORKSHOP
Bo Turner,
Boxer, 1994

101
Gino Iannucci,
Boy Tree, 1994

THINK
Bulb Head,
Team Deck, 1994

IEN WORKSHOP
John Drake,
Butterfly, 1994

ALIEN WORKSHOP
Clone, Team Deck,
1994

WORLD INDUSTRIES
Daewon Song,
Crossing by Marc McKee,
1994

TOY MACHINE
Demon, Team Deck
by Sean Cliver,
1994

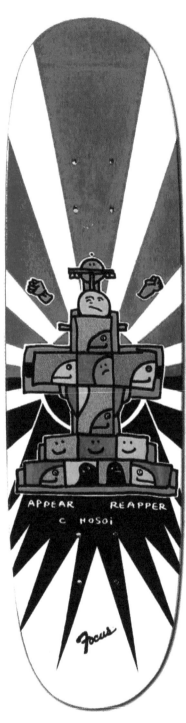

WORLD INDUSTRIES
Jeremy Klein, Dream Girl,
1993

FOCUS
Christian Hosoi by Mark Gonzales,
1994

THE FIRM
Ray Barbee,
Fun Ride, 1994

GIRL
Jovontae Turner,
Tommy, 1994

ALIEN WORKSHOP
Matrix,
Team Deck, 1994

WORLD INDUSTRIES
Kareem Campbell,
Mary Jane, 1994

ALIEN WORKSHOP
Missing Link,
Team Deck, 1994

TOY MACHINE
Monster, Team Deck
by Ed Templeton,
1994

**SANTA MONICA
AIRLINES**
Tim Brauch,
Saint, 1994

MAD CIRCLE
Squeeze,
Team Deck, 1994

GIRL
Eric Koston,
Super Cock, 1994

101
Gabriel Rodriguez,
Superhombre,
1994

101
Gino Iannucci,
The W, 1994

MAD CIRCLE
Tas Pappas,
Warrior, 1994

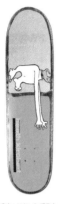

FOUNDATION
Heath Kirchart
by Yogi Proctor, 1994

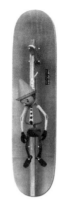

ALIEN WORKSHOP
Rob Dyrdek,
Doll by Mike Hill, 1994

101
Gino Iannucci,
Graffiti by Natas Kaupas,
1994

FOUNDATION
Steve Olson,
Courtney Love
by Cleon Peterson, 199⌐

CLEAN
Karl Watson,
Sketch by Damon Soule,
1994

ALIEN WORKSHOP
Scott Conklin
by Mike Hill, 1994

NEW DEAL
John Montesi
by Jose Gomez, 1994

THE FIRM
Pat Brennen is Dead
1994

WORLD INDUSTRIES
Shiloh Greathouse,
Tagger by McKee,
1994

STEREO
Jason Lee,
Bottles by Nathan,
1994

BLIND
Keenan Milton,
Junkyard Kid,
1994

TOY MACHINE
Ed Templeton,
Black Cloud,
1994

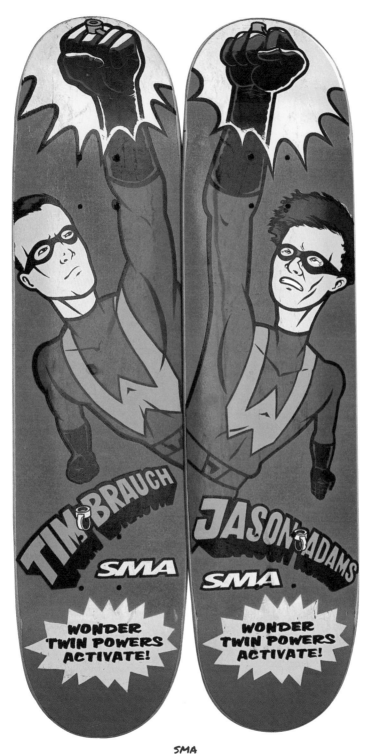

SMA
Tim Brauch and Jason Adams,
Wonder Twins by Carrico, 1994

THE LATE '90S: BACK TO THE MAINSTREAM

THE '90S ARE SO PIVOTAL TO SKATE CULTURE THAT THEY WILL BE THE ONLY DECADE IN THIS TIMELINE NEEDING TWO ENTRIES. AFTER THE TECHNICAL SUPERNOVA OF STREET SKATING AND SMALLER COMPANIES DURING THE EARLY '90S, THE TABLE IS SET FOR THE RETURN OF VERTICAL RELEVANCE (ALONG WITH CONTINUED STREET DOMINANCE) AND (FINALLY) A SUSTAINABLE INDUSTRY NOT SUSCEPTIBLE TO BOOM-AND-BUST CYCLES.

Following inaugural issues in '93, *411 Video Magazine* becomes highly influential by the mid-'90s and is quickly followed by a host of other monthly videos. In '95, ESPN organizes the first X-Games in Rhode Island and mainstream broadcasts draw the attention of larger corporations like Adidas, Puma, and Nike.

On the street-skating front, new stars like Chad Muska, Tom Penny, and Jamie Thomas take skateboarding down larger and larger gaps and handrails. Videos like *Welcome to Hell* by Ed Templeton's company Toy Machine in '96 capitalize on the trend (*Welcome to Hell* also contains the first true stand-alone street part from a girl skater in the form of Elissa Steamer) and Jamie Thomas leaves to start Zero Skateboards while Chad Muska joins the new board division of Shorty's. More finesse-based ledge-skating pros leave Rocco's companies along with Spike Jonze during the early '90s and set up camp at Girl and Chocolate Skateboards (later also starting Lakai Shoes in '99).

In 1998, legislation in California is passed categorizing skateboarding as an HRA (or inherently Hazardous Recreational Activity), freeing municipalities and their employees from claims of liability at skateparks in cases of injury. This opens the doors to countless new parks being built and similar legislation passing worldwide.

By '99, skater-owned shoe companies like Etnies, éS, Emerica, Lakai, Osiris, Axion, Duffs, DVS, DC, and Globe gain success, providing the biggest paycheck in a pro skater's monthly salary. Tony Hawk lands the first 900 at the nationally televised '99 X-Games Best Trick contest and the first installment of his successful video game franchise, *Tony Hawk's Pro Skater* (released that September), reignites another surge in industry profits and mainstream interest.

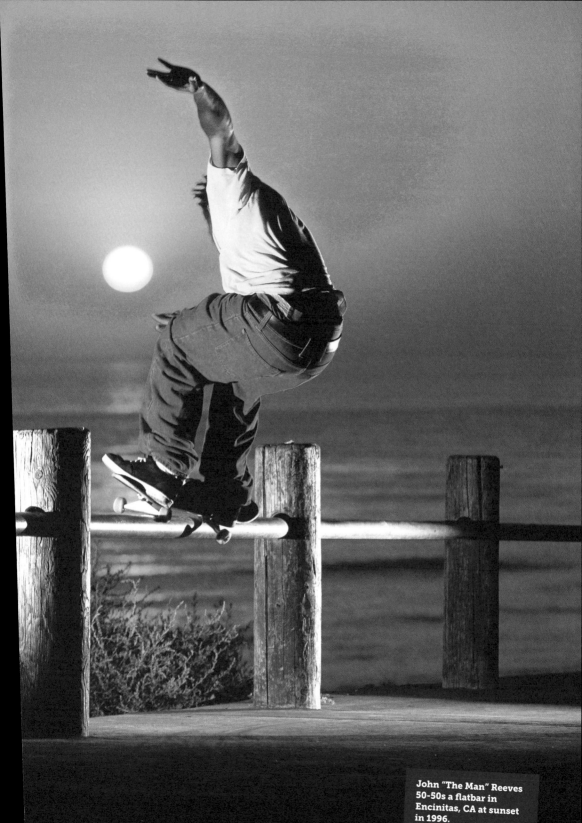

John "The Man" Reeves
50-50s a flatbar in
Encinitas, CA at sunset
in 1996.

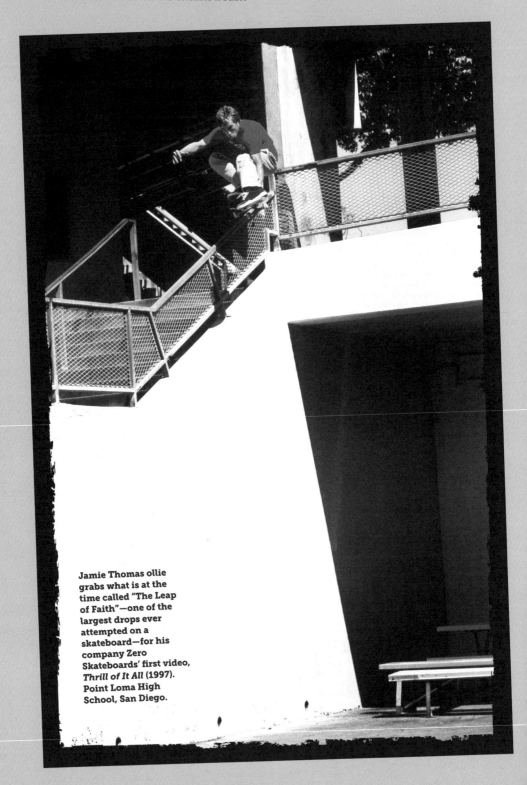

Jamie Thomas ollie grabs what is at the time called "The Leap of Faith"—one of the largest drops ever attempted on a skateboard—for his company Zero Skateboards' first video, *Thrill of It All* (1997). Point Loma High School, San Diego.

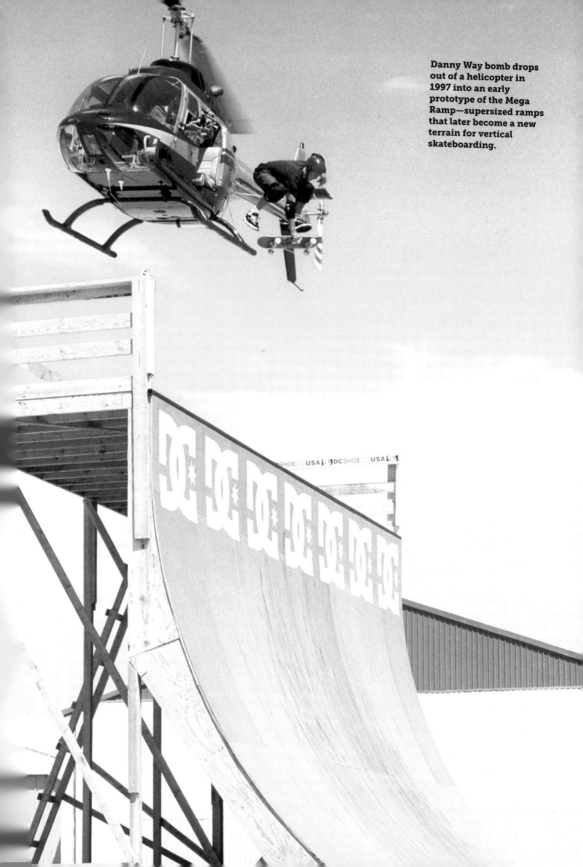

Danny Way bomb drops out of a helicopter in 1997 into an early prototype of the Mega Ramp—supersized ramps that later become a new terrain for vertical skateboarding.

ALIEN WORKSHOP
Abduction Process,
Team Deck, 1995

ALIEN WORKSHOP
Fred Gall by Mike Hill,
1995

STEREO
Carl Shipman,
Bar by Todd Francis,
1995

HOOK-UPS
Brittney the Vampire
Slayer, Team Deck,
1995

ANTI HERO
Bob Burnquist,
Disease, 1995

INVISIBLE
Matt Mumford,
Mighty Mumford, 1995

101
Clyde Singleton,
Old Dirty Cyzzah
by Sean Cliver, 1995

101
Jason Dill,
Pooh, 1995

BLIND
Lavar McBride,
Rasta Lion, 1995

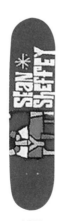

GIRL
Sean Sheffey,
Retro, 1995

CONSOLIDATED
Andy Roy,
Shock Hazard, 1995

BALANCE
Bill Weiss,
South Park, 1995

GIRL
Guy Mariano, Old Man by Spike Jonze & Andy Jenkins,
1995

SANTA CRUZ
Tim Brauch, Wheelchair by Johnny Mojo,
1995

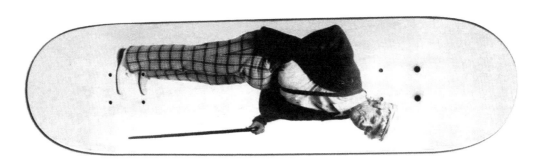

GIRL
Eric Koston, Old Man by Spike Jonze,
1995

MENACE
Eric Pupecki, 1995

MENACE
Joey Suriel, 1995

MENACE
Fabian Alomar, 1995

TOY MACHINE
Jamie Thomas,
Alabama, 1995

PRIME
Caine Gayle,
Tricyle, 1995

101
Natas, 3 Eyed Cat
by Sean Cliver, 1996

ALIEN WORKSHOP
Lennie Kirk,
Angel, 1996

WORLD INDUSTRIES
Arm Wrestle,
Team Deck, 1996

BIRDHOUSE
Andrew Reynolds,
Bear, 1996

CONSOLIDATED
Daredevil,
Team Deck, 1996

TOY MACHINE
Donny Barley,
Black Lung, 1996

SONIC
Tom Knox,
Classic Car, 1996

MENACE
Billy Valdes,
Comic Book, 1996

GIRL
Rick Howard,
Dick by Andy Jenkins,
1996

A-TEAM
Gershon Mosley,
Dr. Demento, 1996

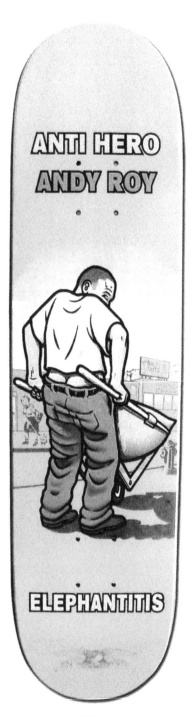

TOY MACHINE
Chad Muska, Wanderer,
1996

ANTI HERO
Andy Roy, Elephantitis by Todd Francis,
1996

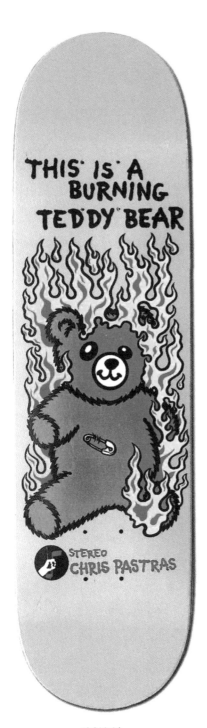

STEREO
Chris Pastras, Teddybear by Christian Cooper,
1996

CREATURE
Darren Navarrette by Johnny Mojo,
1996

FLIP
Tom Penny,
Cheech and Chong,
1996

FLIP
Tom Penny,
Freak Brothers, 1996

FLIP
Tom Penny,
Freddy's Cat, 1996

CREATURE
Jason Adams,
Web by Johnny Mojo,
1996

101
Natas Kaupas,
Dog by Sean Cliver,
1996

101
Natas Kaupas
by Natas, 1996

PRIME
Kris Markovich
by Sean Cliver, 1996

SANTA CRUZ
Tim Brauch,
Fishing by Dimitri Tyl
1996

STEREO
Matt Rodriguez
by Christian Cooper,
1996

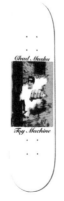

TOY MACHINE
Chad Muska
by Thomas Campbell,
1996

ANTI HERO
Julien Stranger,
Goiter by Todd Francis,
1996

THINK
Matt Pailes,
American by Mike Le
1996

CREATURE
Barker Barrett by Johnny Mojo,
1996

CHOCOLATE
Keenan Milton, Taxi by Andy Jenkins,
1996

STEREO
Carl Shipman, Prisoner by Christian Cooper,
1996

MAPLE
Kien Lieu,
Dragon Yin Yang,
1996

THINK
Duane Peters,
King Skull, 1996

GIRL
Tony Ferguson,
Bend Series
by Andy Jenkins, 1996

ADRENALIN
Matt Reason,
Ganesha, 1996

WORLD INDUSTRIES
Hail to the Chief
by Marc McKee, 1996

THE FIRM
Lance Mountain,
Handpainted, 1996

STEREO
Greg Hunt,
Horn, 1996

REAL
Max Schaaf,
I Hate School, 1996

REAL
Johnny Fonseca,
Johnny Dangerous, 1996

101
Jason Dill,
Natas Kitten, 1996

101
Gino Iannucci,
Natas Panther, 1996

SCARECROW
Misfits Die, My Darl'
Band Deck, 1996

OBEY
Obey the Giant
by Shepard Fairey,
Team Deck, 1996

ANTI HERO
Sean Young,
Oddities by Todd Francis,
1996

ELEMENT
Kris Markovich,
Orange Slices, 1996

ILLUMINATI
Ricky Oyola, Mass Control
by Eli Gesner, 1996

PROFILE
Stevie Williams,
Rasta, 1996

CHOCOLATE
Keenan Milton,
Boy, 1996

ADRENALIN
Chris Senn,
The Choker, 1996

REAL
Shawn Mandoli
by Christian Cooper, 1996

INVISIBLE
Laban Pheidias,
Toy Robot, 1996

ALIEN WORKSHOP
World Religion,
Team Deck, 1996

ACME
X-Treme,
Seoul, 1996

ZERO
American Zero,
Team Deck, 1997

CHOCOLATE
Keenan Milton, City Scene Series,
1997

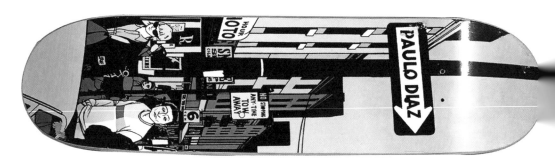

CHOCOLATE
Paulo Diaz, City Scene Series,
1997

CHOCOLATE
Mike York, City Scene Series,
1997

CHOCOLATE
Gino Iannucci, City Scene Series,
1997

CHOCOLATE
Gabriel Rodriguez, City Scene Series,
1997

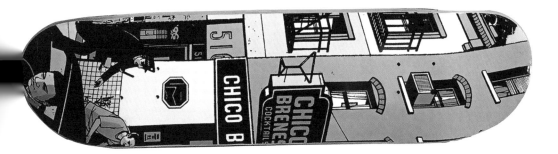

CHOCOLATE
Chico Brenes, City Scene Series,
1997

303
303 Boy,
Team Deck, 1997

HOOK-UPS
357 Girl,
Team Deck, 1997

ANTI HERO
Sean Young,
Leprosy by Todd Francis,
1997

FOUNDATION
Brad Staba,
Animal, 1997

REAL
Keith Hufnagel,
Arabic, 1997

ZERO
Bird,
Team Deck, 1997

MENACE
Steven Cales,
Boxing Brunette, 1997

HOOK-UPS
Detonator 2,
Team Deck by Sean Cli
1997

WORLD INDUSTRIES
Daewon Song,
Dolphin, 1997

151
Eric Dressen,
Eyes, 1997

TOY MACHINE
Fists,
Team Deck, 1997

BIRDHOUSE
Tony Hawk,
Full Skull, 1997

TOY MACHINE
Mike Frazier, Coffee by Ed Templeton,
1997

MAD-CIRCLE
Karl Watson, Egypt by Jesse McMillan,
1997

ANTI HERO
John Cardiel, Cockroach by Todd Francis,
1997

ANTI HERO
Julien Stranger,
Cockroach Stilts
by Todd Francis, 1997

ANTI HERO
Sean Young,
Cockroach Smoking
by Todd Francis, 1997

ANTI HERO
Bob Burnquist,
Cockroach
by Todd Francis, 1997

ANTI HERO
Bob Burnquist,
King by Christian Cooper
1997

ALIEN WORKSHOP
Lennie Kirk,
Truth Murderers, 1997

23
Clyde Singleton,
Lion, 1997

ALIEN WORKSHOP
Fred Gall by Mike Hill,
1997

CHOCOLATE
Chico Brenes
by Evan Hecox, 1997

ANTI HERO
Bob Burnquist,
Dagger by Jef Whitehead,
1997

ANTI HERO
Sean Young,
Seal Boy by Todd Francis,
1997

ANTIHERO
Andy Roy, Roach Series
by Todd Francis,
1997

CHOCOLATE
Paulo Diaz,
Flute by Evan Heco
1997

PANIC
Colin Kennedy,
Ghostbusters, 1997

STEREO
Jason Lee,
Retirement Deck, 1997

CHOCOLATE
Mike York,
Pow, 1997

SHORTY'S
Steve Olson,
Pyramid, 1997

BLIND
Reaper Noose [4],
1997

WORLD INDUSTRIES
She Devil 3
by Marc McKee,
1997

SHORTY'S
Chad Muska Silhouette
by Tony Buyalos,
1997

GIRL
Guy Mariano,
OG by Bucky Fukumoto,
1997

GIRL
Sean Sheffey,
College Series, 1998

GIRL
Mike Carroll,
College Series, 1998

GIRL
Tony Ferguson,
College Series, 1998

GIRL
Tim Gavin,
College Series, 1998

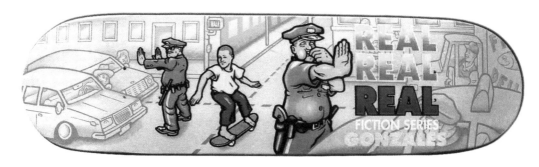

REAL
Mark Gonzales, Fiction Series by Todd Francis,
1998

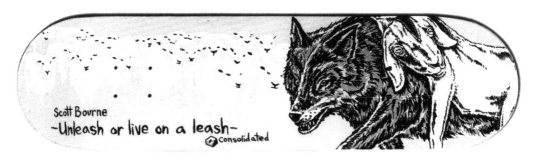

CONSOLIDATED
Scott Bourne, Wolf by Moish Brenman,
1998

ALIEN WORKSHOP
Clone by Mike Hill,
1998

GIRL
Rick Howard,
College Series, 1998

GIRL
Rudy Johnson,
College Series, 1998

GIRL
Guy Mariano,
College Series, 1998

GIRL
Jeron Wilson,
College Series, 1998

SUPREME
Motion Logo,
Art Deck, 1998

SHORTY'S
Chad Muska,
NWB by John Pound,
1998

SHORTY'S
Peter Smolik,
NWB by John Pound,
1998

SHORTY'S
Masked Penis,
NWB by John Pound,
1998

ROOKIE
Jaime Reyes,
1998

REAL
Keith Hufnagel,
Terminator, 1998

BLACK LABEL
Omar Hassan,
Alive Series by Mike Miller,
1999

ENJOI
Rodney Mullen,
Boy Genius, 1999

TOY MACHINE
Ed Templeton,
Girl in Bra
by Ed Templeton, 1999

ELEMENT
Donny Barley,
Hieroglyphics Series,
1999

ARCADE
Malcolm Watson,
Hendrix, 1999

ELEMENT
Listen to Bob Marley,
Team Deck, 1999

ANTIHERO
McJesus,
Team Deck, 1999

CHOCOLATE
Keenan Milton
by Evan Hecox, 1999

TOY MACHINE
Bam Margera,
Mullet, 1999

AESTHETICS
Kevin Taylor,
Racing Series, 1999

BIRDHOUSE
Andrew Reynolds,
Scary Movie, 1999

STEREO
Chris Pastras,
Skyline, 1999

ZERO
Jamie Thomas Smith,
1999

DOGTOWN
Eric Dressen,
Tattoo, 1999

CONSOLIDATED
Alan Petersen, Skull Lady by Todd Bratrud,
1999

CHOCOLATE
Mike York, Robot Series by Evan Hecox,
1999

ALIEN WORKSHOP
Josh Kalis, Ride Everything by Mike Hill,
1999

THE '00S: THE GLOBAL PLAYGROUND

AFTER A SERIES OF UNSUCCESSFUL ATTEMPTS DURING THE '90S, NIKE FINALLY FINDS A WAY INTO THE SKATE MARKET VIA REISSUES OF ITS CLASSIC DUNKS AND "NIKE SB" TEAM OF INFLUENTIAL PROS IN '02. ADIDAS, CONVERSE, AND LATER, NEW BALANCE, JOIN NIKE OVER THE NEXT DECADE IN TAKING AN INCREASING MARKET SHARE (AND TEAMRIDERS) AWAY FROM THE "SKATER-OWNED" SHOE BRANDS. IN '05, NIKE SB RELEASES ITS FIRST PRO SHOE FOR PAUL RODRIGUEZ.

As the Internet expands skateboarding's epicenter outside its California roots, companies begin touring Barcelona, China, Australia, LOVE Park in Philadelphia, and New York to film ever more elaborate team videos. By the time Lakai releases *Fully Flared* in '07, the norm is almost four years of worldwide filming trips and budgets in the millions, not to mention explosions and special effects. Ty Evans (and Spike Jonze) lead the way in pushing skate videography production higher.

The first official Skate Plaza is opened June 11, 2005, in Kettering, Ohio, by Rob Dyrdek and DC Shoes, creating a template for plazas worldwide over the next decade. Traditional skateparks also continue to spring up across the globe including a giant new Venice Beach skatepark in '09.

Companies like Cliché Skateboards out of Lyon, France; Blueprint from the UK; Zoo York in NYC; and later Polar out of Malmö, Sweden, prove that the industry is thriving worldwide. On the media front, *Skateboarder* returns to print monthly by '01 and titles like *Sugar* (France), *Monster* (Germany), and *Sidewalk* (UK) are joined by *Kingpin* magazine—the first pan-European periodical—as *Thrasher* and *Transworld* continue dominance in a healthy print industry.

Parallel to the team video format and street skating, the contest circuit also flourishes. X-Games are joined by Dew Tour, Warped Tour, Maloof Money Cup, and more leading up to the creation of Street League by Rob Dyrdek at the end of the decade. A combination of Street League and the X-Games is ultimately sold to the IOC, and plans to add skateboarding to the Olympics go on for the next ten years.

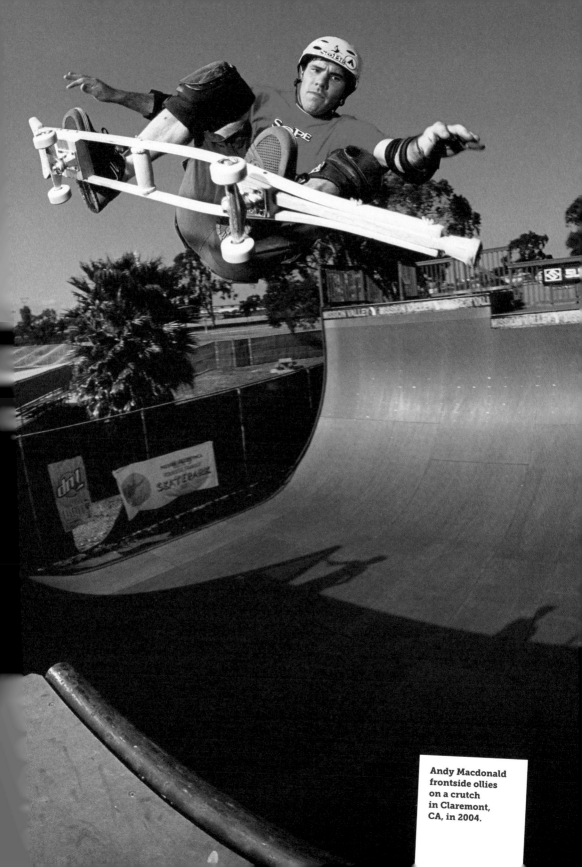

Andy Macdonald
frontside ollies
on a crutch
in Claremont,
CA, in 2004.

" IT'S [SKATEBOARDING] DEFINITELY
MORE OF A JOB NOW. NOT THAT THAT
MAKES IT BETTER OR WORSE. THERE'S
DEFINITELY A LOT MORE MONEY IN IT. I
KIND OF MISS THE DAYS WHEN SKATING
WAS HATED ON—A LITTLE MORE
UNDERGROUND. SKATERS USED TO BE
LIKE THESE HOODLUM OUTLAWS. THAT'S
REALLY WHAT WE TRADED FOR WHAT IT
IS NOW. "

GINO IANNUCCI

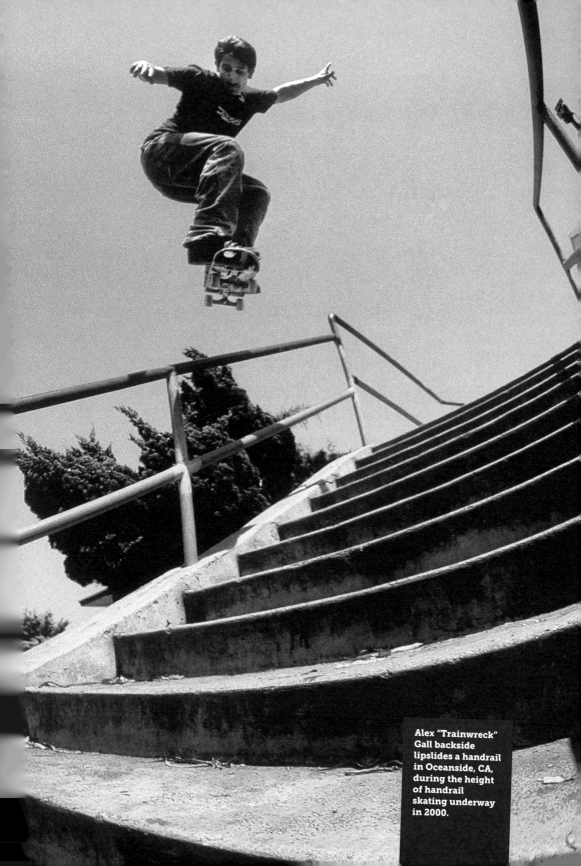

Alex "Trainwreck" Gall backside lipslides a handrail in Oceanside, CA, during the height of handrail skating underway in 2000.

TOY MACHINE
American Monster,
Team Deck, 2000

GIRL
Mike Carroll,
Bug Series, 2000

HABITAT
Co-Exist 2,
Team Deck, 2000

BIRDHOUSE
Heath Kirchart,
Gatorz by Sean Cliver,
2000

HOOK-UPS
Devil Vixen, Team Deck
by Sean Cliver, 2000

SHORTY'S
Peter Smolik,
Dice Game, 2000

FLIP
Tom Penny,
Love Shroom, 2000

TOY MACHINE
Ed Templeton,
Millennium, 2000

SUPREME
Pantone Series,
Blue, 2000

REAL
Mark Gonzales,
Silver Series
by Mark Gonzales, 2000

BULLDOG SKATES
South Side
by Wes Humpston,
2000

ELEMENT
Bam Margera,
Vote Bam, 2000

DECA
Enrique Lorenzo, Mojo Jojo,
2000

EXPEDITION
Karl Watson, Robocop by Dave Kinsey,
2000

TOY MACHINE
Bam Margera
by Ed Templeton,
2000

5BORO
Aaron Suski,
Collage by Suski/Haley,
2000

CLICHÉ
Jérémie Daclin,
Museum Series
by Eric Frenay, 2001

CLICHÉ
Ricardo Fonseca,
Museum Series
by Eric Frenay, 2001

CLICHÉ
Vincent Bressol,
Museum Series
by Eric Frenay, 2001

CLICHÉ
Pontus Alv,
Museum Series
by Eric Frenay, 2001

CLICHÉ
JJ Rousseau,
Museum Series
by Eric Frenay, 2001

ALIEN WORKSHO
Jason Dill, Noir Serie
by Don Pendleton,
2001

ALIEN WORKSHOP
Josh Kalis, Noir Series
by Don Pendleton,
2001

ALIEN WORKSHOP
Rob Dyrdek, Noir Series
by Don Pendleton,
2001

ALIEN WORKSHOP
AVE, Noir Series
by Don Pendleton,
2001

ALIEN WORKSHO
Danny Way, Noir Se
by Don Pendleto:
2001

AESTHETICS
Rob Welsh,
Arcade Series, 2001

CHOCOLATE
Keenan Milton,
A Cortes, 2001

CHOCOLATE
Stevie Williams,
Bar Series by Evan Hecox,
2001

CHOCOLATE
Scott Johnston,
Bar Series by Evan Hecox,
2001

CHOCOLATE
Chico Brenes,
Series by Evan Hecox,
2001

CHOCOLATE
Keenan Milton,
Bar Series by Evan Hecox,
2001

CHOCOLATE
Gino Iannucci,
Bar Series by Evan Hecox,
2001

CHOCOLATE
Richard Mulder,
Bar Series by Evan Hecox,
2001

CHOCOLATE
Mike York,
eries by Evan Hecox,
2001

ENJOI
Marc Johnson,
Blackout, 2001

BOOTLEG
Alex Gall,
Black Widow, 2001

BAKER
Brand Logo,
Team Deck, 2001

GIRL
Eric Koston,
Super Cock, 2001

GIRL
Guy Mariano,
Flow Series by Mike Leon,
2001

GIRL
Tony Ferguson,
Flow Series by Mike Leon,
2001

HABITAT
Kerry Getz,
Frog, 2001

REAL
Mark Gonzales,
Guys by Mark Gonzales,
2001

BIRDHOUSE
Tony Hawk,
Emblem, 2001

ELEMENT
Bam Margera,
HIM, 2001

ATM CLICK
Jake Brown
Iron Maiden Series, 20

BOOTLEG
Elissa Steamer,
Knox Drawing, 2001

SHORTY'S
Chad Muska,
Sun, 2001

ALIEN WORKSHOP
Anthony Van Engelen,
Lumina 2 Series,
2001

CHOCOLATE
Keenan Milton,
2001

ENJOI
Jerry Hsu,
Octopus, 2001

ENJOI
Panda Poo,
Team Deck, 2001

SHORTY'S
Peter Smolik,
Pigs, 2001

ENJOI
Rodney Mullen,
Potty Training, 2001

FLIP
Tom Penny,
Sprite Series, 2001

FLIP
Arto Saari,
Sprite Series, 2001

ANTIHERO
Tony Trujillo,
Tattoo Dagger Series, 2001

WU-TANG CLAN
Band Deck,
2001

CLICHÉ
Jérémie Daclin,
Abstract Series, 2002

CLICHÉ
Cale Nuske,
Abstract Series, 2002

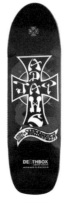

DEATHBOX
Jay Adams,
2002

THE DRIVEN
Jason Jessee
by Mark Gonzales, 2002

TOY MACHINE
Ed Templeton
Butt Hugger Series,
2002

TOY MACHINE
Butt Hugger,
Team Deck, 2002

THE FIRM
Lance Mountain,
Doughboy, 2002

ANTIHERO
Eagle by Todd Francis,
2002

ALIEN WORKSHOP
Heath Kirchart,
Enlightened Series
by Don Pendleton, 2002

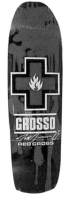

BLACK LABEL
Jeff Grosso,
Red Cross, 2002

ENJOI
Louie Barletta,
Hepburn, 2002

ZOO YORK
Hot Lips,
Team Deck, 2002

VALLELY
Icon, Team Deck,
2002

KROOKED
Mark Gonzales,
Jogging Suit, 2002

SUPREME
Last Supper 1,
2002

SUPREME
Last Supper 2,
2002

SUPREME
Last Supper 3,
2002

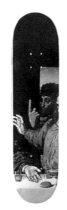

SUPREME
Last Supper 4,
2002

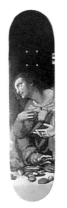

SUPREME
Last Supper 5,
2002

ELEMENT
Natas Legacy,
Panther, 2002

ZOO YORK
Danny Supa,
Lighter Series, 2002

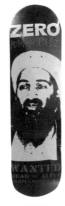

ZERO
Adrian Lopez,
Osama, 2002

WORLD INDUSTRIES
Mad Scientist,
Team Deck, 2002

DGK
Stevie Williams,
NHL, 2002

BLACK LABEL
Kristian Svitak,
No Nazis, 2002

BULLDOG SKATES
OG 70s Pig Series,
Gas Head, 2002

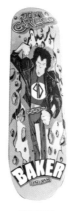

BAKER
Jim Greco,
PD, 2002

CONSOLIDATED
Rainbows,
2002

REAL
Matt Field,
ReVision Series,
2002

REAL
Cairo Foster,
ReVision Series,
2002

REAL
Mark Gonzales,
ReVision Series,
2002

REAL
Keith Hufnagel,
ReVision Series,
2002

REAL
Max Schaaf,
ReVision Series,
2002

ANTIHERO
Tony Trujillo,
Slice of Life Series,
2002

ANTIHERO
John Cardiel,
Slice of Life Series,
2002

ANTIHERO
Peter Hewitt,
Slice of Life Series,
2002

AESTHETICS
Sal Barbier,
Gameboy Series
by Alex Aronovich, 2002

AESTHETICS
Rob Welsh,
Gameboy Series
by Alex Aronovich, 2002

AESTHETICS
Clyde Singleton,
Gameboy Series
by Alex Aronovich, 2002

AESTHETICS
Kevin Taylor,
Gameboy Series
by Alex Aronovich, 2

ALIEN WORKSHOP
Heath Kirchart,
Mondrian, 2002

FLIP
Sorry Logo,
Team Deck, 2002

AESTHETICS
Kevin Taylor,
A Force, 2003

GIRL
Paul Rodriguez,
10 Year Series, 2003

HABITAT
Stefan Janoski,
Quartet, 2003

CLICHÉ
Jérémie Daclin,
Baby Boom Series
by Eric Frenay, 2003

CLICHÉ
Jan Kliewer,
Baby Boom Series
by Eric Frenay, 2003

CLICHÉ
Vincent Bressol,
Baby Boom Series
by Eric Frenay, 2003

CLICHÉ
JJ Rousseau,
Baby Boom Series
by Eric Frenay, 2003

CLICHÉ
Ricardo Fonseca,
Baby Boom Series
by Eric Frenay, 2003

CLICHÉ
Pontus Alv,
Baby Boom Series
by Eric Frenay, 2003

CLICHÉ
Cale Nuske,
Baby Boom Series
by Eric Frenay, 2003

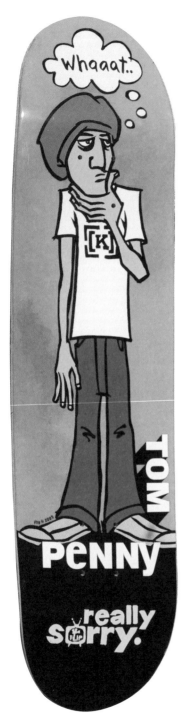

FLIP
Tom Penny, Really Sorry Series,
2003

FLIP
PJ Ladd, Really Sorry Series,
2003

FLIP
Geoff Rowley, Really Sorry Series,
2003

FLIP
Ali Boulala, Really Sorry Series,
2003

RASA LIBRE
Nate Jones,
Thumbprint by Mike Leon,
2003

ALIEN WORKSHOP
Anthony Pappalardo,
Americana Series,
2003

HABITAT
Apex Demi,
Team Deck, 2003

SEEK
Josh Kalis,
Awkward Robot Momen
2003

AESTHETICS
Rob Welsh,
Baby Mama Series,
2003

AESTHETICS
Kevin Taylor,
Baby Mama Series,
2003

AESTHETICS
Sal Barbier,
Baby Mama Series,
2003

BIRDHOUSE
Tom Green,
Bearded Skull, 2003

GIRL
Brandon Biebel,
Bee Bull, 2003

GIRL
Yeah Right,
Team Deck, 2003

RASA LIBRE
Butterflies, Team Deck
by Mike Leon, 2003

RED KROSS
Jeff Grosso,
Classic, 2003

POWELL PERALTA
Steve Caballero,
Chinese Dragon Reissue
by VCJ, 2003

CLICHÉ
Vincent Bressol,
Elvira Series, 2003

CLICHÉ
Ricardo Fonseca,
Elvira Series, 2003

CLICHÉ
Pontus Alv,
Elvira Series, 2003

BLACK LABEL
Adam Alfaro,
Eyeball, 2003

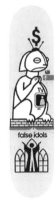

ALIEN WORKSHOP
False Idols,
Team Deck, 2003

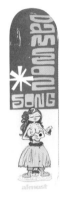

ALMOST
Daewon Song
by Marc McKee, 2003

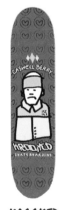

KROOKED
Caswell Berry,
Guest Board, 2003

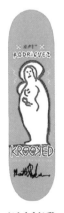

KROOKED
Matt Rodriguez,
Guest Board, 2003

KROOKED
Sean Sheffey,
Guest Board, 2003

KROOKED
Jake Brown,
Guest Board, 2003

KROOKED
Tommy Guerrero,
Guest Board, 2003

KROOKED
Christian Hosoi,
Guest Board, 2003

BAKER
Jim Greco,
Hammerhead, 2003

ELEMENT
Bam, HIM 3,
2003

ALVA
Splatter Logo,
Team Deck Reissue, 200

MYSTERY
Ryan Smith,
Voodoo Series, 2003

KROOKED
Dan Drehobl,
Sweatpants Girl, 2003

SHORTY'S
Rosa Bolts,
Team Deck, 2003

BAKER
Reynolds *Thrasher* Lo
2003

CHOCOLATE
Scott Johnston,
Hot Chocolate Tour,
2003

CHOCOLATE
Gino Iannucci,
Sun Series by Evan Hecox,
2003

CHOCOLATE
Mike York,
Sun Series by Evan Hecox,
2003

CHOCOLATE
Richard Mulder,
Sun Series by Evan H
2003

CHOCOLATE
Scott Johnston, Sun Series by Evan Hecox,
2003

CHOCOLATE
Chico Brenes, Sun Series by Evan Hecox,
2003

CHOCOLATE
Kenny Anderson, Sun Series by Evan Hecox,
2003

GIRL
Rick McCrank, Painter Series,
2003

HABITAT
Brian Wenning, Coexist 3 by Joe Castrucci,
2003

AESTHETICS
Clyde Singleton, Baby Mama Series,
2003

CLICHÉ
I Love Europe,
Team Deck, 2003

DGK
Stevie Williams,
Playa, 2003

ALIEN WORKSHOP
Steve Berra,
Hurry by Pendleton, 2003

STEREO
Jason Lee,
Boots by Ron Rauto, 2003

RASA LIBRE
Reese Forbes,
Zebra Stripes
by Mike Leon, 2003

TOY MACHINE
Bad Turtle Boy Club,
2004

MYSTERY
Adrian Lopez,
Sacred Heart, 2004

SANTA CRUZ
Jeff Kendall,
Pumpkin 30th Anniversary
Reissue Series, 2004

ENJOI
Louie Barletta,
Flashback Series
Thom Lessner, 2004

ENJOI
Caswell Berry,
Flashback Series
by Thom Lessner, 2004

ENJOI
Jerry Hsu,
Flashback Series
by Thom Lessner, 2004

ENJOI
Bobby Puleo,
Flashback Series
by Thom Lessner, 2004

STEREO
Chris Pastras,
Way Out East, 2004

BULLDOG SKATES
Buddy Carr
by Wes Humpston, 2004

POWELL PERALTA
Steve Steadham,
Spade Reissue, 2004

ALMOST
Rodney Mullen,
Freestyle, 2004

KROOKED
Lance Mountain,
Guest Board, 2004

KROOKED
Natas Kaupas,
Guest Board, 2004

KROOKED
Jason Dill,
Guest Board, 2004

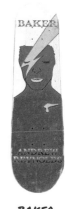

BAKER
Andrew Reynolds,
Ziggy, 2004

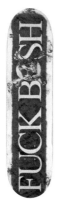

SUPREME
Fuck Bush
by Andrei Molodkin,
2004

BULLDOG SKATES
Shogo Kubo,
Pig, 2004

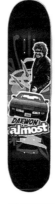

ALMOST
Daewon Song,
'80s Car Series
by Eric Wollam, 2005

ALMOST
Ryan Sheckler,
'80s Car Series
by Eric Wollam, 20

ALMOST
Rodney Mullen,
'80s Car Series
by Eric Wollam, 2005

ALMOST
Greg Lutzga,
'80s Car Series
by Eric Wollam, 2005

ALMOST
Chris Haslam,
'80s Car Series
by Eric Wollam, 2005

CONSOLIDATED
Brownies,
2005

SUPREME
Larry Clark,
ulsa Billy Mann, 2005

KROOKED
Eric Dressen Guest Board,
Gonzales, 2005

TRAFFIC
Ricky Oyola,
Rocky by Stein and Reeves,
2005

**OUTLOOK
SKATEBOARDS**
7 Seconds,
Band Deck, 2005

KROOKED
Zip-Zinger,
'eam Deck, 2005

PLAN B
Paul Rodriguez,
Skull Series, 2005

SUPREME
Zoopreme,
Art Deck, 2006

BIRDHOUSE
Tony Hawk,
Vulture, 2006

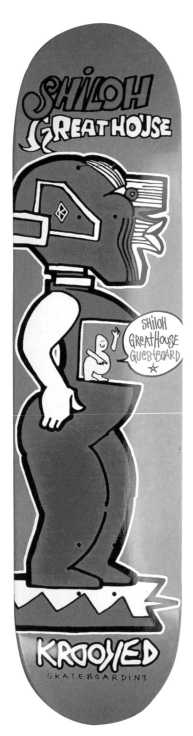

KROOKED
Shiloh Greathouse Guest Board,
2005

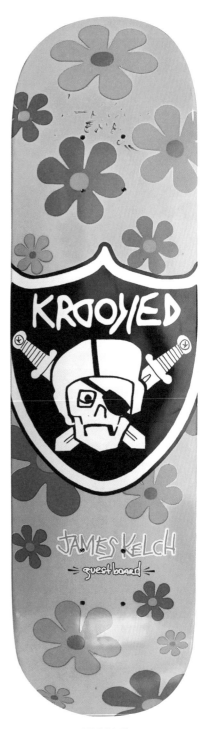

KROOKED
James Kelch Guest Board,
2005

SANTA CRUZ
Rob Welsh,
Powerply Retro Series,
2006

SANTA CRUZ
Henning Braaten,
Powerply Retro Series,
2006

SANTA CRUZ
Alex Carolino,
Powerply Retro Series,
2006

SANTA CRUZ
Flo Marfaing,
Powerply Retro Series,
2006

SANTA CRUZ
Lee Smith,
owerply Retro Series,
2006

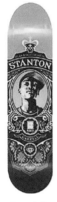

PLAN B
Darrell Stanton,
Shepard Series
by Shepard Fairey, 2006

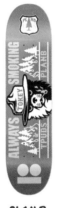

PLAN B
Torey Pudwill,
Always Smoking,
2006

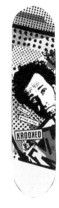

KROOKED
Mark Gonzales,
ReVision, 2006

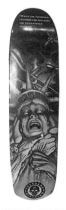

SANTA CRUZ
Jason Jessee,
pe of Liberty, 2006

LANSCAPE
Land Cruiser,
Team Deck, 2006

DGK
Marcus McBride,
Hood Pass Series,
2006

DGK
Stevie Williams,
Hood Pass Series,
2006

BUENO
Hang in There[5],
Friday's Comin'
by Mike Sieben, 2006

KROOKED
Chad Muska,
Guest Series by Gonz,
2006

NATURAL KONCEPT
Blue Shrooms,
Team Deck, 2006

SKATE MENTAL
Made in China,
Team Deck, 2006

STEREO
Bent Arms,
Team Deck, 2007

TURF
Turf Global,
Team Deck, 2007

DGK
Jack Curtin,
Stereotype Series,
2007

BLIND
Shane Cross,
Memorial Deck,
2007

SHUT
Shark Reissue,
Team Deck, 2007

STEREO
Olly Todd,
Nature Series, 2007

STEREO
Dune Baby,
2007

ANTIHERO
I Dislike AH,
2007

PLAN B
Ryan Sheckler Signature,
2007

ELEMENT
Chad Muska, Graffiti by Sketch,
2007

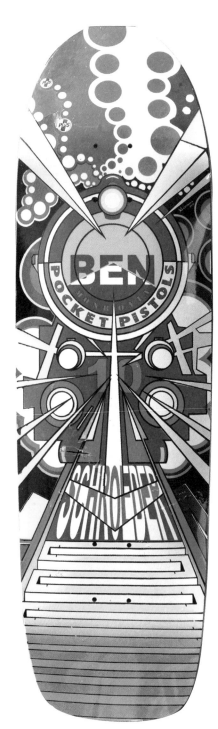

ROGER SKATEBOARDS
Weed and Cobras,
Team Board
by Mike Sieben, 2008

PLAN B
Paul Rodriguez,
Superfuture,
2008

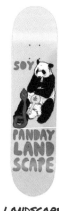

SUPREME
Ritual, Art Deck
by Sean Cliver, 2008

LANDSCAPE
Soy Panday,
Panda, 2008

POCKET PISTOLS
Ben Schroeder,
10 Gio Withers, 2007

CLICHÉ
Lucas Puig,
Fully Flared, 2008

KROOKED
John "Tex" Gibson
Guest Board, 2008

ALMOST
Daewon Song,
Skater of the Year
by Eric Wollam, 2008

SHORTY'S
Sesame Creeps,
Team Deck,
2008

SK8 MAFIA
OG House Logo,
Team Deck,
2008

DGK
I (Heart) Haters,
Motivation, Team Deck,
2008

DGK
Marcus McBride,
ked Up Ghetto Kids
Series, 2008

DGK
Stevie Williams,
Fucked Up Ghetto Kids
Series, 2008

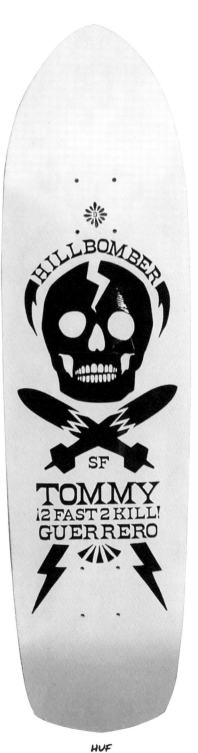

HUF
Tommy Guerrero,
Legend Series, 2009

ORGANIKA
Karl Watson,
Wildlife by Choe,
2009

SKATE MENTAL
Reese Forbes,
Luxury by Brad Staba,
2009

SKATE MENTAL
Matt Beach,
Ewok, 2009

DEATHWISH
Antwuan Dixon,
Fried Pigs, 2009

ALIEN WORKSHOP
Grant Taylor,
Shredder, 2009

CHOCOLATE
Anthony Pappalardo,
Yellow Submarine Series,
2009

ZERO
James Brockman,
Widowmaker, 2009

FLIP
Lance Mountain,
Vato, 2009

ROGER
Skull Bong,
Team Deck
by Mike Sieben, 2009

BLIND
Reaper Wonderland,
2009

WELCOME
Princentaur,
2009

WELCOME
Owl V1.1,
Team Deck, 2009

WESTERN EDITION
John Igei,
Miles Davis 1959
Quintet Series, 2009

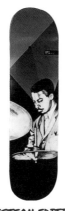

WESTERN EDITION
Brad Johnson,
Miles Davis 1959
Quintet Series, 2009

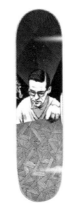

WESTERN EDITION
Nikhil Thayer,
Miles Davis 1959
Quintet Series, 2009

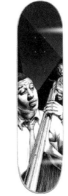

WESTERN EDITION
Yoshiaki Toeda,
Miles Davis 1959
Quintet Series, 2009

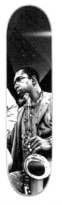

WESTERN EDITION
Jonantae Turner,
Miles Davis 1959
Quintet Series, 2009

ZERO
Tommy Sandoval,
2009

BLIND
James Craig,
Lake Show, 2009

BUMMER HIGH
Daniel Shimizu,
Incan by John Altamirano,
2009

ZERO
John Rattray,
Gilgamesh, 2009

SKATE MENTAL
Dolphin Style,
Team Deck, 2009

ANTIHERO
Frank Gerwer,
Boob Alert, 2009

ROGER
Bender, Team Deck,
by Mike Sieben, 2009

THE '10S: THE RISE OF BROADBAND AND BOUTIQUE BRANDS

WHILE THE INTERNET IS ALREADY DECADES OLD BY 2010, THE ARRIVAL OF BROADBAND AND WEBSITES LIKE THE BERRICS, COMBINED WITH THE RISE OF YOUTUBE, FACEBOOK, AND START OF INSTAGRAM (LAUNCHED IN '10) CONVERGE TO REDEFINE SKATEBOARDING'S MEDIA LANDSCAPE.

Print magazines and the team video model begin a steady decline as ad sales and DVD sales shrink. *Skateboarder* ceases print for a third and final time in '13 and *Transworld* ends print by '19. *Thrasher* meanwhile, buoyed by apparel sales and online content, recaptures the no. 1 media spot. Board sale margins begin a downward spiral and paychecks from shoe sponsors like Nike, Vans, Adidas, and other large mainstream companies become the lion's share of a pro skater's income. A number of key riders leave longtime sponsors—like Anthony Van Engelen and Jason Dill leaving Alien Workshop, to start smaller new board brands like Fucking Awesome (FA) and Hockey.

Skateparks continue popping up as communities see more positive value in skateboarding. In West LA, Stoner Skate Plaza is opened in 2010 as an alternative to the formerly illegal West LA Courthouse and Civic Plaza; then the Courthouse itself is remodeled and leased by Nike SB to become a skate plaza—the first time skateboarders are granted access to a historically illicit spot. A similar victory occurs at Southbank in London that same year.

Supreme releases the video *Cherry* by Bill Strobeck in '14, launching the apparel brand into the stratosphere. Dylan Rieder—an FA rider and the video's star—dies of cancer in '16. In '17, Supreme owner James Jebbia sells a 50% stake in the brand to the Carlyle Group for $500 million. UK streetwear brand Palace also continues to grow and collaborates with Polo/Ralph Lauren in '18—previously unthinkable for a skate brand. Skateistan, the international nonprofit using skateboarding and education as empowerment tools for children, expands from its original location in Kabul (opened in '09) to encompass schools in Cambodia and South Africa by '16. That same year Ron Allen, Karl Watson, and Jabari Pendleton appear in *The Blackboard* a documentary aimed at examining the experiences of black skateboarders and the acceptance of skate culture in the Black community. Finally, In August of '16, the IOC officially announces that skateboarding will be included as a sport in the 2020 Tokyo Summer Games.

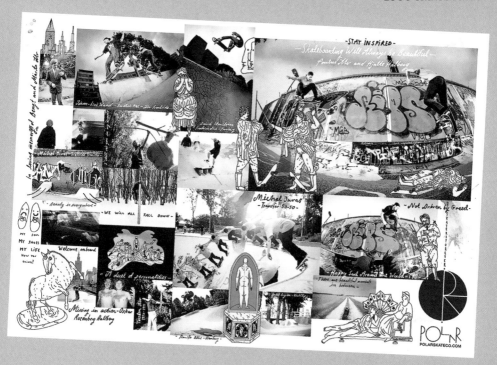

"I THINK LOTS OF THINGS ARE CHANGING IN THE SKATEBOARDING WORLD RIGHT NOW [2013]. IT'S IN A WEIRD PLACE AND THERE ARE DEFINITELY MORE CHANGES TO COME THAT WE WILL ALL SEE IN THE NEAR FUTURE. I THINK IT'S THE DAWN OF A NEW AGE."

Dylan Rieder

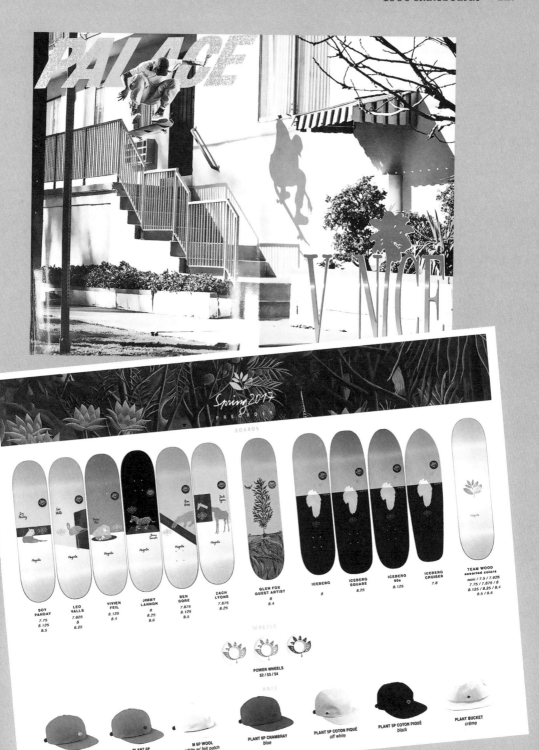

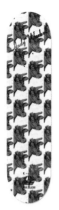

ALIEN WORKSHOP
Omar Salazar,
Warhol Series, 2010

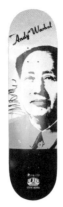

ALIEN WORKSHOP
Steve Berra,
Warhol Series, 2010

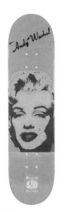

ALIEN WORKSHOP
Rob Dyrdek,
Warhol Series, 2010

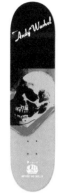

ALIEN WORKSHOP
AVE,
Warhol Series, 2010

ALIEN WORKSHOP
Heath Kirchart,
Warhol Series, 2010

ALIEN WORKSHOP
Dylan Rieder,
Warhol Series, 2010

ALIEN WORKSHOP
Mikey Taylor,
Warhol Series, 2010

ELEMENT
Ray Barbee Tribute
by Sean Cliver,
2010

SKATE MENTAL
Matt Beach,
Sponsored, 2010

ROGER
Sausage Party, Team Deck,
by Mike Sieben, 2010

MARC JACOBS
M.I.A., Art Deck,
by Juergen Teller, 2010

HOPPS
Jahmal Williams
Native Son, 2010

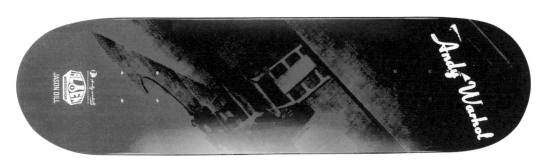

ALIEN WORKSHOP
Jason Dill, Warhol Series,
2010

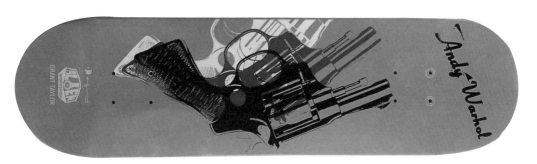

ALIEN WORKSHOP
Grant Taylor, Warhol Series,
2010

ALIEN WORKSHOP
Arto Saari, Warhol Series,
2010

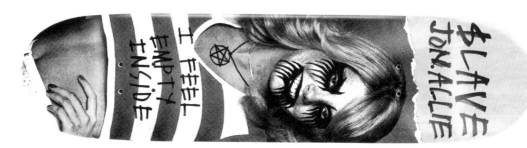

SLAVE
Jon Allie, Empty by Ben Horton,
2010

SLAVE
Jon Goemann by Ben Horton,
2010

SLAVE
Economics, Team Board,
2010

REAL
Dennis Busenitz, D*Face series,
2010

GIRL
Alex Olson, Bad Brains,
2010

GIRL
Alex Olson, Powerslide Cruiser2 Series,
2010

SELFISH
Jereme Rogers,
Switchstance, 2010

PALACE
Lucien Clarke,
King and Queen, 2010

ELEMENT
Bam Margera,
Jackass, 2010

CLICHÉ
American Icons 2
by Marc McKee, 2010

ALIEN WORKSHOP
Grant Taylor,
GT Stencil, 2010

SKATE MENTAL
Shane O'Neill,
Doll, 2010

SKATE MENTAL
Blow Up Doll,
Team Deck, 2010

DGK
Josh Kalis,
Abduction, 2010

CHOCOLATE
Chris Roberts,
Year of the Garvy, 2011

SKATE MENTAL
Taliban This,
2011

WELCOME
Nolan Johnson,
Squirrel, 2011

ALIEN WORKSHO
Grant Taylor,
SOTY, 2011

BLUEPRINT
Colin Kennedy,
Strike a Light, 2011

BLUEPRINT
Nick Jensen,
REUP Underground by Justin Atallian, 2011

SANTA CRUZ
Simpson Series 1,
Homer 1, 2011

CREATURE
Sam Hitz,
Savages by Nate Van Dyke,
2011

ELEMENT
Nyjah Huston,
Rise Up, 2011

BLUEPRINT
Danny Brady,
REUP Illuminations
by Justin Atallian, 2011

DGK
Rodrigo TX,
Rated Series, 2011

GIRL
Rick Howard,
Powerslide Cruiser
Series 2, 2011

ANTIHERO
Jeff Grosso,
Midlife Crisis, 2011

POLAR
Pontus Alv,
Meat Bodies, 2011

BLIND
Ronnie Creager,
Looney Bin, 2011

ALMOST
Lewis Marnell,
Fruit Face, 2011

FLIP
David Gonzales,
Lucifer, 2011

POLAR
Cut Out 1,
Team Deck, 2011

TURF GLOBAL
Mike York,
Pinball Bandit, 2011

HOOK-UPS
Super Assassin,
2012

SK8 MAFIA
Wes Kremer,
2012

SANTA CRUZ
Simpson Series 2,
Homerkopp
by Matt Groening, 2012

ELEPHANT BRAND
Mike Vallely,
sey Devil by Tim Clark,
2012

ALIEN WORKSHOP
Grant Taylor,
Haring by Keith Haring,
2012

LURKVILLE
Man's Ruin, Team Deck,
by Rob Benavides, 2012

WELCOME
Nolas Johnson,
Goat, 2012

ANTIHERO
Tony Miorana,
Shit and Die Series,
2012

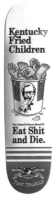

ANTIHERO
Tony Trujillo,
Eat Shit and Die Series,
2012

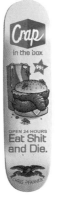

ANTIHERO
Chris Pfanner,
Eat Shit and Die Series,
2012

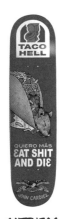

ANTIHERO
John Cardiel,
Eat Shit and Die Series,
2012

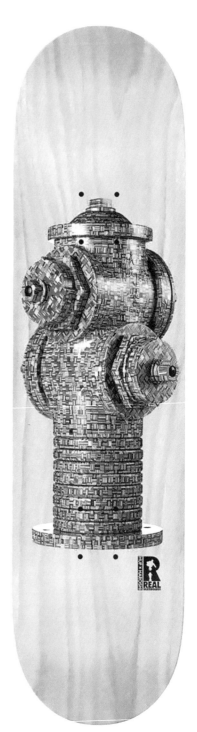

SUPREME
Surfstyle Cruiser, Team Deck,
2012

REAL X HUF
Haroshi Hydrant,
2012

ALIEN WORKSHOP
Omar Salazar
by Keith Haring, 2012

POLAR
Hjalte Halberg,
Chop Chop
by Jacob Ovgren, 2012

POLAR
Pontus Alv,
Happy Sad Around
the World, 2012

POLAR
No Complies Forever
by Pontus Alv, 2013

SEND HELP
Prayer, Team Deck,
y Todd Bratrud, 2013

FLIP
Louie Lopez,
Pinata, 2013

3D
Bear One Off,
Team Deck, 2013

HOPPS
Jahmal Williams,
When Doves Cry, 2013

HOPPS
Music Makers,
Team Deck, 2013

BAKER
Riley Hawk,
OG Logo, 2013

PLAN B
Ryan Sheckler,
Color Fast, 2013

DGK
Jack Curtin,
Art of the Hustle, 2013

SCUMCO & SONS
Chromeball,
Team Deck, 2013

3D
Austyn Gillette,
Walter, 2013

BLIND
Kevin Romar,
Pop Art, 2013

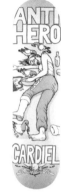

ANTI HERO
John Cardiel,
One Eye Open, 2013

FUCKING AWESOME
Anthony Van Engelen,
Class Photo, 2013

FUCKING AWESOME
Jason Dill,
Class Photo, 2013

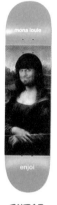

ENJOI
Louie Barletta,
Mona Louie, 2014

FUCKING AWESOM
Chloe Sevigny,
Class Series, 2014

JEFF GROSSO
Pride (Shaped)
by Todd Francis, 2014

THE KILLING FLOOR
Mark Gutterman,
Phrenology, 2014

POLAR
Jerome Campbell,
Tupac Waterguns
by Jacob Ovgren, 2014

BIANCA CHANDO
Nature 2,
Art Deck, 2014

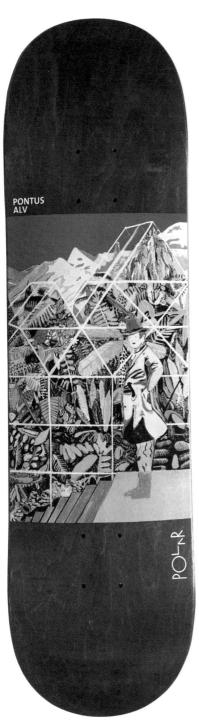

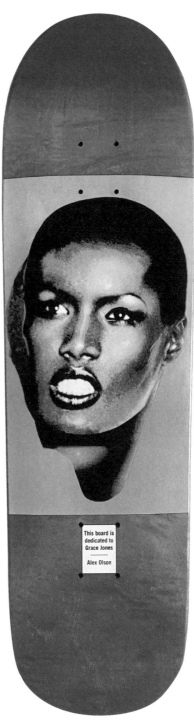

POLAR
Pontus Alv, Mountain Scenery,
2014

BIANCA CHANDON
Ode to Grace Jones, Art Deck,
2014

ANTIHERO
Supreme Collection
by Todd Francis, 2014

PALACE
Knight,
Team Deck, 2014

POCKET PISTOLS
Jeff Hedges,
Grateful Fejj, 2014

ANTIHERO
Jeff Grosso,
Flying Low 1, 2014

HAMMERS USA
DTFKA,
2014

ALMOST
Rodney Mullen,
Superman DC
Superheroes, 2014

3D
Brian Anderson,
Aggressor, 2014

CHOCOLATE
Jerry Hsu,
Bomber Series
by Evan Hecox, 201·

917
Two Princes,
Art Deck, 2015

PRIMITIVE
Shane O'Neill,
Accepted, 2015

PRIMITIVE
Nick Tucker,
Up in Smoke, 2015

PRIMITIVE
Paul Rodriguez,
Up in Smoke
Love Machine, 20·

HAMMERS USA
Crack Baby,
2015

GIRL
Guy Mariano, Skull
of Fame (Michael Jackson)
by Sean Cliver, 2015

**WALL STREET
SKATESHOP**
Asterix, Druid,
2015

CLICHÉ
Last Supper
by Marc Mckee,
2015

CREATURE
Al Partanen,
Visions, 2015

THE KILLING FLOOR
Terrain 1,
Team Deck, 2015

PRIMITIVE
Bastien Salabanzi,
Red Card, 2015

917
Hotline – Jane,
Team Deck, 2015

REAL
Ishod Wair,
Evolution, 2015

HOCKEY
Eyes Without a Face,
Team Deck, 2015

ENJOI
Louie Barletta,
Don't be a Dick
by Dan Drehobl, 2015

HAMMERS USA
Been There Done That
(Re-color), 2015

FUCKING AWESOME
Dylan Rieder,
Black and White, 2015

CLICHÉ
Lucas Puig,
Virgin Mary Tribute
by Sean Cliver, 2016

BLACK LABEL
Auby Taylor,
Breakout, 2016

MEOW
Mariah Duran,
Whiskers, 2016

THE KILLING FLOOR
Lance Chapin,
Visonscape, 2016

BLACK LABEL
Jason Adams,
Trumped, 2016

ALMOST
Willow Wildgrube,
Remix Dude, 2016

PRIMITIVE
Carlos Ribeiro,
Transformers Bumblel
2016

PRIMITIVE
Devine Calloway,
Escape by Frank Frazetta,
2016

SUPREME
Fischer 1,
Art Deck, 2016

PRIMITIVE
Shane O'Neill,
Cyborg, 2016

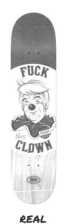

REAL
Chump Trump,
Team Deck, 201

ANTI HERO
Jeff Grosso,
School of SK18, 2017

ALMOST
Daewon Song,
Tom Big Panther, 2017

BLIND
Morgan Smith,
Reaper Veneer, 2017

CHOCOLATE
Jesus Fernandez,
Window Series, 2017

CHOCOLATE
Raven Tershy,
Window Series, 2017

CHOCOLATE
Stevie Perez,
Window Series, 2017

CHOCOLATE
Vincent Alvarez,
Window Series, 2017

CHOCOLATE
Yonnie Cruz,
Window Series, 2017

SUPREME
Gonz Ramm
ark Gonzales, 2017

ANTIHERO
Jeff Grosso,
End Game, 2017

POLAR
Dane Brady,
Dear Polar
by Ron Chatman, 2017

BLOCKHEAD
Rick Howard,
Skunk Reissue,
2018

QUASI
World Team Deck,
2018

STRANGELOVE
Jed Walters,
Team Deck, 2018

ALMOST
Sky Brown,
Skateistan, 2018

BLACK LABEL
Riky Barnes,
Red Baron, 2018

PRIMITIVE
Paul Rodriguez,
Samurai by Paul Jackson,
2018

PRIMITIVE
Tiago Lemos,
Dragon Ball Z Series 2,
2018

SANTA CRUZ
Mars Attacks Artist Series
by Jimbo Phillips,
2018

FUCT
Jawz Art Deck,
2018

ANTIHERO
Grimple Stix,
Night Hammer, 2018

BLIND
Sam Beckett,
Bonged Series, 2018

BLIND
Morgan Smith,
Bonged Series, 2018

BLIND
TJ Rogers,
Bonged Series, 20

ENJOI
Nestor Judkins,
What's the Deal
by Gorm Boberg, 2019

MADNESS
Alex Perelson,
Void, 2019

THE KILLING FLOOR
Tino 2 Reflection
by Tino Rincon,
2019

BLACK LABEL
Jason Adams,
Slappy Hour Curb Girl,
2019

PIZZA
Shark,
2019

MADNESS
Schizo, Team Deck,
2019

HABITAT
Silas Baxter-Neal,
NASA, 2019

STRANGELOVE
Feedback by Sean Cliver,
2019

QUASI
Man,
Team Deck, 2019

QUASI
I Survived School Today,
Team Deck, 2019

QUASI
Tyler Bledsoe,
Portland, 2019

NEW DEAL
Useless Wooden Toys,
Horse 30th Anniversary,
2019

THE '20S: OLYMPICS, COVID & THE FUTURE

LIKE THE REST OF HUMANITY, SKATEBOARDING IS HEAVILY IMPACTED BY THE COVID-19 PANDEMIC—BEGINNING AROUND FEBRUARY 2020 AND CONTINUING THROUGH THE TIME OF THIS WRITING.

Initially, lockdowns worldwide lead to an exponential surge in outdoor activities and exercise. Along with bikes, skateboards become a perfect way to keep busy with gyms, offices, and schools mostly closed. Manufacturers initially struggle to maintain enough inventory to meet demand.

The long-anticipated Tokyo 2020 Olympics and skateboarding's debut as an Olympic sport are pushed back due to the pandemic and finally take place with no spectators in July and August of '21. The pastime's first gold medalists are Yuto Horigome and Momiji Nishiya of Japan for street, and Keegan Palmer of Australia and Sakura Yosozumi of Japan for park. Heavy favorite Nyjah Huston of Team USA fails to reach the podium and vows to return in '24.

In December of '20, Supreme is acquired by VF Corp., owner of Vans, Timberland, the North Face, and more, for $2.1 billion. Palace, meanwhile, collaborates with Adidas in spring '21 to release a team jersey for Juventus worn by the team during a Serie A game.

In '22, skateboarding's final frontier—riding in old age—continues to be pushed back with Tony Hawk still learning new tricks on his ramp at 53 and Tony Alva still hitting the coping in backyard pools at 64. Women, gay, transgender, and non-binary skateboarders continue to increase their ranks and find their well-earned place in a once male-dominated pastime. Only a few years into the '20s and skateboarding's future looks brighter than ever.

Justin Drysen kickflips on some rugged terrain in San Diego in 2020.

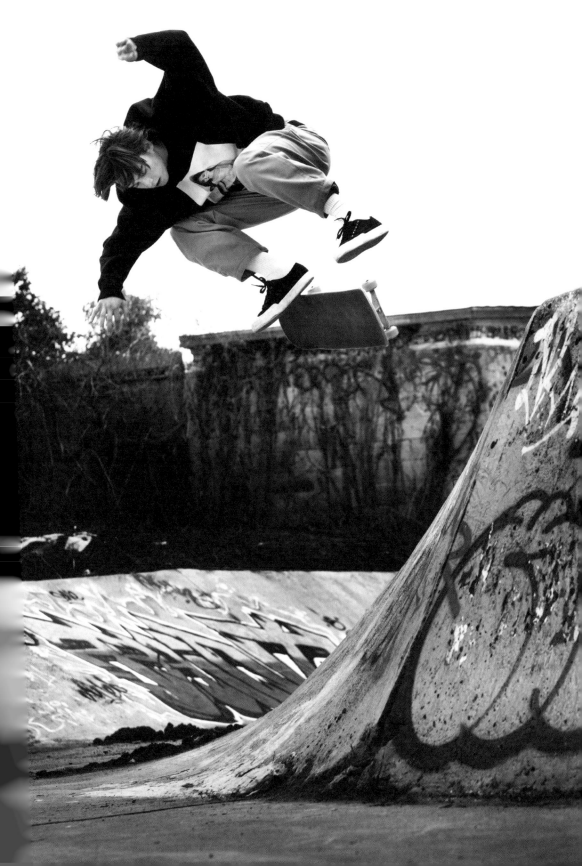

TOKYO

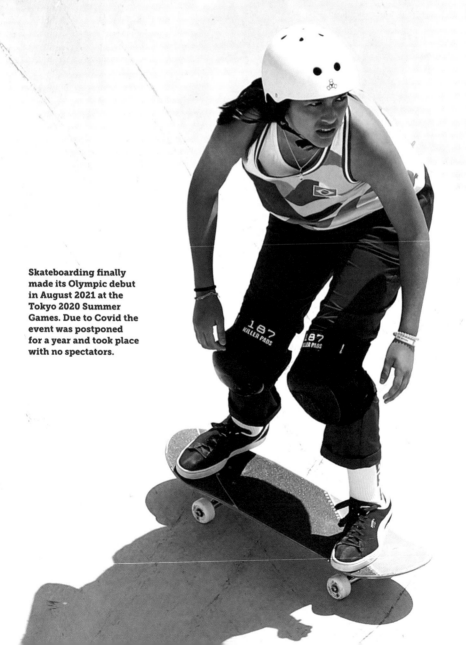

Skateboarding finally made its Olympic debut in August 2021 at the Tokyo 2020 Summer Games. Due to Covid the event was postponed for a year and took place with no spectators.

2020

Yuto Horigome of Japan took home skateboarding's first gold medal for his win in the street section.

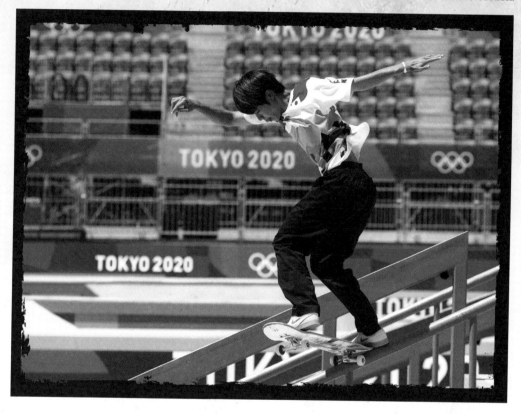

"THE OLYMPICS NEEDS SKATEBOARDING MORE THAN SKATEBOARDING NEEDS THE OLYMPICS. SKATEBOARDING IS ALREADY MORE POPULAR THAN MANY OF THE OLYMPIC SPORTS."

Tony Hawk

PLAN B
Danny Way,
Never Issued Dodo,
2020

STRANGELOVE
Apple Team Deck
by Todd Bratrud,
2020

KROOKED
Alexis Sablone
Guest Board
by Mark Gonzales, 2020

KROOKED
Mike Anderson,
Gathering
by Mark Gonzales, 2020

PRIMITIVE
Paul Rodriguez,
Color Waves, 2020

PIZZA
Fuck Burritos,
Team Deck, 2020

ELEMENT
Nyjah Huston,
Gift of the Gods
by L'Amour Supreme, 2020

STRANGELOVE
Holy Roller
by Sean Cliver, 2020

STRANGELOVE
Hell on Wheels
by Sean Cliver, 2020

STRANGELOVE
Pearl Jam, Band Deck,
by Sean Cliver, 2020

DOOMSAYERS
Eat the Rich,
Team Deck, 2020

DOOMSAYERS
Kill TV,
2021

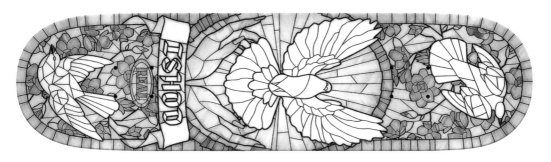

REAL
Ishod Wair, Cathedral by Zach Morrissey,
2021

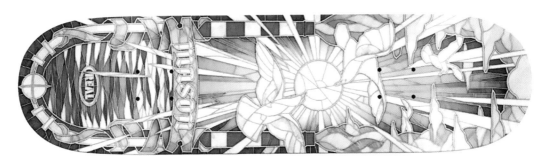

REAL
Mason Silva, Cathedral by Zach Morrissey,
2021

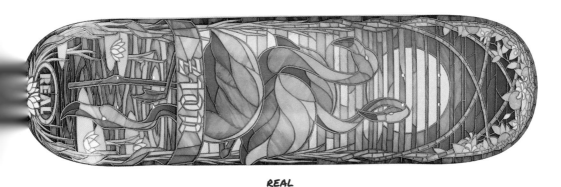

REAL
Zion Wright, Cathedral by Zach Morrissey,
2021

UMA LANDSLEDS
Cody Chapman, Pre Dawn,
2022

THANK YOU
Daewon Song, De La Song,
2022

APRIL
Yuto Horigome, Kinkaku,
2022

FUCKING AWESOME
Tyshawn Jones,
Class Logo, 2022

LIMOSINE
Snake Pit,
2022

UMA LANDSLEDS
Evan Smith,
Star Head Body, 2022

POLAR
Nick Boserio,
Familly, 2022

APRIL
Yuto Horigome,
Japan, 2022

APRIL
Guy Mariano,
Pro, 2022

ANTIHERO
Peter Hewitt,
Grimple in Character,
2022

ANTIHERO
Daan Van Der Linden,
Grimple Guest, 2022

POLAR
Hjalte Halberg,
urning Sink, 2022

WKND
Karsten Kleppan,
Icy Hot, 2022

WKND
Tom Karangelov,
Sympathy Dropout, 2022

MAGENTA
Leo Valls,
Extra Vision, 2022

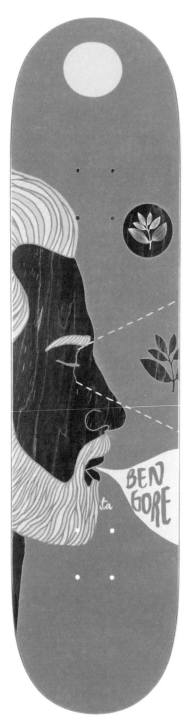

MAGENTA
Ben Gore, Visions,
2022

BAKER
Riley Hawk, Clear Blue Sky,
2022

SANTA CRUZ
Blake Johnson,
Beach Wolf, 2022

SANTA CRUZ
Henry Gartland,
Sweet Dreams, 2022

BAKER
Tristan Funkhouser,
Crop Circles, 2022

WELCOME
Chris Miller,
Collage Gaia, 2022

QUASI
Josh Wilson,
Urbex, 2022

QUASI
Tyler Bledsoe,
Dreamcatcher, 2022

BLACK LABEL
Chris Troy,
Beware, 2022

BLACK LABEL
Patrick Ryan,
Juxtapose, 2022

BIRDHOUSE
Tony Hawk,
Phantas, 2022

BIRDHOUSE
Shawn Hale,
Ravers, 2022

5BORO
Cinco Barrios,
2022

5BORO
Shinya Nohara,
VHS, 2022

HEROIN
Razor Egg Symmetrical,
Team Deck, 2022

HOPPS
Jahmal Williams,
3 Lions, 2022

FROG
Jesse Alba,
Drive, 2022

GLUE
Leo Baker,
2022

CHOCOLATE
Kenny Anderson,
Smile, 2022

DOOMSAYERS
Mary,
Team Deck, 2022

BACON
Colt 45,
Team Deck, 2022

FUCKING AWESOME
Louie Lopez,
Dream Tunnel, 2022

HOCKEY
Andrew Allen,
HP Synthetic, 2022

LIMOSINE
Cyrus Bennett,
Exodus, 2022

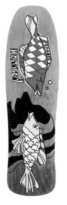

KROOKED
Ray Barbee,
Friends Street Shape
by Gonz, 2022

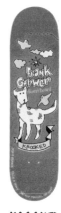

KROOKED
Frank Gerwer
Guest Board, 202

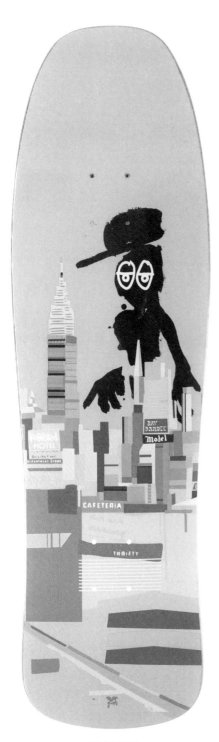

KROOKED
Ray Barbee, Art Deck,
2022

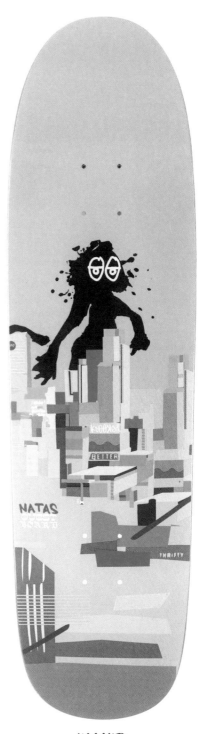

KROOKED
City by Natas Kaupas, Art Deck,
2022

MODERN SKATEBOARD ANATOMY

AFTER NEARLY 70 YEARS OF EVOLUTION SINCE THEY WERE FIRST COMMERCIALLY PRODUCED, HERE IS WHAT THE MODERN SKATEBOARD LOOKS LIKE AND THE NAME OF EACH PART.

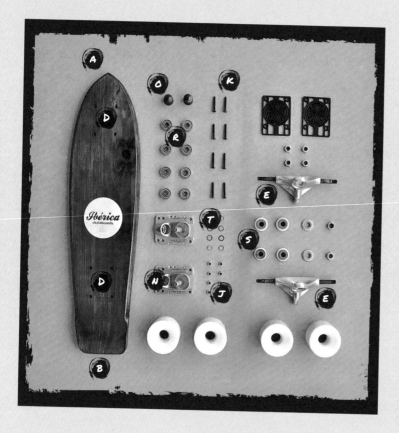

BOARD OR DECK

- **A** Nose
- **B** Tail
- **C** Concave
- **D** Mounting Holes

TRUCKS

- **E** Hanger
- **F** Kingpin
- **G** Kingpin Nut
- **H** Axle
- **I** Axle Nuts
- **J** Truck Nuts
- **K** Truck Bolts
- **L** Bushings
- **M** Baseplate
- **N** Pivot Cup
- **O** Pivot Bushing
- **P** Lower Cup Washer
- **Q** Top Cup Washer

WHEELS

- **R** Bearings
- **S** Spacers
- **T** Axle Washers

" INNOVATION GOES FORWARD WHETHER OR NOT ANYONE GRAFTS IT BACK INTO SKATEBOARDING. I MEAN SKATEBOARD TRUCKS: THEY'VE GOTTEN BETTER AND BETTER. HOLLOW AXLES AND LIGHTER MATERIALS. IT CAN BE INCREMENTAL TOO. IT DOESN'T ALL HAVE TO BE AS REVOLUTIONARY AS URETHANE WAS. "

CR STECYK III

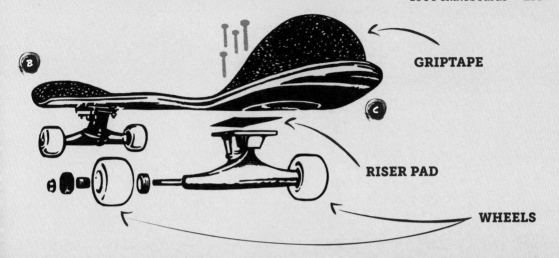

GRIPTAPE

RISER PAD

WHEELS

"I THINK EVERYONE GIVES THE CREDIT TO [FRANK] NASWORTHY FOR DOING THE FIRST URETHANE WHEELS [CADILLAC WHEELS, '73], AND BY ALL MEANS GIVE HIM CREDIT, BUT SOMEBODY STILL HAD DROP IN BALL BEARINGS, AND THAT WAS THE GENIUS OF THE ROAD RIDER WHEELS AND THE PRECISION BEARINGS."

Tim Piumarta, Director of Product Innovations at NHS/Santa Cruz, 2010

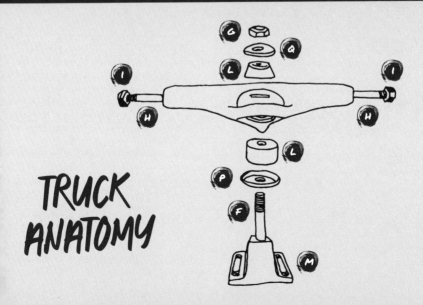

TRUCK ANATOMY

Modern skateboards and their accessories in use.

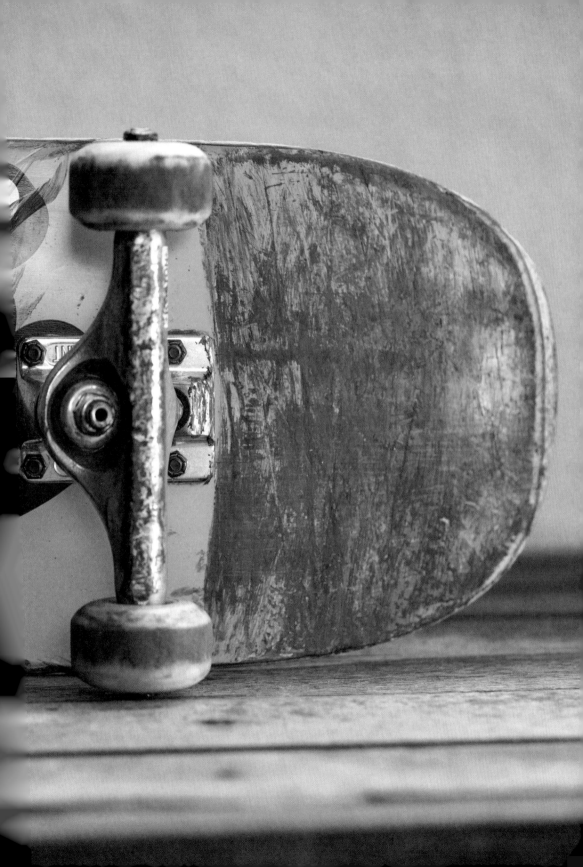

LEGENDS: AMS AND PROS

EARLY IN SKATEBOARDING'S EVOLUTION, THE PROMOTIONAL TEMPLATE FROM SURFING WAS CARRIED OVER AND IT WAS DECIDED THAT THE BEST WAY TO PROMOTE AND SELL SKATEBOARDS WAS THROUGH SIGNATURE MODELS.

This began with Phil Edwards—best known as a pro surfer, with his Makaha pro model in '63—but quickly switched to actual skateboarders' names on the skateboards.

If you had your name on a skateboard, you became a pro skateboarder. The designation of pro was also sometimes made simply by entering a pro contest. But in those cases that would quickly be followed by a signature model. If you were talented enough to receive free product and endorsements but did not yet have a signature skateboard to your name, you became known as an "amateur" or am skateboarder.

Almost immediately, legends were born. The culture of skateboarding was more or less written and told using the most influential pros and ams. By the mid '70s, Tony Alva became the first true superstar pro with worldwide name recognition. Using that cachet, at the age of 19 in '77, he became the first pro to launch his own namesake company, Alva Skates.

Since then, ams and pros alike have driven the popularity of almost every skateboard company created. A single popular pro, like Chad Muska in the late '90s, might have an entire company built around them, as Chad did with Shorty's Skateboards in '98. Other times, industry wars have erupted over companies fighting for up-and-coming amateurs on the premise that they would quickly become market-driving pros. In '22, even with signature footwear sometimes eclipsing the influence and dominance of signature boards, pros and ams still make up the lifeblood of the skateboard industry.

> *"I'D SAY IT'S LIKE A CROSS BETWEEN PROFESSIONAL SURFERS AND PROFESSIONAL HOCKEY PLAYERS. WITH A TOUCH OF ROCK STAR."*
>
> **Tony Alva on what is pro skateboarding**

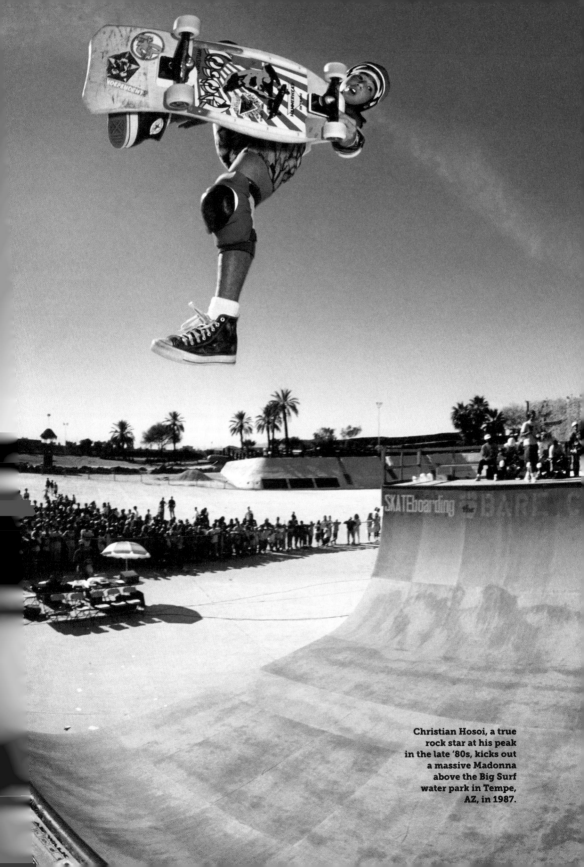

Christian Hosoi, a true rock star at his peak in the late '80s, kicks out a massive Madonna above the Big Surf water park in Tempe, AZ, in 1987.

MAKAHA
Phil Edwards,
1963

ALVA
Tri-logo,
Team Deck, 1977

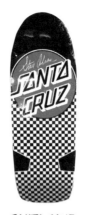

SANTA CRUZ
Steve Olson, Circle Logo
on Checkerboard, 1980

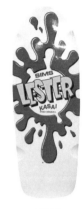

SIMS
Lester Kasai,
Splash, 1983

**SANTA MONICA
AIRLINES**
Jay Adams, 1984

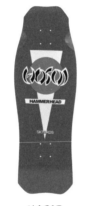

HOSOI
Christian Hosoi,
Hammerhead, 1985

**SANTA MONICA
AIRLINES**
Natas Panther 2, 1985

HOSOI
Christian Hosoi,
Street Flag, 1987

SANTA CRUZ
Jason Jessee,
Mermaid by Jim Phillips,
1989

H-STREET
Matt Hensley,
Pole Spin by Obradovich,
1989

**SANTA MONICA
AIRLINES**
Steve Rocco 2,
1989

SANTA CRUZ
Jeff Kendall,
Atom Man, 1990

WORLD INDUSTRIES
Jeremy Klein,
Black Eye, 1991

LIFE
Sean Sheffey,
1991

PLANET EARTH
Brian Lotti,
1992

GIRL
Jovontae Turner,
Tommy, 1994

TOY MACHINE
Donny Barley,
Black Lung, 1996

SHORTY'S
Steve Olson,
Pyramid, 1997

ELEMENT
Bam Margera,
Vote Bam, 2000

CHOCOLATE
Gino Iannucci,
Poets, 2009

FLIP
Lance Mountain,
Vato, 2009

ANTIHERO
Jeff Grosso,
Midlife Crisis, 2011

FUCKING AWESOME
Anthony Van Engelen,
Class Photo, 2013

LIMOSINE
Cyrus Bennett,
Exodus, 2022

MUSEUMS & THE SKATEBOARDING HALL OF FAME

BY 1997, SKATEBOARDING'S CULTURE, HISTORY, AND LIST OF LEGENDS HAD MATURED AND BEEN SUFFICIENTLY DOCUMENTED TO MERIT ITS VERY OWN MUSEUM.

That year, Todd Huber opened the Skatelab Museum in Simi Valley, a suburb of Los Angeles and by '09, skateboarding's official Hall of Fame (SHoF) was established by the museum. Since then, over 130 pros, ams, skate industry and cultural icons, skateparks, and skateshops have been inducted via their annual nominating and voting process to be immortalized for their contributions to the pastime.

Reaching back to the '60s and covering pros from decades as recent as the '90s, SHoF has aimed to make the list of recipients as diverse and widely agreed upon as possible. The 2021 inductees, for example, included Colleen Boyd, one of the best-known female skaters from the '60s; '80s pro Mike Smith, inventor of the Smith grind; and Kareem Campbell, one of the most iconic pros of the '90s and the first African American skateboarder with his own bestselling shoe brand (Axion).

Other museums have begun to pop up elsewhere as skateboarding culture continues to move from society's fringes into the mainstream. In '03, Jürgen Blümlein and his collective FauxAmi opened their own Skateboard Museum in Stuttgart, Germany. The museum has since relocated to Berlin. Longtime skateboarder Jack Smith also had his own skateboard museum in Morro Bay (since closed, with its collection donated to Todd Huber). In '13, NHS, parent company to Santa Cruz, Independent, Creature, etc. opened its own museum dedicated to its brand's nearly fifty years of history. In '15, Tony Hawk's first skateboard from '79—a beat-up blue Bahne complete—was added to the Smithsonian's National Museum of American History and its growing collection of skateboard artifacts.

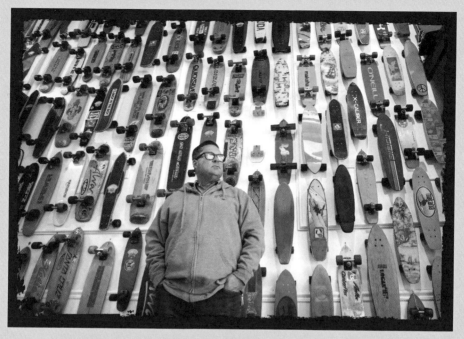

**Todd Huber at the Skateboarding
Hall of Fame Museum in Simi
Valley, CA.**

"SKATEBOARDING HAS
ONLY VERY RECENTLY
BEGUN DOCUMENTING AND
CREDITING ITS OWN HISTORY
BEYOND WHAT WAS
PREVIOUSLY TOLD AS A SORT
OF ORAL TRADITION."

Lance Mountain

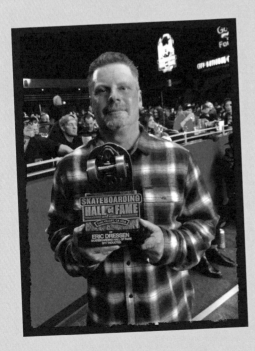

**Eric Dressen with his
Hall of Fame trophy after
being inducted in 2017.**

SKATE CULTURE: OUTLAWS

SINCE MORE OR LESS THE DAWN OF DOGTOWN AND RISE OF BACKYARD POOLS (AND, OF COURSE, FULL PIPES), SKATEBOARDING HAS BEEN DIRECTLY LINKED TO TRESPASSING, VANDALISM, DESTRUCTION OF PRIVATE PROPERTY, AND OTHER ILLICIT ACTIVITIES.

This has always been a big part of the "Skate and Destroy" appeal and romanticism—putting skateboarders in the same realm as bikers, punks, and anarchists. Lawlessness is all but written into the skateboarders' genetic code influencing nearly every facet of the culture.

After two of the driest years on record occurred in California in '73 and '74, concerned residents emptied their backyard pools to save water by the thousands, just as the Dogtowners were looking for new transitioned cement to test out their new, grippier urethane wheels. As if by fate, skateboarders immediately began hopping fences and ignoring property laws to ride the abundance of perfect backyard bowls. Ever since that moment, no self-respecting skateboarder would let a fence or a law get in the way of riding what was deemed "skateable."

In the skateboarder's viewpoint, it is our right to ride anything and everything on this planet. Especially when that thing is something as skateable as a picture-perfect backyard pool. As the pastime evolved, this same ethos was applied to skateparks, then street spots, then stairs, handrails, and benches and onward in much the same way. Once climbing a fence isn't a bother ("never stop hopping fences" sounds familiar), skateboarders will stop at almost nothing to ride terrain as they see fit. Skate culture today is more or less built on the premise of its being forbidden. Breaking the law is not only a song.

Tony Alva attacks the coping of the Gonzales pool—a legendary backyard pool in Santa Monica, CA—circa 1985.

"SKATEBOARDERS HAVE HISTORICALLY BEEN PORTRAYED AS OUTCASTS, REBELS, AND EVEN CRIMINALS. AS SKATING EVOLVED, THE NEED TO EXPLORE TERRITORIES AND NEW LIMITS SOMETIMES COLLIDED WITH THE ESTABLISHMENT. SKATEBOARDERS FACED CURFEWS, PROHIBITIVE LEGISLATION, AND BANS FROM PUBLIC AREAS."

Mike Vallely

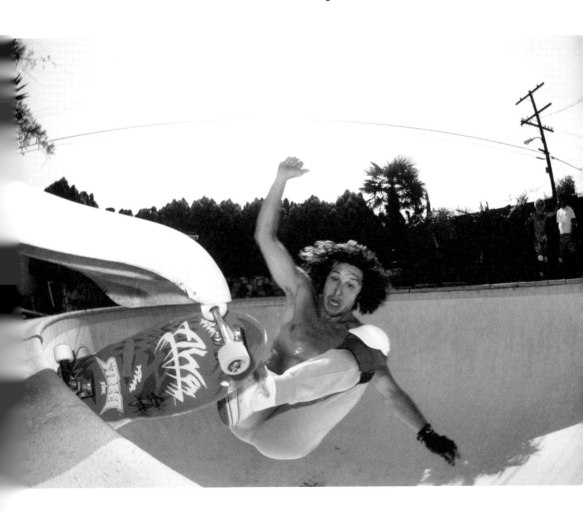

SKATE MEDIA: MAGAZINES

MAGAZINES WERE THE FIRST MEANS BY WHICH SKATEBOARDING AND ITS CULTURE WERE BROADCAST TO THE WORLD.

Beginning as early as '63, when Larry Stevenson began including ads promoting skateboarding in his publication *Surf Guide*, then exploding the following year with the launch of the *Skateboarder Quarterly* (later shortened to *Skateboarder* in the '70s), skate culture was purposefully preached through the magazines by its own industry in order to expand sales, lay down fads, and build participation.

By '81, following the demise of *Skateboarder* turned *Action Now* and the gaping void that was felt with the loss of the "Skateboard Bible," Rich Novak of Santa Cruz Skateboards and Fausto Vitello of Independent Trucks teamed up to launch *Thrasher* magazine in San Francisco as the new heir to the throne. Incensed with *Thrasher*'s "Skate and Destroy" ethos and a topless model in an Independent ad, Tracker Trucks gave birth to *Transworld SKATEboarding* (TWS) the following year as a more wholesome option for those in the pastime looking to "Skate and Create."

Cut to the year 2000 and *Thrasher* and *TWS* were joined by nearly fifty other major magazines exclusively dedicated to promoting skateboarding worldwide: *Slap, Big Brother, Kingpin, Sugar, Monster, Sidewalk, Document, 43, Color, Strength, Warp, Limited, Transworld Japan, Flat, Thrasher France, Concussion, Paper, Skateboard Canada (SBC)*, the *Skateboarder's Journal (SBJ), Skate Book, Homeboy, Freestyle, Medium, Concrete Wave, Ollie Mag Japan, Giftorm, Poweredge, Soma, Lowdown, RAD, Erosion, Skateboard!, Dogway, Phat, Juice, Push Periodical, No Way, Any-Way, B-Side, Free, The Skateboard Mag, Solo,* and *North Skateboard Magazine* are but a few of the endless list of titles that went on to spread the gospel of skateboarding.

Since the peak of the skateboarding magazines around 2010, internet content and the rise of smartphones and tablets have cut that list of titles down dramatically. There are under five monthly mags (including *Thrasher*) dedicated exclusively to skateboarding in print today.

> *" SKATEBOARDER MAGAZINE WAS OUR BIBLE IN THE '70S. WE WOULD JUST STUDY EVERY PHOTO. EVERY AD. EVERY CAPTION. EVERYTHING. IT WAS THE INSTRUCTIONAL MANUAL. "*
>
> **Eric Dressen**

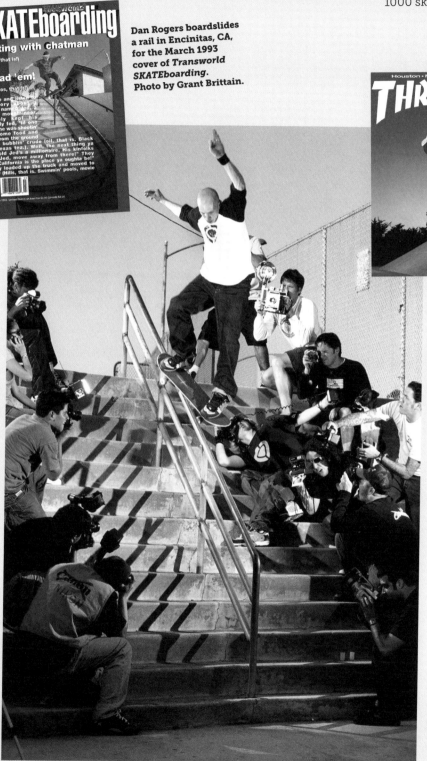

Dan Rogers boardslides a rail in Encinitas, CA, for the March 1993 cover of *Transworld SKATEboarding*. Photo by Grant Brittain.

Phil Shao (RIP) hits the top bar at the legendary Fort Miley in San Francisco for the cover of *Thrasher* in July 1996. Photo by Ogden.

Jamie Thomas Smith grinds a thirteen-stair rail for a skate media-themed cover of *Transworld* in 2000. Photo by Grant Brittain.

SKATER FUEL: VIDEOS

WHILE MAGAZINES AND STILL PHOTOGRAPHY CAPTURED AND DISTRIBUTED THE NEWEST MOVES, TRENDS, AND UP-AND-COMING PROS (AND AMS) TO THE WORLD UP UNTIL THE '80s, THE ARRIVAL OF BETAMAX AND VHS QUICKLY ADDED A NEW DIMENSION, JUST AS EVERY HOUSEHOLD ON THE PLANET WAS PLUGGING IN THEIR NEW VCR.

Skate films had existed as far back as *Skaterdater* in '65; however skate videos were born in '82 when Stacy Peralta released *Skateboarding in the '80s* as something to play at the Powell trade show booth. As the giant shoulder-held cameras shrunk down to smaller, more practical consumer camcorders, Peralta followed up his first efforts with *The Bones Brigade Video Show* in '84. That same year Vision released *Skatevisions.* Almost immediately, the new medium took over. Annual company skate videos became the industry standard.

Photos and sequences of the newest tricks that had previously been studied in minutiae by skateboarders around the world through mags could now be shared instantly in pixel-generated full-color video. The skate video itself became responsible for a massive wave of progression as a kid in Liverpool, England (Geoff), could now be as close to the action as any of the California locals on the deck at Del Mar Skate Ranch, Upland Pipeline, or McGill's skatepark in Carlsbad.

By the early '90s, an entire culture had sprung up around skate videos. The music, trends, tricks, and modus operandi of skateboarding at large were wrapped up and disseminated to the world—spooled up inside black VHS tapes with ornate box art. Video became the new bible even though magazines still defined things as well. *Video Days in '91*—filmed and directed by future Academy Award–winning director Spike Jonze and starring Mark Gonzales, Jason Lee, Guy Mariano, Rudy Johnson, and Jordan Richter—has been deemed the best skate video of all time by countless skate critics and more or less set the template for all to come thereafter.

Today, the "full-length" is an art form with its own film festivals, filmmakers, annual releases from giant corps like Vans, Supreme, or Nike SB, and filming a "part" makes up the bulk of any professional or amateur skateboarder's job description. In '22, the internet combines all three mediums—text, photos, video—and just like mags and VHS before it, serves as the pastime's delivery method—still with the stated mission of mainlining skate culture to the masses.

The skateboard video's founding father, Stacy Peralta, still carried the Z-Boy style in his DNA. Solona Beach, 1984.

Tony Hawk on the cover of *The Bones Brigade Video Show*, the first true skate video, released that same year by Stacy, CR Stecyk III, Powell Peralta, and the Bones Brigade.

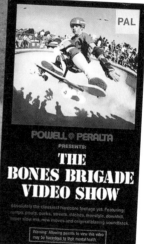

PAL

POWELL · PERALTA
PRESENTS:
THE BONES BRIGADE VIDEO SHOW

Absolutely the classiest hardcore footage yet. Featuring: ramps, pools, parks, streets, ditches, freestyle, downhill, super slow mo, new moves and original blaring soundtrack.

Warning: Allowing parents to view this video may be hazardous to their mental health.

"I ORGANIZED MY WHOLE LIFE AROUND SKATE VIDEOS—WHEN THEY WERE COMING OUT, WHAT YEAR THEY WERE RELEASED. MY WHOLE CHILDHOOD WAS BASICALLY FRAMED UP BY THE ANTICIPATIONS AND THEN PREMIERES OF THESE VIDEOS."

Jake Johnson

SKATE MEDIA: BOOKS

WHILE MAGS AND VIDEOS HAVE HISTORICALLY MADE UP THE LION'S SHARE OF THE OUTPUT, A FEW KEY BOOKS HAVE SOUGHT TO BETTER DEFINE VARIOUS ASPECTS OF THE PASTIME.

Skate books can be split into three categories. The first and most common would be the coffee-table/illustrated book variety. The second type would be closer to an academic essay exploring one specific realm of skateboarding. Then, thirdly, would be autobiographies and skate novels.

Some of the first definitive titles arrived in the '70s. In '75, Russ Howell released *Skateboard: Techniques, Safety, Maintenance*—his book highlighting general information he picked up as a lead pro through the '60s and '70s. By the late '90s, authors like Michael Brooke and his book *The Concrete Wave: The History of Skateboarding*, released in '99, followed up with attempts at documenting the pastime from its inception through the turn of the millennium.

In '04, skateboard artist Sean Cliver released his first edition of *Disposable: A History of Skateboard Art*. Along with his '09 version, *The Disposable Skateboard Bible*, Sean's book series remains the definitive deck collector's guide. As far as academic essays, Jocko Weyland's '02 book *The Answer Is Never: A Skateboarder's History of the World* is consistently celebrated as one of the best arguments for the entire culture.

Finally, on the autobiography and skate novel front, Tony Hawk's *Occupation: Skateboarder* (2000), Rodney Mullen's *The Mutt: How to Skateboard and Not Kill Yourself* (2004), and Christian Hosoi's *Hosoi: My Life as a Skateboarder Junkie Inmate Pastor* (2012) all provide valuable insight into skateboarding's biggest names, while *The Most Fun Thing* (2021) by journalist Kyle Beachy is a good memoir in essays.

"IF MY BOOK HAS AN ARGUMENT, IT'S THAT 'HEY, SKATEBOARDING IS WAY MORE INTERESTING THAN WE'RE GIVING IT CREDIT FOR. LET'S LOOK AT IT.'"

Kyle Beachy on his book "The Most Fun Thing"

SKATE MEDIA: FILMS

SKATEBOARDING ON THE BIG SCREEN HAS A COLORFUL HISTORY, STRETCHING BACK TO *SkaterDater* IN '65. HOLLYWOOD HAS—AT TIMES—BEEN RESPONSIBLE FOR USHERING IN BIG CHANGES OVERNIGHT.

In the '80s, *Thrashin'* (1986) and *Gleaming the Cube* (1989) were a sea change. Other times, it happened more indirectly with films like *Back to the Future* (1985) or *Police Academy 4* (1987), where something as simple as Michael J. Fox riding a skateboard to school (or the members of the Bones Brigade appearing in the intro to *Police Academy*) inspired countless kids to get their first completes, fueling a massive industry boom.

In the '90s, films like *Kids* by Larry Clark also impacted the culture, even if the representation was more subtle. The film focuses on the New York City skater lifestyle—as it was in '95—steeped in alcohol, drugs, petty crime, and ultimately the AIDS epidemic. On the West Coast, *Lords of Dogtown* (2005) retold the story of the '70s Z-Boys documentary in a feature film starring Hollywood A-listers Heath Ledger and Emile Hirsch.

In '18, Jonah Hill directed *Mid90s* based loosely on his own experience growing up with skate culture in West LA. The film is set at the fictional skateshop Motor, which was based on his memories of hanging out at Hot Rod skateshop in Westwood. In '21, Mikey Alfred directed *North Hollywood*, with a similar autobiographical plotline charting his trajectory as a skateboarder and making some of the big life decisions.

Although skate culture has been explored in a myriad of ways, there has never truly been a definitive fictional skate film to date.

❝ ON THE LORDS OF DOGTOWN FILM I WAS TASKED WITH PAINTING EXACT DUPLICATES OF THE ORIGINAL SURFBOARD I MADE FOR SKIPPERBOY ENGBLOM IN '74. THERE WAS ONE FOR SKIP THE ACTUAL PERSON. ANOTHER WAS FOR HEATH LEDGER THE ACTOR WHO PLAYED ENGBLOM. TWO MORE WERE FOR THE STUNTMEN. AND THE FIFTH WAS A BREAKAWAY UNIT THAT WAS FOR THE DRUNKEN DESPAIRING SKIP CHARACTER TO TOSS OFF THE SHOP ROOF. ❞

CR STECYK III

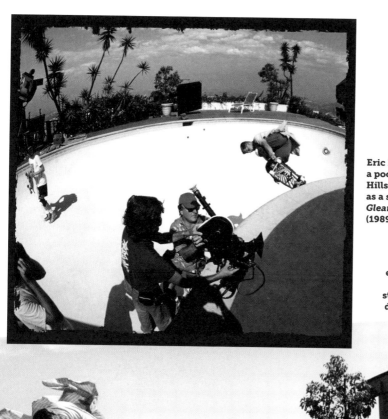

Eric Dressen tail blocks
a pool in the Hollywood
Hills while skating
as a stunt double for
Gleaming the Cube
(1989).

Stacy Peralta gets some
early Hollywood experience
filming Eric for the movie,
starring Christian Slater and
directed by Graeme Clifford.

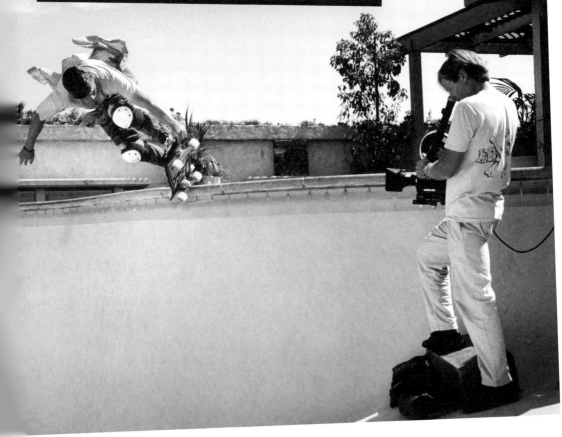

SKATE MEDIA: DOCUMENTARIES

ON THE DOCUMENTARY SIDE, A DEEP MEDIA LIBRARY OF NONFICTION INVESTIGATIONS HAS BEEN DEVELOPED. MOST FREQUENTLY, THESE HAVE FOCUSED ON A SINGLE PRO OR INFLUENTIAL GROUPS.

There were a number of releases before '01's *Dogtown and Z-Boys*; however, Stacy Peralta's choice to feature his Santa Monica–based crew and Venice riders in the '70s set the template for the modern skate documentary by centering on the skaters' perspective.

Prior to *Dogtown*, documentaries like *The Devil's Toy* ('66 by Claude Jutra) or *Skateboard Kings* ('78 by Horace Ové) aimed more at sensationalizing skateboarding (both positive and negative) for the general public. Peralta, who had already lived it, instead sought to tell his story from his perspective, even if still sensationalized.

Since '01, documentary releases (not including the actual skate videos released by the companies) have evolved to include profiles of industry pillars like Steve Rocco (*The Man Who Souled the World*, '07) and legendary pros like Christian Hosoi (*Rising Son: The Legend of Skateboarder Christian Hosoi*, '06), and cautionary tales like *Stoked: The Rise and Fall of Gator* ('03 by Helen Stickler), which documents the rape/murder committed by '80s vert pro Mark "Gator" Rogowski.

In '19, Bing Liu's *Minding the Gap* documenting his own crew's real-life issues was nominated for an Academy Award after it won at Sundance. Meanwhile, Carol Dysinger's '19 release *Learning to Skate board in a Warzone (If You're a Girl)* covering the incredible story of the Skateistan project in Kabul won the Academy Award for Best Documentary Short Subject in February '20.

Finally, the HBO documentary *Tony Hawk: Until the Wheels Fall Off* ('22 by Sam Jones) repurposes Stacy Peralta as a narrator and witness (along with Rodney Mullen, Lance Mountain, and more) to the incredible career of skateboarding's most well-known ambassador as he turns 54.

Jay Adams (RIP) craving down Bicknell Hill in Santa Monica for the poster of 2001's *Dogtown and Z-Boys*. Poster and photos by CR Stecyk III.

DOGTOWN
AND Z BOYS

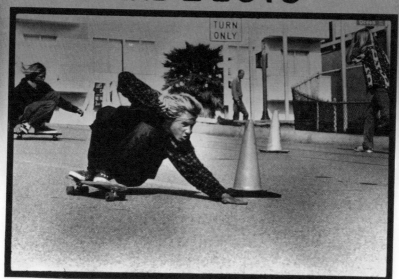

A FILM ABOUT THE BIRTH OF THE NOW
NARRATED BY SEAN PENN

PRODUCER AGI ORSI, EXECUTIVE PRODUCER JAY WILSON
CO–PRODUCERS DANIEL OSTROFF, STEPHEN NEMETH, GLEN E. FRIEDMAN
EDITOR PAUL CROWDER, PRODUCTION DESIGNER C.R.STECYK
DIRECTOR STACY PERALTA

A VANS OFF THE WALL PRODUCTION

SKATE MEDIA: MUSIC

SKATEBOARDING HAS ALWAYS BEEN AN ARTISTIC FORM OF SELF-EXPRESSION, AND MUSIC HAS ALWAYS PLAYED A BIG PART OF THAT.

Whether blasting Led Zeppelin at a pool in the '70s or bumping Notorious B.I.G. out of a boom box at Love Park in Philadelphia in the '00s, the pastime has always been tied to music (this ironically makes it similar to dancing, in a way). Early contest skaters in the '70s and '80s would build contest runs to specific tracks almost in the same way figure skaters do in the Olympics. This led way to video parts similarly later being edited entirely to a song, usually of the skater's choosing.

Like the artwork that characterizes board graphics, skateboarding also eventually gave birth to its very own sound—most notably in the early '80s with the explosion of the California hardcore punk scene. Ultimately, this resulted in what is today classified as Skate Rock—its very own music genre. Black Flag, the Circle Jerks, the Dead Kennedys, and the Descendents were all early products of this cultural fusion.

Described as "fast, loose, and raw" and imitating the sensation of skating, Skate Rock evolved further with bands like Suicidal Tendencies, 7 Seconds, JFA, and the Big Boys in the mid-to-late '80s—then ultimately morphed into mainstream pop punk with bands like Green Day, Blink-182, the Offspring, and Bad Religion in the '90s. Many of the bands also received their own skate decks (oftentimes with Texas-based manufacturer Zorlac), producing a host of graphics and models that today sit at the top of most board collectors' grail lists.

> "PUNK ROCK WAS REALLY NEW. I CAME FROM A BROKEN HOME AND SKATEBOARDING WAS ALREADY A GOOD OUTLET FROM THAT. I ALSO REALLY LIKED THE (SEX) PISTOLS. I LIKED SID VICIOUS. I LIKED THE DESTRUCTIVENESS OF IT. IT LOOKED APPEALING AND ATTRACTIVE. PUNK AND SKATEBOARDING WERE MADE FOR EACH OTHER."

Duane Peters

"I'VE LEARNED A LOT THROUGH SKATEBOARDING. IT TAUGHT ME A LOT ABOUT DISCIPLINE, PERSEVERANCE, GETTING OVER FEARS, AND LEARNING TO FAIL BEFORE YOU CAN SUCCEED. IT TAKES A LOT OF PATIENCE. WHAT I'VE LEARNED FROM PATIENCE IS THAT IT IS THE DEFINITION OF LONG SUFFERING—WHICH IS THE SAME FOR MUSIC."

Steve Caballero on merging skateboarding and music for his band the Faction

Billie Joe Armstrong (right) and Green Day show off their boards made in collaboration with Real Skateboards' Actions Realized program to help the Oakland Children's Hospital in 2013.

SKATE MEDIA: VIDEO GAMES

THE FIRST MASS-PRODUCED VIDEO GAME INVOLVING SKATEBOARDING DID NOT APPEAR UNTIL 1986 WITH THE RELEASE OF ATARI'S 720°. RELEASED SOLELY AS AN ARCADE GAME AND NAMED AFTER TONY HAWK'S ICONIC '85 TRICK, 720° WAS QUICKLY ADAPTED TO HOME GAME PLATFORMS.

It was followed up by similar rudimentary skate games from other brands like *Skate Boardin'* ('87), *California Games* ('87), *T&C Surf Designs: Wood and Water Rage* ('88), and *Skate or Die* ('88). Yet it was not until '99 and the release of the first *Tony Hawk's Pro Skater* from Activision on PlayStation that the genre truly came into its own.

THPS successfully merged both the sensations and playability of skateboarding along with skate culture (music, current top pros, board graphics, true-to-life-looking spots/tricks) and launched skate video games as a bankable venture, in addition to making Tony Hawk and many of the pros featured sizable chunks of cash. Hawk revealed in '18 that at one point the original game landed him a single royalty check of $4 million—not even counting the later sequels and spin-offs.

Following the massive success of Hawk and Activision's *Pro Skater* franchise (there are something like twenty more in the series and counting as of this writing), other games like *Grind Session* ('02), *EA Skate* ('07) and its subsequent series of follow-ups (*Skate 4* was released in '22), *Shaun White Skateboarding* ('10), *Skater XL* ('20), and onward have all tried to match what began in '99. However, to date, the *THPS* family remains king of skate video games, with high-definition remakes of the first two games released to great success in '20 and no real contenders on the horizon.

A digital Tony Hawk catches a Japan Air—a trick he helped name in real life—in the virtual world of *Tony Hawk Pro Skater 1.*

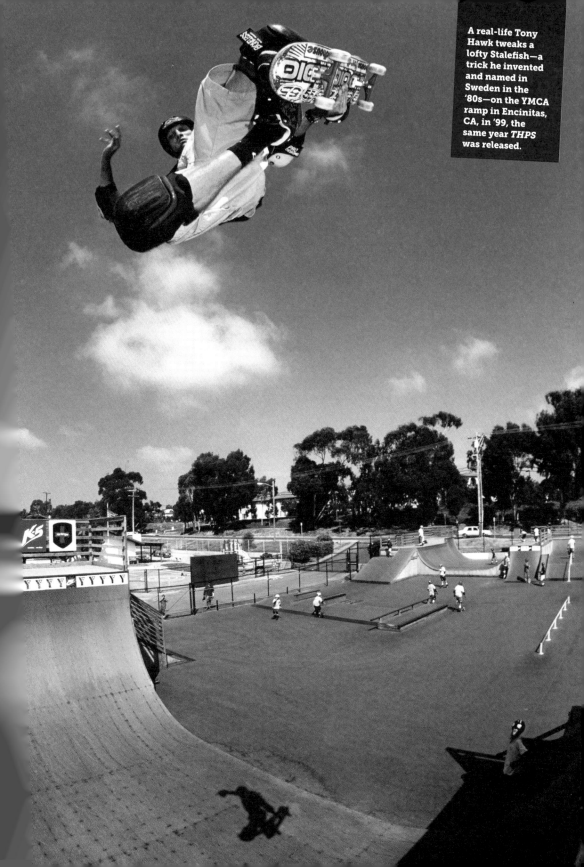

A real-life Tony Hawk tweaks a lofty Stalefish—a trick he invented and named in Sweden in the '80s—on the YMCA ramp in Encinitas, CA, in '99, the same year *THPS* was released.

SKATE MEDIA: INTERNET & WEBSITES

SKATEBOARDING WAS RATHER QUICK TO EMBRACE THE EMERGING NEW MEDIA OFFERED BY DIAL-UP MODEMS AND EARLY INTERNET PLATFORMS.

The earliest incarnations of the internet surfaced in '78 as Bulletin Board Systems (BBS), where users with a modem could dial up a number and share text with others on that BBS. Funnily enough, it was the "Skate and Destroy" staff of *Thrasher* that first dipped their toes into the medium—launching the *Thrasher* BBS as early as '87 as an undercover message board for skaters worldwide.

When the modern-day internet arrived in the '90s, it all but wiped out BBS sites; still, *Thrasher* had a huge head start. The largest and most influential message board in skate today—the Slap message boards—is still a subsidiary of High Speed (owners of *Thrasher* and former sister magazine *Slap*). As companies and other media outlets caught up and bandwidth grew to allow full-resolution photos and later, videos, an outright online war broke out by the turn of 2000 with multiple sites including *Bluetorch*, *Alloy*, *MonsterSkate*, Antix.com, and more, raising capital by the boatloads to steal staff away from the established print magazines (by then *Thrasher*, *Transworld SKATEboarding*, *Big Brother*, *Slap*, *Strength*, and a few more ruled the media world.)

Two print ads from '00's Antix.com, an attempt by the heads of the skate industry including Steve Rocco, Steve Douglas, Santa Cruz, Alien Workshop, Tum Yeto, Giant Distribution, CCS Skateshop, and more to capitalize on the emerging internet market at the turn of the millennium.

Still, by 2010 the dot-com bubble had swelled and burst, and by becoming the de facto home to companies' videos online, *Thrasher* retook the top online spot, and by 2019 it was essentially the only magazine still being printed monthly as well as holding the top spot on the web. Other digital-only entities like the Berrics (and their exclusive skatepark in LA) and even YouTube-based the *Nine Club*, or Street League's *ETN* have since risen to grab some market share (at times successfully, at other times not so successfully), yet each time *Thrasher* has ultimately prevailed as the online king of skate media.

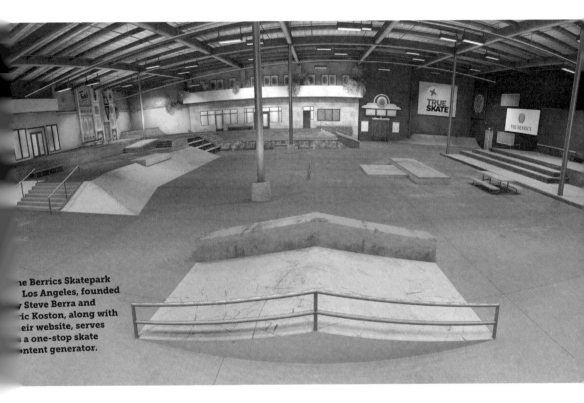

The Berrics Skatepark
Los Angeles, founded
y Steve Berra and
ic Koston, along with
eir website, serves
a one-stop skate
ontent generator.

"THE INTERNET OPENED ANOTHER OUTLET TO SEE SKATEBOARDING. BEFORE, IF THE TOUR DIDN'T GO THROUGH YOUR TOWN, YOU WERE SHIT OUT OF LUCK. YOU'RE WAITING FOR A VIDEO OR A MAGAZINE—AND THAT WAS IT. NOW, WITH MORE SITES LIKE THE BERRICS, WE HAVE ANOTHER WAY TO REACH KIDS."

Eric Koston on starting the Berrics in 2008

SKATE MEDIA: SOCIAL MEDIA

LIKE THE EARLY BBS SITES, SKATEBOARDERS' SUB—SOCIETY NETWORKS LENT THEMSELVES PERFECTLY TO THE ADOPTION OF SOCIAL MEDIA AS IT EMERGED IN THE EARLY '00s.

Most skaters' first experiences with it began as early as Friendster (I remember my co-workers signing up when I worked at *Skateboarder* as it launched in '02), then quickly moved to MySpace ('03), then Facebook ('04), and finally Instagram (launched in '10)—turbocharged with the emergence and dominance of the iPhone over the past decade and a half.

In '22, I believe it is safe to say Instagram remains the leader in skate culture with ams and pros essentially able to live off the footage and content they post there, nearly without any other forms of centralized or traditional media. Skaters today will usually trade Insta handles at a spot, and some communicate primarily through DMs. I use those tools for nearly half the pros or ams I need to interview for magazines I work for today, and of course, skaters share spots and almost everything else through the platform (now part of Meta).

While it's easy to point out the negative points of social media, I think it is also important to see the great connectivity and democratization (let alone the accessibility of pros to their fans in skateboarding) allowed by the social platforms of today. Still, at some point we all need to simply go outside and skate.

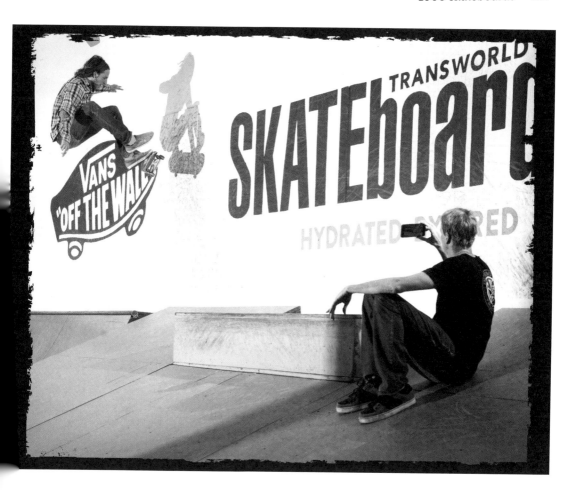

"INSTAGRAM ISN'T ALL BAD. SOMEBODY LIKE DONNY BARLEY,
FOR EXAMPLE, HE'S ONE OF MY FAVORITES.
HE MIGHT NOT HAVE TOO MUCH FOOTAGE OUT THROUGH
COMPANIES ANYMORE BUT I CAN WATCH HIM
SKATE NOW ON HIS INSTAGRAM AND GET EXCITED."

Alex Olson on social media in skateboarding

TRICKS AND PROGRESSION

SKATEBOARDING IS FIRST AND FOREMOST ABOUT ROLLING. HOWEVER, ONCE IN MOTION—SINCE ITS EARLIEST DAYS—SKATEBOARDING HAS ALSO BEEN ABOUT PERFORMING "TRICKS."

Back in the '50s and '60s, those tricks were closer to something you might do with a yo-yo or Hula-Hoop—yet progressively, over time, they have evolved to include aerial acrobatics that push the limits of human athleticism. Funnily enough, the explosion of the Dogtown revolution (and urethane wheels) in '73 led to pure trick progression being pushed into the back seat as skateboarders refocused on actually riding on (and up) surfaces beyond simple flatground freestyle routines. Akin to surfers who had just discovered waves after decades stuck on placid lakes, Dogtown reset skateboarding's priorities before again progressing tricks on what now included vertical terrain.

Tony Alva's inaugural air in Santa Monica's Dog Bowl in '77 truly lit the fuse as the mother of all tricks. Within months Alan "Ollie" Gelfand's no-handed air or ollie was unveiled, and by '82 Rodney Mullen had adapted it to flatground—unlocking street terrain the globe over for innovators like Natas Kaupas, Mark Gonzales, and onward. By '84, Mike McGill spun the McTwist (an upside-down 540), followed by Tony Hawk's 720 ('85) and leading all the way to his 900 (two and a half full rotations) in the '99 X-Games.

Today, skateboarders continue to expand what is deemed possible—on "Mega Ramps," down thirty-stair handrails, on ledges, curbs, flatground, massive gaps, pools, and even full pipes—pushing the limits of the available ramps or street spots and equipment technology as well as the limits of human capabilities. Yet it must always be stated that the Dogtowner/Z-Boys rules to progression are still in effect: good tricks only matter with good style. Kooks beware.

"IF YOU REALLY WANT TO UNDERSTAND SKATE HISTORY, YOU CAN UNDERSTAND IT BEST JUST BY STUDYING SKATE TRICKS. BECAUSE THERE WAS AN EVOLUTION. AT THE SAME TIME, THESE DAYS ALMOST EVERYTHING HAS BEEN DONE."

Jef Hartsel

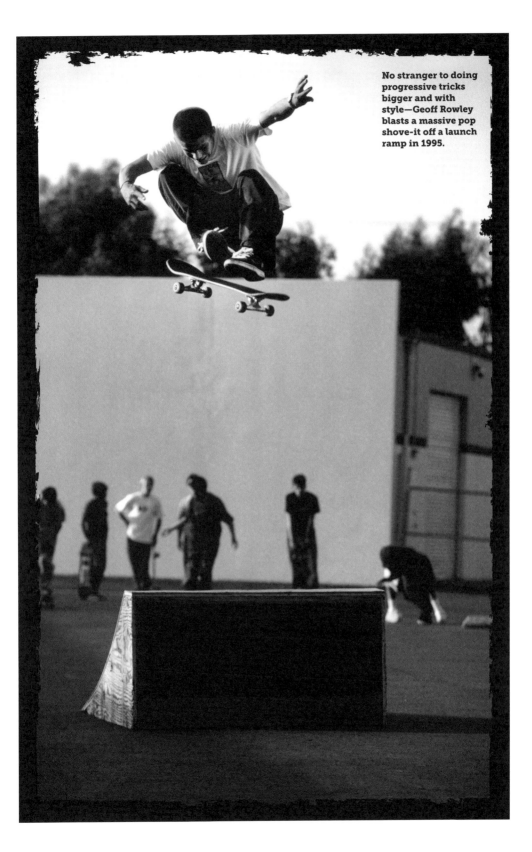

No stranger to doing progressive tricks bigger and with style—Geoff Rowley blasts a massive pop shove-it off a launch ramp in 1995.

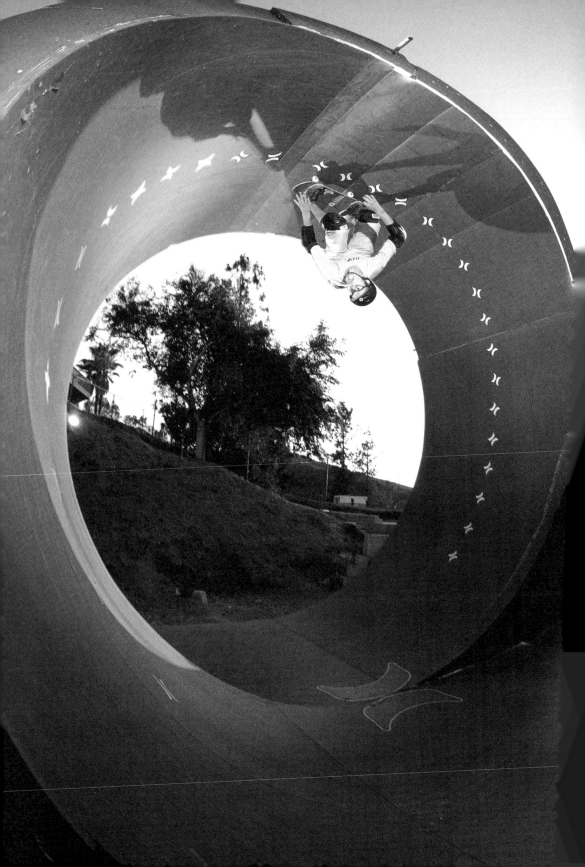

"I NEVER THOUGHT I'D SEE GUYS DOING THE LOOP. I NEVER DREAMED I'D SEE DUDES DOING TWENTY-STAIR HANDRAILS."

Tony Alva

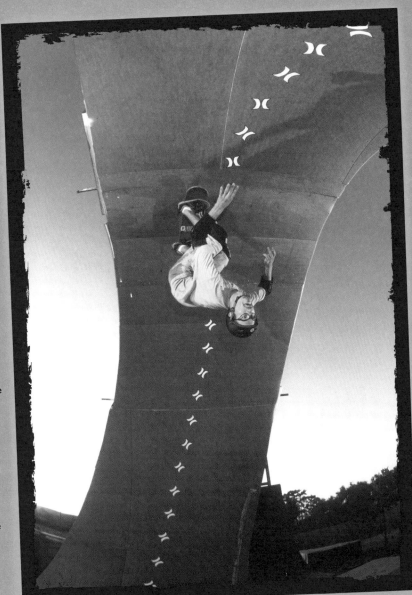

Duane Peters first tried the loop in 1979—famously breaking his collar bone before Tony Hawk finally documented a make in 1995. Bob Burnquist, pictured here in his own backyard, made the loop almost a standard obstacle with various firsts like doing it switchstance (backwards), landing a loop with a gap at the top, and looping inside a stand-alone full pipe (with no roll-in track) in the early '00s.

NAMESAKES:
TRICKS NAMED AFTER PROS

TRICKS HAVE BEEN BENCHMARKS FOR A SELECT FEW PROS (AND EVEN MORE RARELY AMS), GRANTING THEM THE RARE OPPORTUNITY FOR A CHANCE AT IMMORTALITY—HAVING A TRICK NAMED IN THEIR HONOR.

Tricks like the Ty Hop (a precursor to the modern shove-it) by Ty Page date back to the early '70s. Yet many early tricks like the Bertlemann or Bert were actually named after surfers (in this case Larry Bertlemann). Most of the namesake tricks used today come from the era after the Dogtown (and urethane) revolution.

The most famous was the aforementioned ollie or no-handed frontside air, named after Alan "Ollie" Gelfand in '78. That same year, Jeff Tatum also coined the "JT Air" for his first backside ollies (possibly even before Gelfand). By the turn of the '80s, the idea of naming a trick after yourself gained more traction. Steve Caballero spun the first (no-handed) fakie 360s on vert and named it the Caballerial in late '80. From there, a host of vertical staples were invented and named including the Smith grind, named after Mike Smith in '81 (yet first grinded by Alan Losi) and of course the McTwist—named after Florida's Mike McGill in '84.

Since then, tricks have continued to be named after pros even on the streets, like the Barley grind, named after Donny Barley during the mid '90s; the Suski grind, named after Aaron Suski during the late '90s; and the Bennett grind, named after Matt Bennett during the '00s. And while skateboarding's progression arc has slowed over the past couple of decades, and the practice of namesake tricks has at times been frowned upon, surely future tricks on the horizon will also be blessed with their creator's monikers.

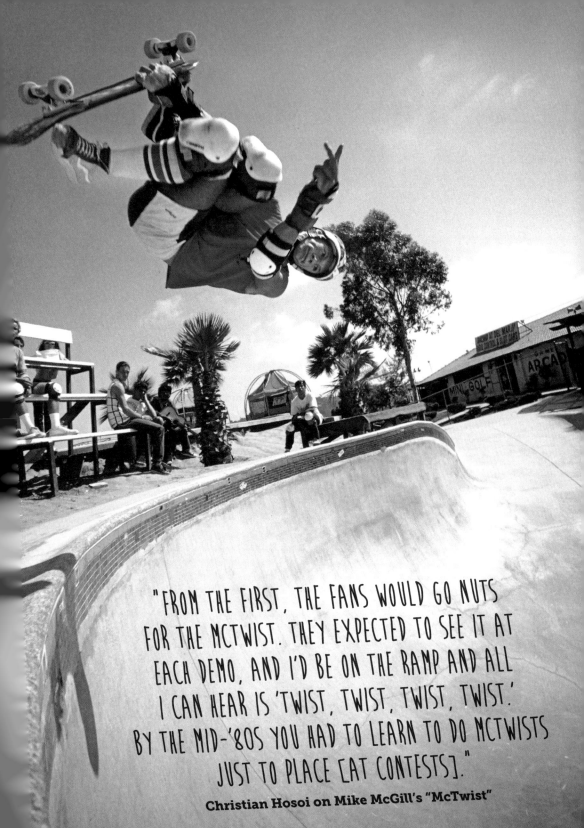

"FROM THE FIRST, THE FANS WOULD GO NUTS FOR THE MCTWIST. THEY EXPECTED TO SEE IT AT EACH DEMO, AND I'D BE ON THE RAMP AND ALL I CAN HEAR IS 'TWIST, TWIST, TWIST, TWIST.' BY THE MID-'80S YOU HAD TO LEARN TO DO MCTWISTS JUST TO PLACE [AT CONTESTS]."

Christian Hosoi on Mike McGill's "McTwist"

WHAT IS STYLE?

SKATEBOARDING, LIKE SURFING, HAS LONG PRIZED STYLE AS ONE OF THE MAIN WAYS OF DIFFERENTIATING BETWEEN "BARNEYS" OR KOOKS AND THE REAL-DEAL SCENE LEADERS.

What is style? Style is everything. It is the way one's body moves and flows through the execution of the tricks or even just foot placement while rolling. It is the difference between looking stressed or looking natural and relaxed. It is also, of course, the "kit" or clothes worn while skating, the little eccentricities from personality quirks to facial expressions, musical and equipment choices, and onward, all the way down to the color of wheels you might choose to ride, or how you treat others at the spot or skatepark.

Style is the feeling you generate in others watching you ride. It is the very soul of the thing. And while it is absolutely critical to every aspect of the pastime, it is probably the hardest thing to actually explain or put into words. You simply know it when you see it. That said, many skateboarders and skate writers have used this Charles Bukowski quote to help define the thing:

"Style is the answer to everything. A fresh way to approach a dull or dangerous thing. To do a dull thing with style is preferable to doing a dangerous thing without it. To do a dangerous thing with style is what I call art. . . . Style is the difference, a way of doing, a way of being done." —Charles Bukowski

Mark Gonzales footplants off a tree in Laguna Beach, CA, with his unmistakable and unmatchable style.

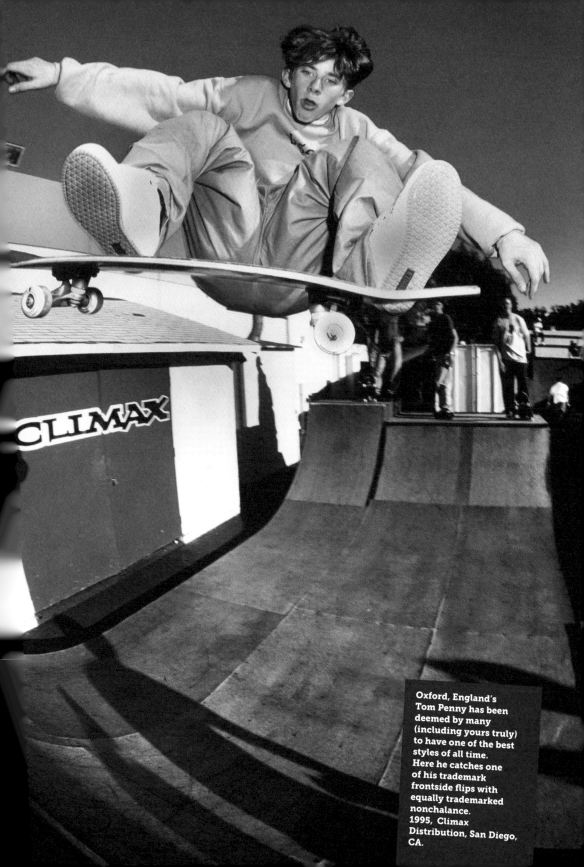

Oxford, England's Tom Penny has been deemed by many (including yours truly) to have one of the best styles of all time. Here he catches one of his trademark frontside flips with equally trademarked nonchalance. 1995, Climax Distribution, San Diego, CA.

CLOTHING THROUGH THE YEARS

UNLIKE MOST ORGANIZED TEAM SPORTS, SKATEBOARDING HAS NEVER USED UNIFORMS OR REQUIRED GEAR. THROUGHOUT ITS HISTORY, THIS HAS OPENED THE DOOR TO PERSONAL EXPRESSION THROUGH CLOTHING AND PERSONAL STYLE.

Initially born out of surf attire, by the '80s and '90s skating had more or less created a universe of its own—wholly divorced from beach culture and in many cases closer to the urban-based styles of punk rock and hip-hop, yet still with a distinct skate flavor.

Through the decades, key pros and influential figures have driven skate fashion. From Tony Alva and Jay Adams in the '70s, to Christian Hosoi and Natas Kaupas in the '80s, Chad Muska and Kareem Campbell in the '90s, Ali Boulala and Gino Iannucci in the '00s, Dylan Rieder and Stefan Janoski in the '10s, all the way to Oski Rozenberg and Tyshawn Jones in the '20s—pro skating has always been as much about what you wear as it is about what you do. The main rule has been that there are no rules.

These trends have also always mixed clothing made by skate brands (beginning during the late '80s with Skate Rags and Vision Street Wear) with certain staples (like a pair of timeless 501 Levis jeans) from more corporately owned entities outside the skate realm. And while there has more often than not been little rhyme or reason to what is ultimately deemed "the look" of the moment (anything goes and function almost never trumps fashion), the only contant is that one must perpetually be aware of the ever-changing landscape.

" *I'LL NEVER FORGET GETTING THE ORIGINAL BLIND JEANS IN 1993. RIGHT THEN YOUR OUTFIT MEANT EVERYTHING. THE BLIND JEANS CAME SUPER LONG WITH A FRAYED END AND WERE MADE TO BE CUT TO FIT. I CUT THEM TO REACH THE BOTTOM OF MY HEEL WHEN STANDING UP. BUT WHEN YOU BEND YOUR LEG THEY WOULD COME WAY UP. I'D WEAR THOSE WITH CUT-OFF AIRWALKS AND THESE ARGYLE SOCKS I FOUND AT THE THRIFT STORE.* **"**

JEREMY WRAY ON 1993 SKATE FASHION

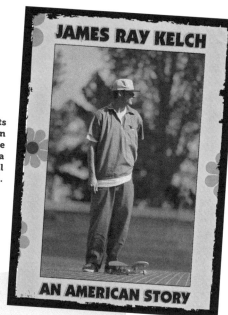

James Kelch sets the 1993 fashion template at the Embarcadero aka EMB in SF for a Real Skateboards ad.

JAMES RAY KELCH

AN AMERICAN STORY

Natas Kaupas and Mark Gonzales dressing up in some outlandish thrift store gear for a 1987 photo shoot in *Transworld*. Jokes aside, both had serious impact on the way skaters dress.

KEY BRANDS

SKATEBOARDING HAS HISTORICALLY BEEN DEFINED BY KEY BRANDS. WITHOUT A LEAGUE LIKE BASKETBALL'S NBA OR SOCCER'S UEFA, THE BRANDS HAVE TRADITIONALLY DETERMINED SKATEBOARDING'S STARS VIA THEIR SIGNATURE-ENDORSED PRODUCT. LIKE SKATE CLOTHING, THIS BEGAN WITH SURF (AND EVEN ROLLER-SKATE) BRANDS AS THE BIGGEST CULTURAL DRIVERS IN THE '60S/'70S.

Hobie and Makaha were the two surf-related brands that released the first pro boards during the '60s. By the early '70s, brands like Zephyr or Z-Flex, G&S, Variflex, Bahne, and a bit later Alva emerged as the dominant manufacturers, while it could be argued that *Skateboarder* was also a pivotal brand in its own right. Vans, born in '66, has been one of the most important labels in skateboarding since at least the dawn of the '70s, while Santa Cruz and its extended family of Independent Trucks, Road Rider Wheels, and *Thrasher* all grew in influence by the early '80s. By the middle of that decade, the "Big Five" were established as Santa Cruz (including SMA and Sims), Vision (including Schmitt Stix and Lucero), Powell Peralta, *Transworld*/Tracker, and *Thrasher*. A few key footwear brands including Airwalk, Vision Street Wear, and Etnies also gained relevance at the end of the '80s.

At the dawn of the '90s the entire industry crumbled—resetting the brand landscape with start-up companies led by Steve Rocco's World Industries and H-Street (including Life and Planet Earth)—followed by Blind, Plan B, 101, the New Deal (later joined by Mad Circle and Underworld Element), Alien Workshop/Habitat, Girl/Chocolate, Black Label, and others. The seeds planted by the early '90s companies, along with the return of Powell and Santa Cruz, and birth of newer companies like Toy Machine, Zero, and Shorty's have today led to a brand landscape loosely rooted to the change of guard three decades back. On the footwear side, the continued dominance of Vans has been balanced with the rise of linchpins like DC, DVS, éS, Lakai, Fallen, and more.

Key brands in '22 include Fucking Awesome, Polar, Supreme, Palace, Vans, Independent, and a few dozen more depending heavily on who you ask and what type of skateboarding fans they are. Although they don't actually make skateboards, brands like Nike SB, Adidas Skateboarding, New Balance Skateboarding, and a few other outside brands are impossible not to mention. Even Louis Vuitton recently released a skate shoe for UK skater Lucien Clarke. Suffice to say, the line between skate and non-skate brands has sometimes blurred to the point of nonexistence.

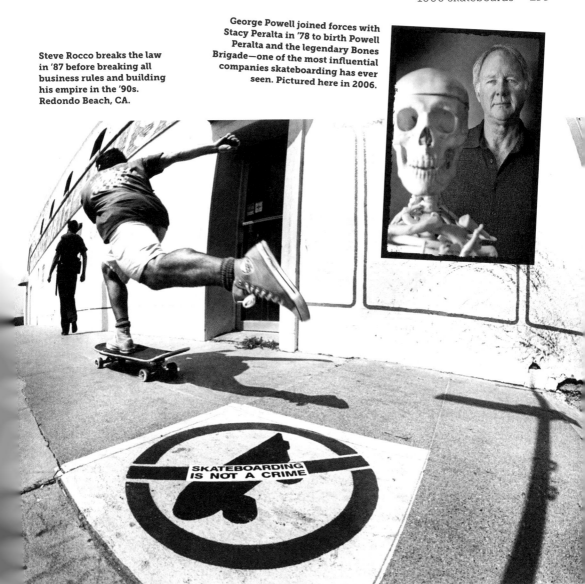

Steve Rocco breaks the law in '87 before breaking all business rules and building his empire in the '90s. Redondo Beach, CA.

George Powell joined forces with Stacy Peralta in '78 to birth Powell Peralta and the legendary Bones Brigade—one of the most influential companies skateboarding has ever seen. Pictured here in 2006.

SKATEBOARDING IS NOT A CRIME

"ONE OF THE GREAT THINGS ABOUT HAVING YOUR OWN COMPANY IS SHARING WITH YOUR FRIENDS. MY FRIENDS JUST HAPPENED TO BE MARK GONZALES AND NATAS KAUPAS. SO WE STARTED BLIND WITH MARK AND 101 WITH NATAS."

Steve Rocco, on starting World Industries, Blind, and 101

10 BESTSELLING BOARDS THROUGH THE YEARS

AT THEIR ABSOLUTE PEAK IN THE MID-TO-LATE '80s, A SINGLE PRO MODEL BOARD MIGHT SELL UPWARDS OF 50,000 DECKS A YEAR. WHILE THAT FORMULA CHANGED DRAMATICALLY OVER THE COURSE OF THE '90s, THE FOLLOWING ARE TEN OF THE BESTSELLING PRO MODEL SKATEBOARDS EVER RELEASED, IN CHRONOLOGICAL ORDER.

1 STACY PERALTA, G+S WARPTAIL 2, '77

Following their rise to cult status at the Del Mar Nationals in March of '75, the Z-Boys not only revived skateboarding, which had been in a slump since the '60s, they also became some of the first pros with enough charisma and name recognition to power bestselling decks. Peralta's Gordon & Smith Warptail 2 model became the top-selling board in an exploding new market.

2 TONY ALVA, TRI-LOGO PRO, '78

Not to be outdone, Dogtown's biggest personality and skateboarding's first true international superstar, Tony Alva, launched a company of his own. After he hired famed fashion photographer Raul Vega to direct the high-quality ad campaign, his Slasher logo and gradient die-cut grip became one of the most recognized icons in the pastime. Alva Skates' second-generation Tri-Logo deck sold through the roof.

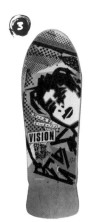

3 MARK GONZALES, FACE, VISION, '86

Moving ahead through the early '80s, skateboarding again took a serious dip in popularity before a worldwide explosion during the latter half of the decade. Vision's iconic neon Gator and Mark Gonzales models began paying monthly royalty checks as high as $13,000. Andy Takakjian's Gonz artwork is arguably one of the most emblematic pop culture embodiments of glam.

4 STEVE CABALLERO, DRAGON BATS, POWELL PERALTA, '87

By the time The Search for Animal Chin ('87) dropped, Powell Peralta had risen to the number one selling company in skateboarding and the Bones Brigade were household names. V.C.J.'s Dragon Bats, on sale from '87 to '89, may be one of skateboarding's bestselling boards ever.

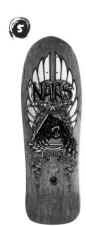

NATAS KAUPAS, NATAS PANTHER 3, SMA, '89

In the peak year of '89, number two manufacturing house NHS (Santa Cruz and Santa Monica Airlines) sold 598,000 boards. Among them, 37,250 Rob Roskopp Face models, 42,000 Corey O'Brien Reapers, and 56,400 Natas Panther boards. Jeff Kendall puts it in perspective: "There are twice as many skateboarders right now as there were in the late '80s. Still, you'd be hard-pressed to find a single pro model that sells more than 3K a year today." *

MIKE VALLELY, WORLD INDUSTRIES, BARNYARD, '89

Combining the first successful "double kick" board, Marc McKee's first graphic, and an absolutely red-hot Mike Vallely, the Barnyard put World Industries on the bestseller map and remains one of the most important decks in skateboard history. In Mike's words, "The most money I ever made off any single deck was the Barnyard. I was averaging $12,500 a month for a long time but some checks were as high as $15,000."

MATT HENSLEY, KINGSIZE, H-STREET, '90

At the dawn of the '90s, everything changed. The "Big Five" companies fell, street skating took over, and World Industries and H-Street locked the top two spots in board sales respectively. Matt Hensley embodied everything the new generation wanted. Both versions of his Kingsize board seemed like prerequisite equipment for anyone under 20 years old.

TOM PENNY, CHEECH + CHONG, FLIP, '96

Tom Penny had amassed a devoted following second to none by the late '90s. His board sold accordingly. As Geoff Rowley explains, "Tom loved Cheech and Chong for obvious reasons. Cheech Marin was rad enough to let us make the board as long as he got some royalties." It came out in '96 and is still one of Flip's bestselling models today.

CHAD MUSKA, SHORTY'S, HEADPHONES, '97

The idea of skateboarding superstars tied to their board graphics became somewhat of a rarity by '97. However, as Rick Kosick stated at the time, "Chad Muska was the Christian Hosoi of the '90s." His iconic first Shorty's Headphones model and later Rising Sun tribute board took Shorty's from a small Santa Barbara bolts operation to leading international board brand.

BAM MARGERA, ELEMENT, '02

After MTV's first run of *Jackass* ('00 – '02), then on through *Viva La Bam* ('03 – '06) along with multiple movies/music projects, Bam's HIM "Heartagram" board picked up enough mainstream appeal to reach sales levels not seen since the '80s. Along with Tony Hawk's Birdhouse models following his run of video games ('99 – present), Bam's board proved the worldwide bestseller wasn't down for the count.

** The major factors in the decline of big-selling pro models after '89 were the rise of shop, logo boards, and blanks, the massive proliferation of brands and pros, and vastly shorter runs of each board/graphic released.*

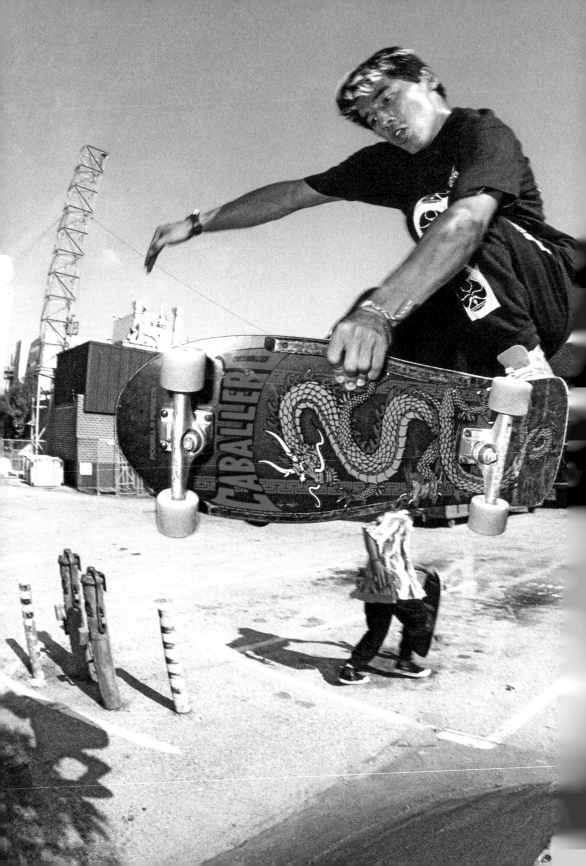

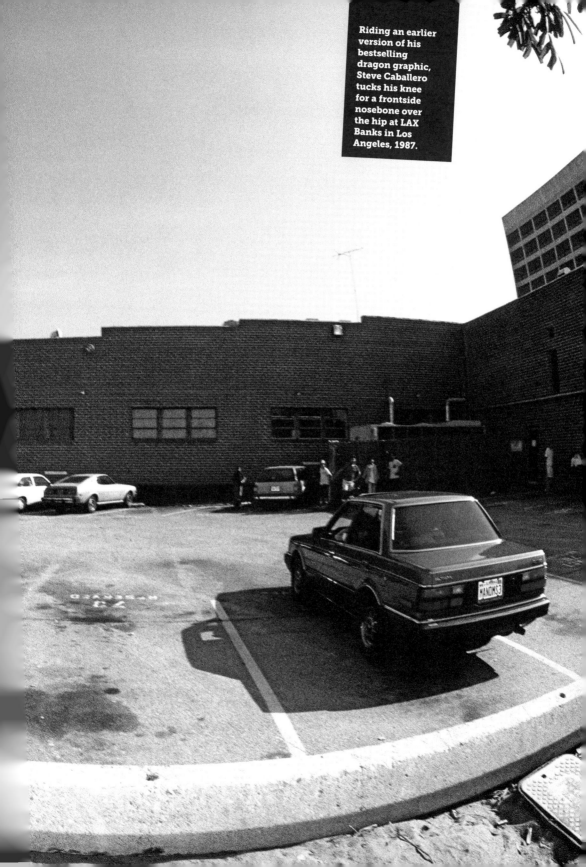

Riding an earlier version of his bestselling dragon graphic, Steve Caballero tucks his knee for a frontside nosebone over the hip at LAX Banks in Los Angeles, 1987.

EVOLUTION OF BOARD SHAPES

AT SOME POINT DURING THE '50s, KIDS BEGAN NAILING ROLLER-SKATE WHEELS TO 2-BY-4 PLANKS. AS THE POPULARITY OF "SIDEWALK SURFING" SKYROCKETED IN THE EARLY '60s, THE FIRST MANUFACTURED SKATEBOARDS APPEARED, THEIR "BANANA" SHAPES NOT FAR REMOVED FROM THE 2-BY-4 PLANKS THAT SPAWNED THEM.

Due to the harsh ride of clay wheels, and nationwide bans, skateboarding was officially dead from '66 to around '73, when Cadillac Wheels unleashed urethane. Board shapes and construction during the second boom varied. Logan Earth Ski achieved huge success with the solid wood diamond tail, while G&S experimented with fiberglass compounds. Meanwhile, around the same time, Tracker Trucks set the standard four-hole pattern for mounting trucks. With the onslaught of vertical terrain, boards were growing wider. This peaked at the turn of the decade as both Dogtown and Alva arrived at what came to be known as the "Pig," a 10 in monster board with little to no shape. By '83, wide boards had become the standard and had begun to redevelop some distinct shaping including tailcuts and the fishtail. Unfortunately, by then skateboarding was back in a slump.

The mid-to-late '80s would become the pinnacle of board shape experimentation. By '86, with the advent of street skating and a new boom about to ignite worldwide, the once standard oval Pig board had all but disappeared. The release of the Hosoi Hammerhead in '86 took the skateboard world by storm. Immediately following its release, every pro hoping to eat needed a signature shape that would differentiate their model from the rest. While the Hammerhead's intentions had been mainly based on function, fashion quickly became the driving force behind other skateboard shapes. A rush by manufacturers and professionals alike to outdo each other ultimately resulted in some of the least functional, albeit cool-looking, skateboards ever made. The string of unique shapes during the late '80s culminated with the crown prince of nonfunctional boards, and possibly the least skateable skateboard ever made, the notorious Misfits Coffin board from Plan 9. As the decade neared its end, street skating began shifting focus away from the vert superstars and placing a newfound emphasis on trick difficulty. As a result, functionality once again became the main concern for manufacturers. Within a year, simplicity was cool again and the final leg in skateboarding's path to the present was underway.

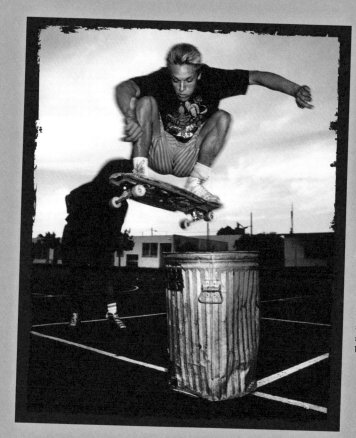

Natas Kaupas ollies a trash can in 1987, resetting what is possible on a skateboard and simultaneously pushing manufacturers to make lighter, smaller boards suited for tricks like this one.

By late '89, street skating had all but eclipsed vert skating as skateboarding's primary terrain. With the introduction of switchstance skating and noseslide combos, bigger and steeper noses became a must. Manufacturers began drilling second sets of bolt holes for an optional extra inch. However, a longer nose also meant a shorter wheelbase. Switch skating and the '89 Vallely Barnyard board brought into question the need for a nose and tail altogether. Meanwhile, Venture's introduction of the six-hole truck in '92, which ensured bolt-free noseslides, set the standard for the smaller modern four-hole pattern. By '93, manufacturers had settled on a rounder version of the '89 double kick boards. To facilitate the ridiculous flip tricks being attempted at the time, skateboards, along with wheels, began to once again shrink in width. During that period, skateboarding would also suffer through a short stint of "everslick." The ultra-skinny Popsicle board peaked around '95 at close to 6 ½ in. wide. In the late '90s, boards grew back up to around 8 in. and rediscovered a blunter, wider nose. Since then, skateboard dimensions have stabilized at around 8.25 x 31 in; wheels are back up to around 54 mm. Over the past decade, "shaped" or non-symmetrical boards with different noses and tails have staged a comeback through companies like Welcome, Polar, Dear, and also reissued classic boards from brands like Powell and Santa Cruz. Today almost anything goes.

'40S–'50S

The earliest skateboards were
mostly homemade using 2-by-4 planks
and roller-skate wheels.

'50S–'60S

By the late '50s most boards were
still homemade but began to take
on surfboard shapes.

EARLY '60S

The first manufactured
skateboards are released and shaped
like surfboards.

LATE '70S

Boards continue to grow in size
as vertical skateboarding becomes
dominant.

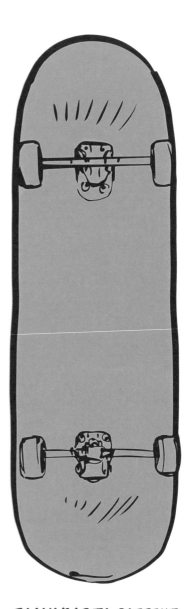

LATE '80S

Boards peak in width at around 10 inches and still have a nose and tail.

EARLY '90S TO PRESENT

Boards take on the asymmetrical "popsicle" shape with near identical nose and tail and settle at a width of about 8 inches.

"WE USED TO CALL THE GROOVES IN THE SIDE
OF THE BOARD 'MONEY BUMPS' BECAUSE THOSE SHAPES
ALWAYS SOLD BETTER. THAT WAS WHAT
DIFFERENTIATED YOU IN THE '80S FROM THE OTHER PROS
AT THE CONTEST. IT WAS THE MONEY BUMPS
AND THE DIAMOND TAIL. THE COLORS AND SHAPES
WERE ALL OVER THE MAP. WE WERE JUST EXPERIMENTING.
EVENTUALLY THEY JUST FOUND THE MOST
EFFICIENT WAY TO MAKE A SKATEBOARD."

John Thomas on '80s Alva shapes

ICONIC ARTISTS

SINCE THE FIRST MASS-PRODUCED SKATEBOARD (AND EVEN
BEFORE), THE ARTWORK ON THE DECKS (AND WHEELS) HAS BEEN
ALMOST AS IMPORTANT AS THE PRODUCT. ICONIC ARTISTS HAVE
EMERGED AS KEY CULTURAL DRIVERS DATING BACK TO THE HOBIE
AND MAKAHA BRANDS ('60s).

For sake of simplicity and to skip the surf-bred era, we can start mentioning names around the time of Zephyr with CR Stecyk III and Jeff Ho all but creating the skateboarder's artistic DNA. Simultaneously, artists like Wes Humpston (Bulldog, Dogtown, SMA, etc.) and Jim Phillips (Independent, Santa Cruz, Speed Wheels, and more) emerged by the late '70s as icons while skate graphics grew more and more ornate—covering the full board bottom by the early '80s.

Competing with Jim Phillips's iconic run of '80s boards, Vernon Courtlandt Johnson (VCJ) at Powell Peralta and Brian Schroeder aka "Pushead" at Zorlac created some of the most treasured board graphics ever through that decade and the turn of the 1990s. Around '91, VCJ left Powell and his replacement Sean Cliver was stolen away (along with a giant chunk of market share) by Steve Rocco at his World Industries empire. Quickly, Cliver and artist Marc McKee took the helm and their string of influential graphics for World, Blind, 101, Liberty, Plan B, and Menace defined much of that decade. From the late '90s into the '00s Andy Jenkins aka Mel Bend, Evan Hecox, Mike Leon, and more at Girl and Chocolate's "Art Dump" set much of the graphic tone. Around the same time, Mike Hill, Don Pendleton, and Joe Castrucci created a decade of highly prominent artwork for the brands Alien Workshop and Habitat in Ohio.

Beyond professional artists and art departments, professional skaters themselves have at times created their own graphics—sometimes creating careers and influence equal to or greater than their skating. Beginning arguably with Neil Blender, whose graphics for his own G&S boards and then later the Alien Workshop remain some of the greatest ever produced, skaters like Mark Gonzales (first through Vision, then through Blind and his current company, Krooked) and later Ed Templeton (through the New Deal, then Toy Machine) have also spanned multiple decades and become revered artists in their own right.

Neil Blender was one of the first pros to create all his own graphics and influenced many others to do the same. Frontside ollie on his Gordon & Smith Rocking Dog graphic. Del Mar Skate Ranch, 1986.

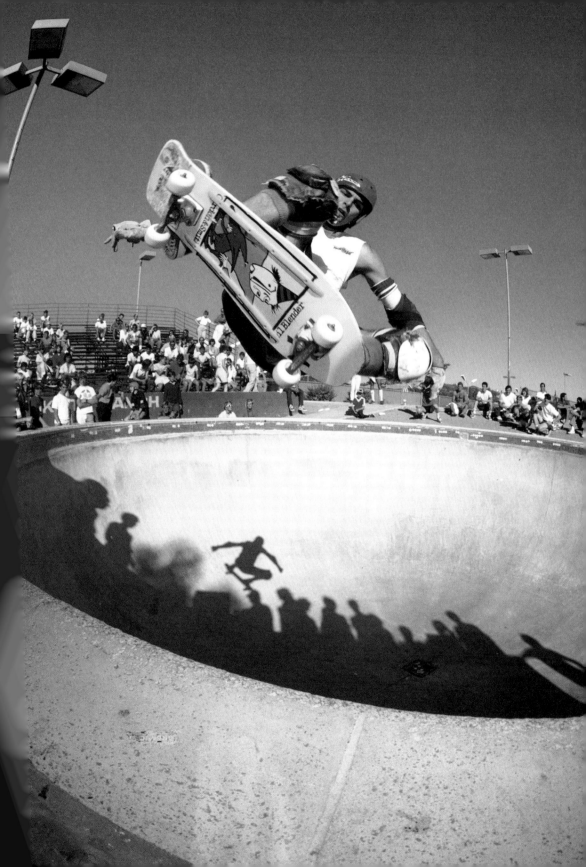

DOGTOWN
Bigfoot
by Wes Humpston,
1978

POWELL PERALTA
Alan Gelfand,
Ollie Tank by VCJ,
1980

POWELL PERALTA
Tony Hawk,
Iron Cross by VCJ,
1983

ZORLAC
Double Cut,
Team Deck, by Pushead,
1984

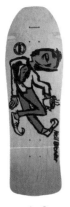

G+S
Neil Blender,
Coffee Break by Blender,
1986

G+S
Neil Blender,
Picasso by Blender,
1987

VISION
Mark Gonzales,
Coloring Board by Gonz,
1987

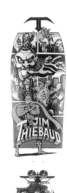

**SANTA MONICA
AIRLINES**
Jim Thiebaud, Joker
by Jim Phillips, 1989

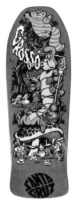

SANTA CRUZ
Jeff Grosso,
Alice in Wonderland
by Jim Phillips, 1989

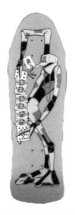

POWELL PERALTA
Ray Barbee,
Ragdoll by Sean Cliver,
1989

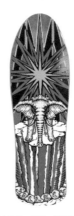

WORLD INDUSTRIES
Mike Vallely,
Elephant 2 by Marc McKee,
1989

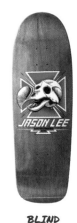

BLIND
Jason Lee,
Dodo by Marc McK
1991

101
Natas Kaupas,
Crack Pipe [2]
by Andy Jenkins, 1991

WORLD INDUSTRIES
Hail to the Chief
by Marc McKee,
1996

GIRL
Rick Howard,
Dick by Andy Jenkins,
1996

ANTI HERO
Sean Young,
Seal Boy by Todd Francis,
1997

TOY MACHINE
Ed Templeton,
Girl in Bra
by Ed Templeton, 1999

ALIEN WORKSHOP
Heath Kirchart,
Enlightened Series
by Don Pendleton, 2002

RASA LIBRE
Reese Forbes,
Zebra Stripes
by Mike Leon, 2003

KROOKED
Chad Muska,
Guest Series by Gonz,
2006

CLICHÉ
American Icons 2
Marc McKee, 2010

ALIEN WORKSHOP
Grant Taylor,
Haring by Keith Haring,
2012

STRANGELOVE
Feedback
by Sean Cliver,
2019

KROOKED
Ray Barbee,
Friends Street Shape
by Gonz, 2022

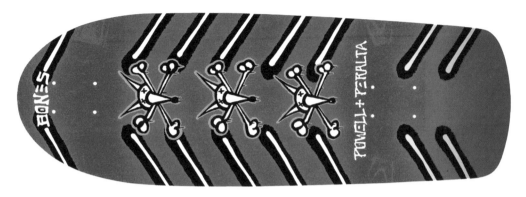

POWELL PERALTA
Rat Bones, Team Deck, by CR Stecyk III,
1980

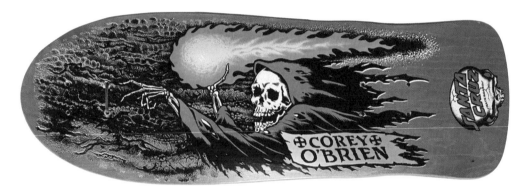

SANTA CRUZ
Corey O'Brien, Reaper by Jim Phillips,
1988

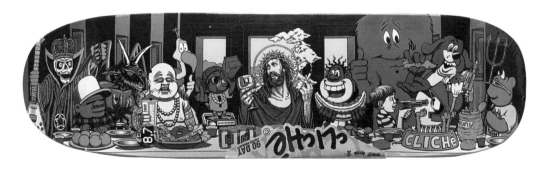

CLICHÉ
Last Supper by Marc Mckee,
2015

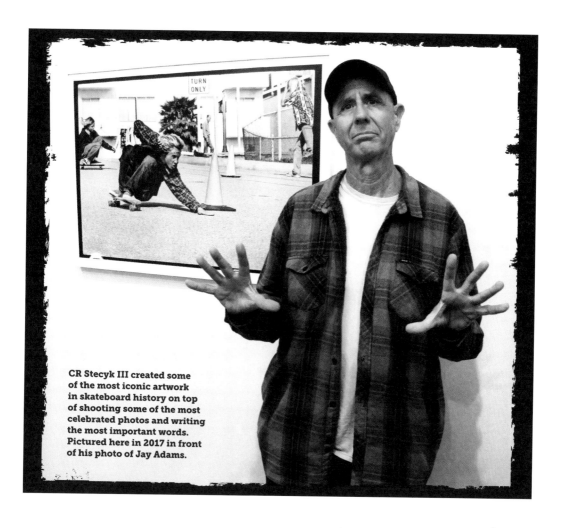

CR Stecyk III created some of the most iconic artwork in skateboard history on top of shooting some of the most celebrated photos and writing the most important words. Pictured here in 2017 in front of his photo of Jay Adams.

"THE ZEPHYR LOGO WAS AN EVOLUTIONARY COLLECTIVE EFFORT. JEFF HO HAND SIGNED HIS SHAPES WITH A CRESCENT MOON. DALE MCLEOD AND I EACH SILKSCREENED SOME BOARD LAMINATES THAT REFERENCED THAT. I CUT A STYLIZED STENCIL VERSION OUT ONE DAY AND SPRAYED IT ON A BOARD WITH A TRANSPARENT AUTOMOTIVE PAINT."

CR Stecyk III on creating the Zephyr logo in the '70s

CONTROVERSIAL GRAPHICS

SKATEBOARDERS AND THE COUNTERCULTURE THEY EMBODY HAVE RARELY SHIED AWAY FROM PUSHING BOUNDARIES. BOARD GRAPHICS HAVE BEEN NO DIFFERENT.

While the '70s saw the introduction of more elaborate graphics and perhaps some controversial elements like the Dogtown "Vato" writing or the Independent Maltese Cross ('78), and the '80s were mostly full of skulls, snakes, and daggers—it was not until around 1990/91 during the industry slump that resulted in skateboarding going underground again that board graphics truly pushed shock value to the limit. Marc McKee's full-frontal-nudity graphic for World Industries pro Randy Colvin in '91 set the bar as high (or as low) as it could get. So much so that skateshops demanded the boards be kept in giant plastic bags, which McKee and owner Rocco then famously added stickers to stating "Warning: Censorship is weak as fuck".

Colvin's board kicked off a string of what today are deemed the most controversial graphics to date. On top of a masturbating girl (McKee has since explained he copied the image from a centerfold in Penthouse), Rocco owned companies released boards with crack pipes (Natas 101 by Andy Jenkins, '91), Satan (Natas 101 by McKee '91), blatant racial stereotypes ("Napping Negro" Jovontae Turner World by McKee '92), accidental gun deaths (Guy Mariano Blind by McKee '92), and even a board that came with your first cigarette and matches (Ronnie Bertino "Mr. Butts" Blind by Cliver '93).

Since the golden age of controversial graphics in the early '90s the industry has toned down for the most part (generally for the sake of sales) as skateboarding again grew in popularity over the course of the late '90s, '00s, and '10s. Although more recently, boards like the Polar's "Rollerblade Guillotine" graphics (Hjalte Halberg Polar Chop Chop '12) and some of Fucking Awesome's artwork (See the Jason Dill 911 Holographic board '16) have reprised some of the more shocking/controversial themes to keep skateboarding safely unsafe.

❝ NATAS DID A BOARD WITH THE SPACE SHUTTLE BLOWING UP THAT SAID "OOPS." GONZ ONCE HAND-PAINTED HUNDREDS OF INDIVIDUAL BOARDS. WE HAD BOARDS THAT HAD FREE CIGARETTES. PICTURES OF NAKED LADIES. CRACK PIPES. COPYRIGHT INFRINGEMENT. LOTTERY TICKETS. AND EVEN POLITICAL COMMENTARY. WE RIDICULED EVERYTHING UNDER THE SUN. ESPECIALLY OURSELVES. ❞

STEVE ROCCO

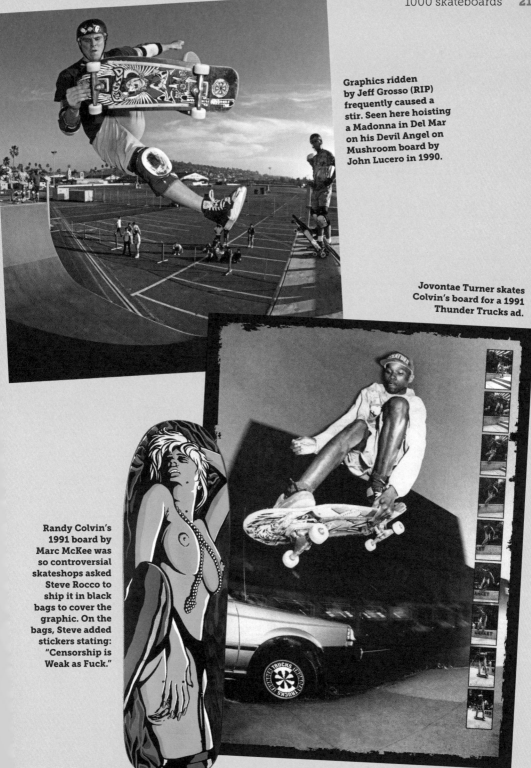

Graphics ridden by Jeff Grosso (RIP) frequently caused a stir. Seen here hoisting a Madonna in Del Mar on his Devil Angel on Mushroom board by John Lucero in 1990.

Jovontae Turner skates Colvin's board for a 1991 Thunder Trucks ad.

Randy Colvin's 1991 board by Marc McKee was so controversial skateshops asked Steve Rocco to ship it in black bags to cover the graphic. On the bags, Steve added stickers stating: "Censorship is Weak as Fuck."

QUOTABLE BOARDS

PROFESSIONAL SKATEBOARDERS HAVE CONSISTENTLY BEEN OUTSPOKEN AND STRONGLY OPINIONATED—EVEN IF THEY ARE NOT DIRECTLY PAID TO TALK. HERE ARE SOME MEMORABLE SIGNATURE BOARDS THROUGH THE YEARS AND QUOTES FROM THE PROS THAT HAD THEIR NAMES ON THEM.

All quotes from my articles in *Transworld* and *Skateboarder* ('01–'22)

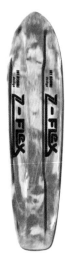

Z-FLEX: JAY ADAMS, MULTI-COLOR, 1974

❝ FOR ME AND MY GENERATION. OUR PARENTS WERE FROM THE '60S SO DRUGS WERE A BIG PART OF EVERYTHING. FOR THE DOGTOWNERS IT WAS LIKE IF YOU DIDN'T DO DRUGS. YOU COULDN'T EVEN HANG OUT. THERE WERE GUYS THAT DIDN'T DO DRUGS BUT TO US THEY WERE JUST SQUARE. ❞

JAY ADAMS

POWELL PERALTA: TOMMY GUERRERO, V-8 DAGGER, 1984

❝ THE DAGGER WAS ACTUALLY ON THE FRONT GRILL OF A '30S OR '40S FORD COUPE. THE CENTERPIECE WAS A FISHEYE PHOTO OF THE GRILL AND UP TOP IT HAD THE V8 EMBLEM. BASICALLY. WE HAD A ROUGH VERSION THAT I GAVE TO KEVIN ANCELL, WHO DID MY VERY FIRST GRAPHIC. HE DIMINISHED IT TO JUST THE DAGGER WITH ROSES AROUND IT BUT IT STILL HAD THE V8 IN THERE. ❞

TOMMY GUERRERO

VISION: MARK GONZALES, 1, 1985

" SOMETIMES I THINK MY MEMORIES OF THE '80S ARE SHOT BECAUSE I HIT MY HEAD. JOE JOHNSON RECENTLY ASKED ME, 'MARK . . . YOU DO REMEMBER YOU HIT YOUR HEAD WHEN YOU WERE TRYING TO DO A 360 FRONTSIDE INVERT?' I GO. 'OH YEAH. I DO REMEMBER. I'VE GOT PHOTOS.' I HARDLY EVER USED MY CANNON SURE SHOT UNTIL I BANGED MY HEAD. AND I TOOK PHOTOS OF LIKE RANDOM SHIT AFTER I HAD HIT MY HEAD.' MAYBE THAT'S WHAT HAPPENED. "

MARK GONZALES

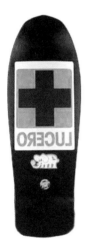

SANTA CRUZ: JOHN LUCERO, RED CROSS, 1988

" I WANTED TO PUT OUT A SLIGHTLY LARGER BOARD UNDER SCHMITT STIX WITH THE RED CROSS GRAPHICS ON IT. FOR WHATEVER REASON, THEY DIDN'T WANT TO DO IT SO I FIGURED I'D JUST PUT IT OUT ON MY OWN. I LEFT SCHMITT STIX AT THE HEIGHT OF MY CAREER AND STARTED MY OWN COMPANY [FIRST UNDER SANTA CRUZ, THEN AS BLACK LABEL]. AND, SINCE THEN, I HAVEN'T HAD ANY MONEY. "

JOHN LUCERO

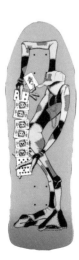

POWELL PERALTA: RAY BARBEE, RAGDOLL BY SEAN CLIVER, 1989

" AFTER ANIMAL CHIN, STACY [PERALTA] WAS ALREADY KIND OF WAITING FOR THE NEXT DEAL. SO WHEN STREET CAME IN—I THINK HE SAW THAT AS IT. HE COULD SEE WHAT IT WAS GOING TO BECOME. I REMEMBER HIM PUSHING OTHER VERT BOARDS ASIDE TO RELEASE MY FIRST BOARD. "

RAY BARBEE

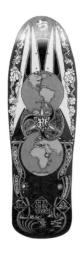

WORLD INDUSTRIES: JEF HARTSEL, GLOBES, 1989

❝ PEOPLE KIND OF TRIP ON ME SOMETIMES. LIKE. 'MAN.
YOU WENT FROM PUNK TO RASTA.' I'M LIKE ALWAYS LIKE.
'DUDE. IT'S ALL REBEL MUSIC.' REGGAE IS TOTALLY
ANTI-GOVERNMENT. ANTI-ESTABLISHMENT. ❞

<div align="right">

JEF HARTSEL

</div>

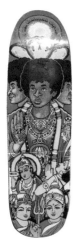

WORLD INDUSTRIES: RON CHATMAN, EXPERIENCE, 1990

❝ I WAS CONSIDERED A WHITE BOY BECAUSE I SKATED—BUT
I STILL SKATED BECAUSE I LOVED IT. AND IT WAS PROBABLY
THE BEST TIME OF MY LIFE. I WAS A SPONSORED SKATER
KID THAT BY SIXTEEN WANTED TO DROP OUT OF SCHOOL
AND TAKE THE GED. JUST TO SKATE. ❞

<div align="right">

RON CHATMAN

</div>

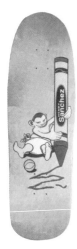

REAL: HENRY SANCHEZ, CRAYON, 1991

❝ I WAS APPROACHED BY JIM [THIEBAUD] OR JEFF [KLINDT]
ABOUT BEING A PRO FOR REAL. I COULDN'T BELIEVE IT.
IN HINDSIGHT. I DESERVED IT BUT NO ONE KNEW WHO I WAS
SO IN TERMS OF SELLING MY BOARD IT PROBABLY DIDN'T
DO SO WELL. ❞

<div align="right">

HENRY SANCHEZ

</div>

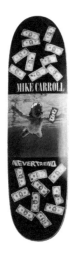

PLAN B: MIKE CARROLL, NEVERTREND, 1992

❝ WHEN PLAN B STARTED WE KNEW IT WOULD BE SO MUCH BETTER [THAN H-STREET] BECAUSE THEY [ROCCO'S COMPANIES] HAD SUCH GOOD GRAPHICS AND CONCAVES. AFTER QUESTIONABLE CAME OUT PEOPLE WERE TRYING TO SAY WE WERE LIKE THE NEW BONES BRIGADE AND THIS AND THAT. THAT STARTED TO GET TO MY HEAD. ❞

MIKE CARROLL

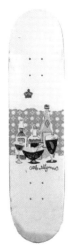

STEREO: CARL SHIPMAN, BAR BY TODD FRANCIS, 1995

❝ JASON LEE CAME UP TO ME AT MÜNSTER IN '93 AND TOLD ME. 'LOOK. I'D BE STOKED IF YOU'D COME RIDE FOR STEREO.' HE TOLD ME ABOUT THE COMPANY HE AND CHRIS [PASTRAS] WERE PUTTING TOGETHER—WHAT THEY WERE ABOUT. THE WHOLE VIBE SOUNDED ABSOLUTELY AMAZING—IT JUST APPEALED. ❞

CARL SHIPMAN

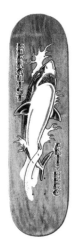

ANTI HERO: BOB BURNQUIST, SHARK BY JEF WHITEHEAD, 1996

❝ MY BEST MEMORIES OF THE ANTI HERO DAYS ARE TRAVELING WITH [JOHN] CARDIEL AND JULIEN [STRANGER]. I THINK WE DID 56 PARKS IN 19 DAYS. JUST SLEEPING IN BOWLS—WATCHING THE STARS AND WAKING UP TO SKATE. ❞

BOB BURNQUIST

CHOCOLATE: MIKE YORK, POW BY EVAN HECOX, 1997

❝ THOSE GUYS WERE TELLING ME ABOUT 'CHOCOLATE POW' MONTHS BEFORE I EVEN GOT ON THE TEAM. I THOUGHT THE WHOLE THING WAS A JOKE. ONCE I GOT ON, THEY'RE TELLING ME THAT I'M GONNA BE DRINKING SOME CHOCOLATE MILK BOTTLE, CRUISING AROUND IN '70S GEAR AT THE BEACH IN SANTA MONICA. ❞

MIKE YORK

TOY MACHINE: ELISSA STEAMER, EXTRA, 2001

❝ I TURNED PRO FOR TOY MACHINE IN MARCH OR APRIL OF '98. SO IT WAS PRETTY QUICK. TWO YEARS. BUT BACK THEN TWO YEARS WAS A LIFETIME. YOU WERE AM FOR TWO YEARS, THEN WOULD TURN PRO. THEN YOU WOULD RETIRE AT LIKE 25. ❞

ELISSA STEAMER

ENJOI: RODNEY MULLEN, BOY GENIUS BY MARC JOHNSON, 2001

❝ THERE WAS JUST AN ERUPTION OF CREATIVITY FROM MARC [JOHNSON] WHEN HE STARTED ENJOI. THAT'S HIS NATURE. AND EACH ONE WAS FUNDAMENTALLY DIFFERENT. GOD. THAT STUFF JUST COMES OUT OF HIM. ❞

RODNEY MULLEN

GIRL: PAUL RODRIGUEZ, OG, 2003

❝ GETTING A BOARD FROM GIRL WAS A DREAM COME TRUE. SKATING WITH [ERIC] KOSTON AFTER GROWING UP WITH HIM BEING MY FAVORITE SKATER WAS AMAZING TOO. AT ONE POINT I WAS ON ALL THE EXACT SAME SPONSORS AS KOSTON AND I WAS SO PSYCHED LIKE, 'MY FAVORITE DUDE HELPED ME OUT AND GOT ME TO WHERE I WANT TO BE.' ❞

PAUL RODRIGUEZ

SANTA CRUZ: ALEX CAROLINO, POWERPLY RETRO SERIES, 2006

❝ I WENT TO SANTA CRUZ AND MET JEFF KENDALL WHEN WE GOT ON. IT'S SUCH A LEGENDARY COMPANY. LATELY, I WATCHED THE THREE FIRST VIDEOS (WHEELS OF FIRE ['86], STREETS ON FIRE ['88], AND SPEED FREAKS ['89]) JUST TO LEARN MORE. ❞

ALEX CAROLINO

CLICHÉ: LUCAS PUIG, FULLY FLARED, 2008

❝ FOR THE PREMIERE OF FULLY FLARED, I HADN'T SEEN ANY OF THE FOOTAGE. YOU WALK INTO THIS GIANT HALL. I DON'T EVEN KNOW HOW MANY PEOPLE WERE THERE. HUNDREDS. YOU SEE YOURSELF ON THAT GIANT SCREEN. IT'S CRAZY. IT WAS EMOTIONAL. I THOUGHT I WAS GOING TO TEAR UP AT PARTS—MARIANO AND MARC JOHNSON. ❞

LUCAS PUIG

FUCKING AWESOME: CHLOE SEVIGNY CLASS SERIES, 2014

❝ I'VE BROUGHT CHLOE [SEVIGNY] ON SESSIONS BEFORE. HER OLDER BROTHER, PAUL, WAS REALLY INTO SKATING AND SHE WAS KIND OF THE YOUNG GIRL THAT WAS LIKE, 'OH, SKATING'S SO COOL!' SO SHE WAS ALWAYS AROUND SKATERS. ❞

ALEX OLSON

BAKER: TRISTAN FUNKHOUSER, CROP CIRCLES, 2022

❝ BAKER IS A FAMILY SO EVERY BOARD MEANS A LOT TO ME. WE'VE BEEN THROUGH SO MUCH AND BEEN EVERYWHERE TOGETHER. ❞

TRISTAN "T-FUNK" FUNKHOUSER

MAGENTA: BEN GORE VISIONS, 2022

❝ BOARD GRAPHICS ARE SORT OF LIKE SKATING: I THINK IT'S GOOD WHEN PEOPLE GET TO EXPERIMENT WITH DIFFERENT THINGS. BEING CREATIVE HAS ALWAYS BEEN A PART OF THE REASON I LOVE MAGENTA. IT SEEMS LIKE THAT GETS LOST A LITTLE SOMETIMES WITH OTHER BRANDS. ❞

BEN GORE

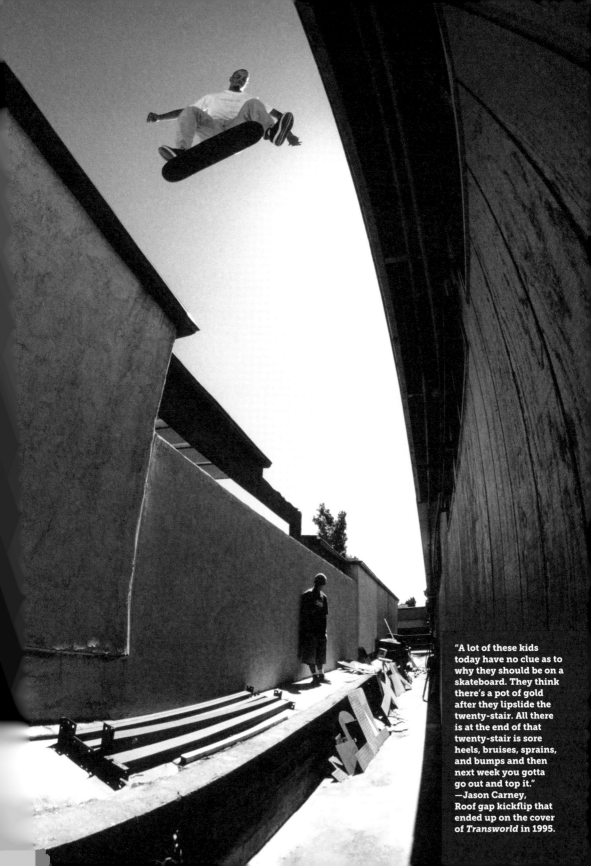

"A lot of these kids today have no clue as to why they should be on a skateboard. They think there's a pot of gold after they lipslide the twenty-stair. All there is at the end of that twenty-stair is sore heels, bruises, sprains, and bumps and then next week you gotta go out and top it."
—Jason Carney,
Roof gap kickflip that ended up on the cover of *Transworld* in 1995.

FAMOUS SKATESHOPS

BRICK-AND-MORTAR SKATESHOPS HAVE BEEN HUGELY INFLUENTIAL IN SPREADING THE PRODUCTS AND CULTURE. FOR MOST SKATEBOARDERS, THEY ARE THE ENTRY POINT TO A WHOLE NEW UNIVERSE—FOREVER TREASURING THAT FIRST EXPERIENCE OF SEEING AN ENTIRE WALL COVERED WITH BOARDS, AND A COUNTER FULL OF MULTICOLORED WHEELS, STICKERS, TRUCKS, AND ACCESSORIES.

Wherever your first experience might have been, that shop will probably always remain sacred to you. For that reason, any attempt to summarize all the "famous" skateshops on the planet will always be incomplete, but I'll attempt to at least hit some of the broad strokes.

By most accounts the first official professional skateshop in the world was Val Surf—opened on Oct 6, 1962, in North Hollywood and still open to this day, now with four locations throughout the LA area. Prior to Val Surf, shops like Greg Noll's Surf Shop in Hermosa Beach lay claim to selling skateboards in the '50s but that predated mass-produced boards. After Val Surf, the Zephyr Shop in Santa Monica (opened in '71) quickly became the most famous shop on the planet with the best team of that generation (the Z-Boys). After the Zephyr Shop was converted back to a surf shop (Horizons West) in '77, Skateboard City in West LA briefly rose to fame (with riders Jay Adams, Tony Alva, and Peralta) before Rip City Skates in Santa Monica became the most famous skateshop on the Westside from the turn of '80, appearing in the first skate video (*The Bones Brigade Video Show* '84), and it's still open at its original location on Santa Monica Blvd. today.

The world's first skateshop: Val Surf in North Hollywood, 1962.

An ad for SF's Concrete Jungle featuring Jake Phelps (RIP), later *Thrasher's* editor-in-chief.

1714 WALLER ST. SAN FRANCISCO CA 94117
(415) 751 8829 / SKATE SHOP (415) 386 0188

"FOR ME. THE SKATE SHOP IS THE ROOT OF A CITY'S SKATE CULTURE: IT BRINGS PEOPLE TOGETHER. SKATESHOPS AND THE EVENTS THEY ORGANIZE ARE GREAT FOR LOCAL SKATERS BECAUSE THEY MEET PEOPLE FROM LOTS OF DIFFERENT COUNTRIES."

Sam Partaix

Moving north: San Francisco has housed a number of famous shops as well. Concrete Jungle was a pivotal shop during the early '80s; Skates on Haight and FTC (Free Trade Center) emerged in the late '80s to become two of the most revered shops on the planet. FTC today has five locations including SF, Tokyo, and Barcelona. In Philadelphia, Sub Zero Skateshop had a massive impact on skateboarding worldwide with its influential team and videos during the '90s. In New York, it would be impossible not to mention Supreme, launched in '94 on Lafayette Street by James Jebbia and sold to VF Corp., as a global collection of 12 stores worldwide (NY, Tokyo, London, Paris, LA, etc.) and as one of the largest brands on the planet, for $2.1 billion in '20.

International skateshops of note (past and present) would include Slam City Skates in London, Hawaii Surf and Street Machine in Paris (also located in San Diego), Session Skateshop in Norway (started in Stavanger and now boasts 8 locations throughout Norway), Antisocial in Vancouver, Titus Skateshops in Germany, and countless others. Support your local skateshop.

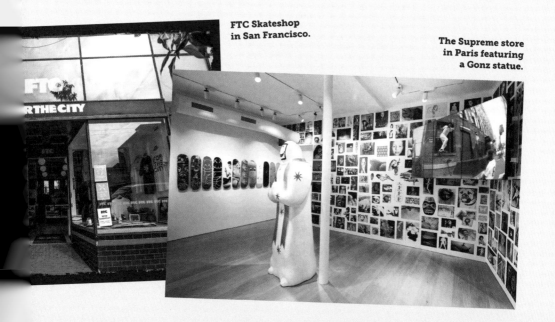

FTC Skateshop in San Francisco.

The Supreme store in Paris featuring a Gonz statue.

SKATE SPOTS OVERVIEW

THE PLACES AND TERRAIN SKATEBOARDERS CHOOSE TO RIDE ARE CALLED "SPOTS." SKATE SPOTS USUALLY EXCLUDE SKATEPARKS AND PLACES BUILT FOR SKATEBOARDING. INSTEAD, THEY ARE LOCATIONS IN THE STREETS, DITCHES, BACKYARD POOLS, PLAZAS, HILLS, AND MORE WHERE A NATURALLY GOOD PLACE TO RIDE HAS BEEN CHOSEN AND NAMED BY SKATERS.

Often spots are kept secret and somewhat guarded so as not to "blow them out." This strain of localism was loosely carried over from surfers at the Southern California pools and schoolyards first skated in the '60s and '70s.

As far as I have been told, one of the first "spots" on the planet was the hill at Pacific Palisades High School in the '60s. From there, the five banked schools in West LA—Paul Revere, Kenter Canyon, Bellagio, Mar Vista, and Brentwood—became the de facto spots in the '70s along with a string of backyard pools and ditches including the Dog Bowl, Gonzales Pool, the Toilet Bowl, Baldy fullpipe in Upland, and infinite others. When street skating gained more traction in the '80s the Venice Pavilion, Brooklyn Banks in NY, and the Embarcadero or EMB in SF took over as skateboarding meccas.

Spots worldwide also gained fame including Southbank in London, the Eiffel Tower banks in Paris aka Les Bassins, MACBA and Sants train station in Barcelona along with more US spots gaining relevance like Love Park in Philadelphia in the '90s, Pier 7 in SF, and Hubba Hideout. Hubba Hideout, a pedestrian bridge (since demolished) with ledges down stairs in San Francisco, named "Hubba" after the crack smokers who dwelled there, went on to become the universal name for any ledge down stairs. For example, even the ledge down the stairs at the Tokyo 2020 Olympics would be called a "Hubba" by skaters.

Skate spots have come and gone as cities have banned skateboarding and "skatestopped" spots or demolished them to keep skateboarders from exploiting them. However, an endless game of cat and mouse exists between skaters who see potential in urban and suburban space not made for them and the authorities, local businesses, and developers who seek to keep them out.

New York's Brooklyn Banks under the Manhattan side of the Brooklyn Bridge have been one of the world's most famous skate spots since the early '80s.

"TWO HUNDRED YEARS OF AMERICAN TECHNOLOGY HAS UNWITTINGLY CREATED A MASSIVE CEMENT PLAYGROUND OF UNLIMITED POTENTIAL. BUT IT WAS THE MINDS OF ELEVEN-YEAR-OLDS THAT COULD SEE THAT POTENTIAL."

CR Stecyk III, *Skateboarder*, Fall 1975

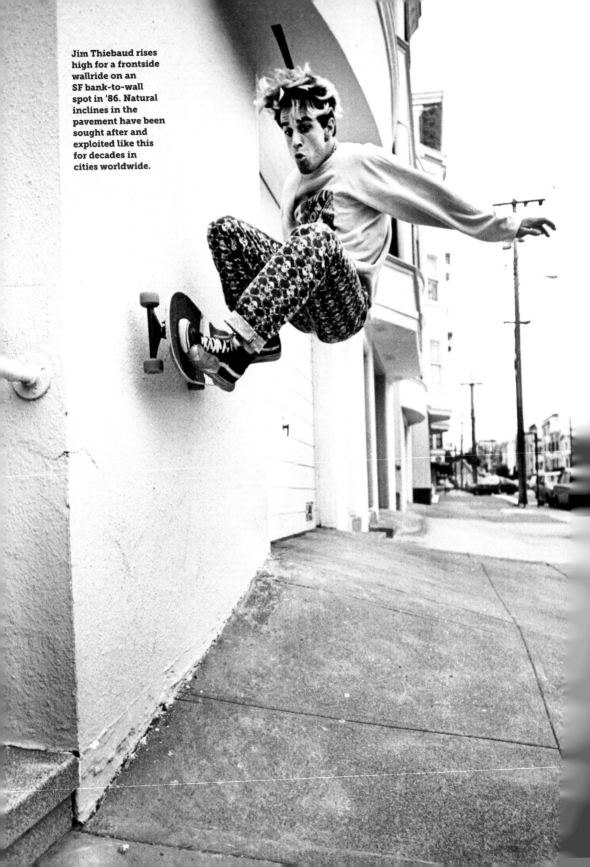

Jim Thiebaud rises high for a frontside wallride on an SF bank-to-wall spot in '86. Natural inclines in the pavement have been sought after and exploited like this for decades in cities worldwide.

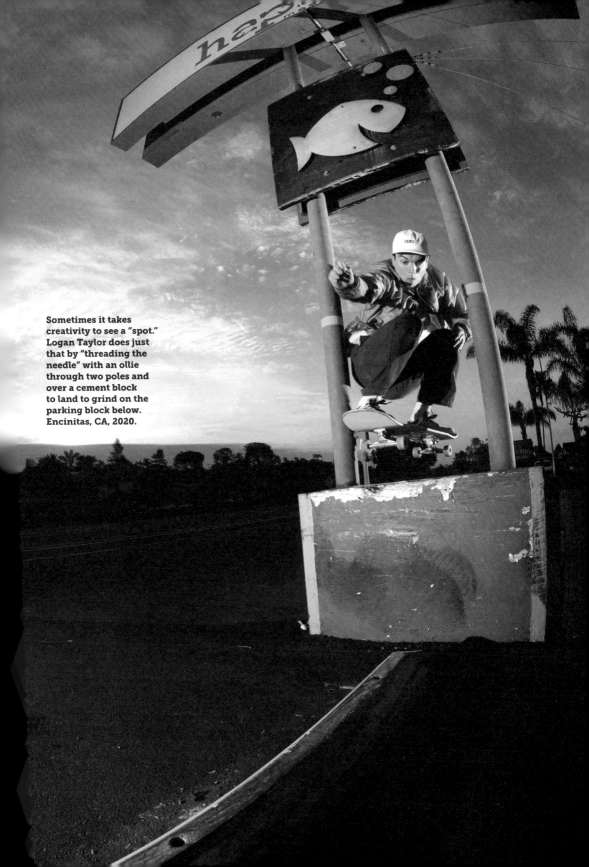

Sometimes it takes creativity to see a "spot." Logan Taylor does just that by "threading the needle" with an ollie through two poles and over a cement block to land to grind on the parking block below. Encinitas, CA, 2020.

HALLOWED GROUNDS

ON RARE OCCASIONS, SKATE SPOTS HAVE BECOME SO LEGENDARY THAT THEY ARE LAUDED AS THE HALLOWED GROUNDS OF SKATE CULTURE.

This may occur with the complete ignorance of mainstream society, as it has for something like the Baldy fullpipe in Upland, CA. First skated in 1969 by Pat Mullis—who according to Upland legend Steve Alba (aka Salba) found the 15-ft. (4.6 m.)-tall, 600-ft. (183 m.)-long water drainage tube—the Baldy fullpipe was one of the first vertical terrains ever ridden and became the template for the Pipeline Skatepark fullpipe and countless others since. Still skateable in 2022 and still illegal (the pipe is part of what is officially called the San Antonio Dam), it remains one of skateboarding's holiest sites.

More recent hallowed grounds include the aforementioned Embarcadero in San Francisco, also sometimes called EMB (this was actually the name of the crew who skated the plaza— "Embarco's Most Blunted"). If any single spot could be deemed the petri dish for modern street skating, the red brick surface of the Embarcadero Plaza (officially named Justin Herman Plaza until 2017) and its Vaillancourt Fountain would be it.

Although nearly completely remodeled around 2000 when the benches (famously called the "C-Block" by skaters) and transitioned sidewalls (containing the legendary "Gonz Gap") were removed, the plaza was first skated in the late '70s but truly became iconic in '86 when Mark Gonzales ollied from the sidewall to the elevated stairs, christening the first "gap" known worldwide. This later led to innovators like Mike Carroll, Henry Sanchez, Jovontae Turner, and others all but inventing present-day street skating on the benches, stairs, curbs, and gaps there over the course of 1990–92 and documenting it in videos like *Questionable*, *Tim and Henry's Pack of Lies*, and *Love Child*.

Hallowed skate grounds exist worldwide in 2022 and I have spent the past decade catering an Instagram hashtag called #skatenerdstarmaps receiving and documenting recent as well as long-forgotten spots. I currently have over 1500 locations recorded.

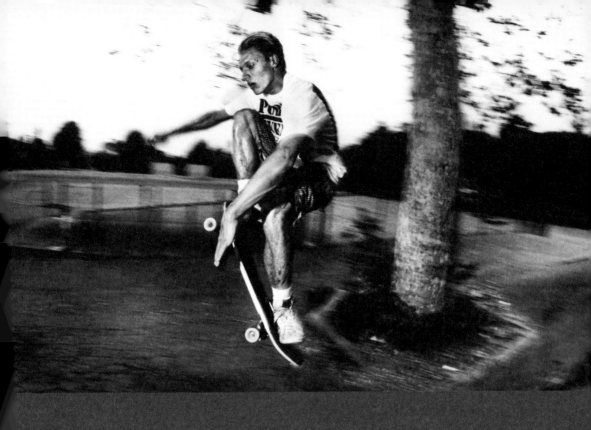

"BASICALLY, WHAT SKATEBOARDERS ARE TRYING TO SAY IS THAT NOBODY REALLY OWNS PROPERTY. WE ALL KIND OF SHARE IT. YOU TAKE A PIECE OF GRANITE OUT OF THE EARTH AND MAKE IT INTO SOMETHING TO SIT ON (A BENCH), AND IT MAKES YOUR BUSINESS MONEY——BUT YOU DON'T ACTUALLY OWN THAT ROCK. I THINK THE MESSAGE OF SKATEBOARDERS IS THAT NOBODY OWNS ANY OF IT. WHEN YOU USE IT, YOU BECOME A PART OF IT. YOU HEIGHTEN YOUR SENSE OF AWARENESS TO REALITY. AND THAT'S WHAT GIVES SKATEBOARDERS THEIR LEG UP AND AN ADVANTAGE. THAT'S WHAT SHOULD GIVE SKATEBOARDERS THEIR MOTIVATION."

Jake Johnson

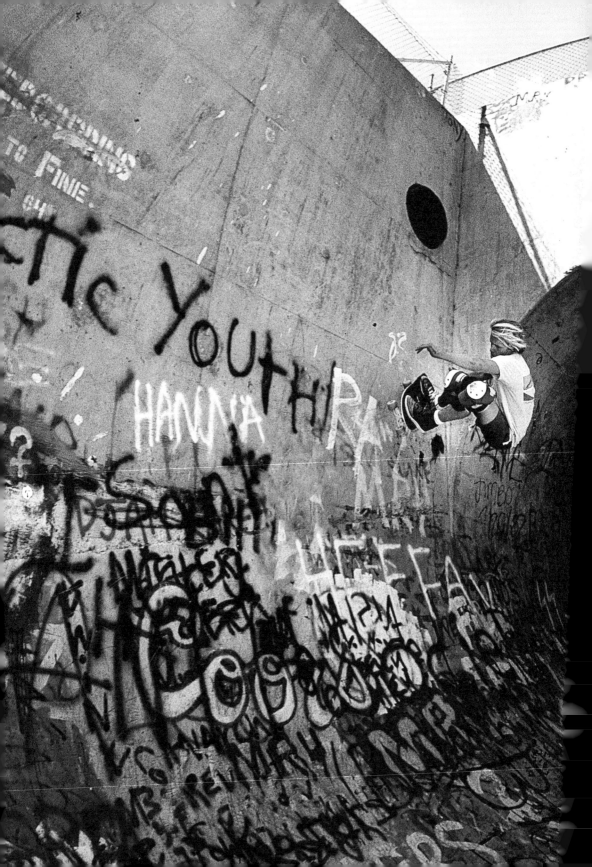

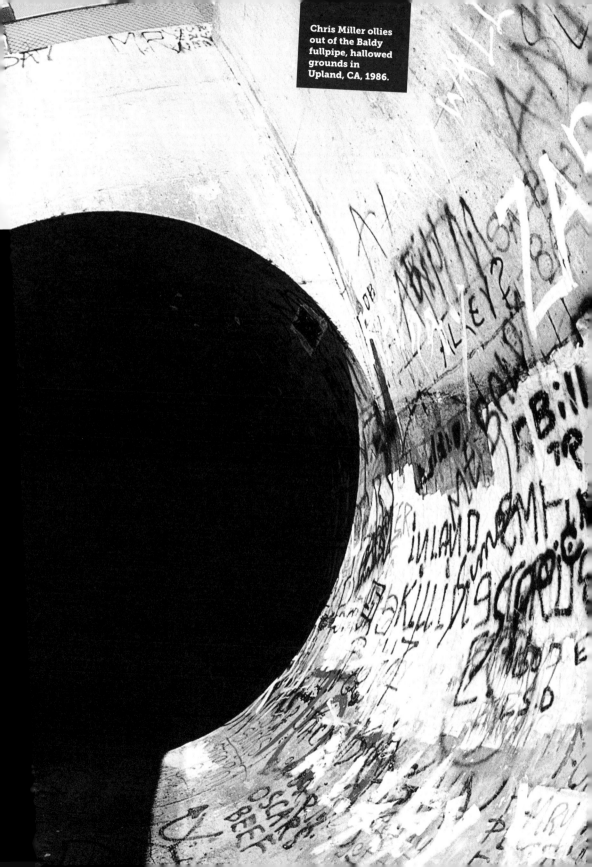
Chris Miller ollies out of the Baldy fullpipe, hallowed grounds in Upland, CA, 1986.

FAMOUS SKATEPARKS

THE WORLD'S FIRST OFFICIAL SKATEBOARD PARK, SURF CITY, OPENED IN TUCSON, ARIZONA, IN SEPTEMBER OF 1965. SINCE THEN, THE IDEA OF RAMPS, CEMENT PARKS, WAREHOUSES, AND PLAZAS OFFICIALLY DESIGNATED FOR SKATEBOARDING HAS EBBED-AND-FLOWED IN ALMOST EVERY CITY AND TOWN ON THE PLANET, FOR THE MOST PART RISING AND FALLING WITH THE PASTIME'S POPULARITY.

Some of the most famous skateparks hail from the '70s with the first explosion of commercial outdoor (mostly cement) facilities. Carlsbad Skatepark, north of San Diego, was the first skatepark in California, opened in March 1976, and would later also be the location of (Mike) McGill's Skatepark—built on the remnants of its bowls during the late '80s and early '90s. Today both are gone. Kona Skatepark in Jacksonville, Florida, was built in '77 and remains the longest-running private skatepark in the world.

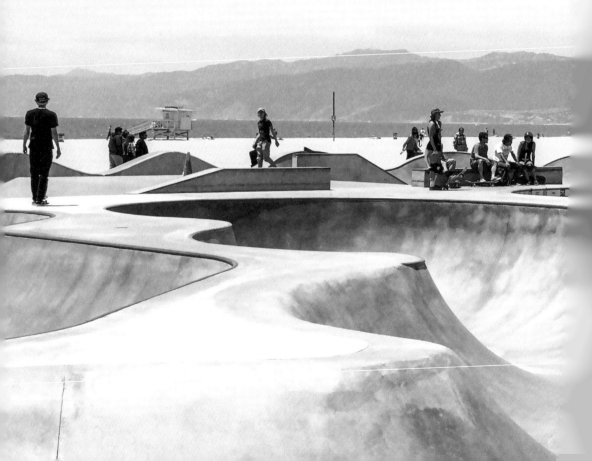

On the non-private side, Derby Skatepark in Santa Cruz, opened in '76, is one of the longest-operating (and most famous) public parks. Meanwhile, Pipeline Skatepark in Upland (with the Baldy fullpipe–inspired feature), Del Mar Skate Ranch in North San Diego County, and Marina Del Rey Skatepark in Los Angeles (with the replica Dog Bowl) are arguably three of the most influential and best-known skateparks of all time for their role in defining vertical skateboarding even if all three were demolished by the early to mid-'80s.

Present-day famous public and commercial (non-DIY) skateparks would include the Black Pearl in the Cayman Islands, the largest skatepark in the western hemisphere when it was built in '05; Venice Beach Skatepark, opened in the heart of Dogtown in '09; the Berrics and Stoner Plaza in LA; the Skatepark of Tampa; Prado Skatepark in Marseilles; Oslo Skatehall in Norway; and too many others to list.

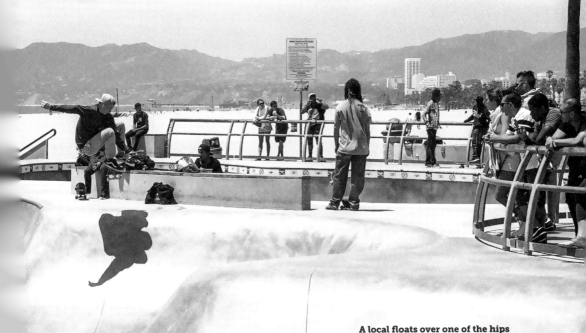

A local floats over one of the hips in the Venice Skatepark snakerun. The park was built in '09 near the former location of the Venice Pavilion, one of the centers of the skateboard universe since the '70s.

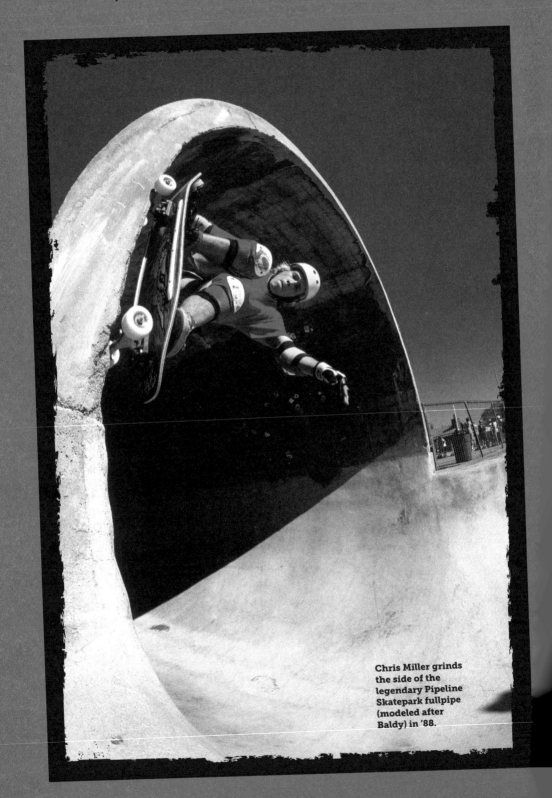

Chris Miller grinds the side of the legendary Pipeline Skatepark fullpipe (modeled after Baldy) in '88.

Salba gets up to the over-vert in the same pipe in '89. The entire skatepark was his kingdom.

"I WAS AT UPLAND [PIPELINE SKATEPARK] ON OPENING DAY IN 1977 AND ALL THE WAY THROUGH THE END OF IT. THE ORIGINAL UPLAND COMBI WAS TOTALLY RAD. IT WAS A RAD TRAINING GROUND. UPLAND WAS THE PIPELINE OF SKATEBOARDING. IT WAS THE MOST HECTIC PLATFORM."

Steve "Salba" Alba

HISTORY OF CONTESTS

CONTESTS HAVE REMAINED A SOMEWHAT CONTROVERSIAL TOPIC WITHIN SKATEBOARDING, WITH THE CORE OF THE CULTURE PERSISTENTLY REJECTING COMPETITION AND WHAT THEY VIEW AS A "JOCK" MENTALITY. STILL, ORGANIZED CONTESTS HAVE HISTORICALLY BEEN CENTRAL TO THE PASTIME'S TECHNICAL INNOVATIONS (OFTEN UNVEILED AT SUCH EVENTS) AND THE MAIN MEANS OF PRESENTING AND PROMOTING SKATEBOARDING TO THE MAINSTREAM, AS WELL AS SIMPLY A GOOD EXCUSE FOR EVERYBODY TO COME TOGETHER AND SKATE.

The first official contest was organized by Makaha in August 1963 on the parking lot of the Pier Avenue Junior High School in Redondo Beach, California. By '65 the first National Skateboarding Championships were held in Anaheim and broadcast on ABC. After the late '60s slump and return in the '70s, contests returned notably with the '75 Del Mar Nationals where the Z-Boys famously made their debut.

During the '80s, the NSA-organized contest series saw the unveiling of landmark tricks like Mike McGill's McTwist at Del Mar in '84 and Tony Hawk's 720 only a year later. Annual contests like Titus's Müenster Championships in Germany became staples on the pro circuit and created a pretext for almost all of the industry to head to Europe each summer. Contests would also long serve as the way for an amateur skateboarder to officially turn "pro" (in addition to getting a signature model deck) simply by registering as one for a major event.

At the 1999 X-Games Best Trick Contest, Tony Hawk famously unveiled the 900 on live television and congruently—with the rise of the X-Games and launch of Street League in 2010—mass-market skate contests would ultimately result in skateboarding becoming an Olympic sport for the Tokyo 2020 Summer Games (delayed until 2021 due to COVID-19).

❝ THE DIFFERENCE BETWEEN CONTESTS NOW AND BACK IN THE DAY IS THAT NOW THERE ARE A GROUP OF CONTEST SKATERS THAT ARE REALLY GOOD AT IT AND THEY ARE THE ONLY GUYS WHO ENTER AND WIN. BACK WHEN I SKATED THEM [MID-'90S], IT WASN'T LIKE THAT. BACK THEN, GUYS LIKE KAREEM [CAMPBELL], ED TEMPLETON, ETHAN FOWLER, OR [TOM] PENNY AND OTHER GUYS LIKE THAT WOULD WIN THEM. ❞

ANDREW REYNOLDS

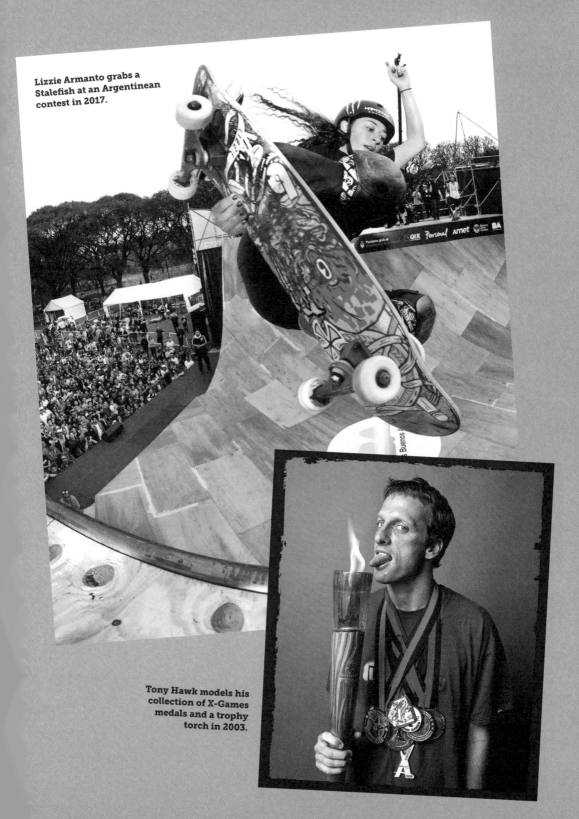

Lizzie Armanto grabs a Stalefish at an Argentinean contest in 2017.

Tony Hawk models his collection of X-Games medals and a trophy torch in 2003.

DIY SKATEPARKS

DIY PARKS AKA "DO IT YOURSELF" FLOURISHED AFTER INSURANCE RATES AND LIABILITY ISSUES CLOSED THE VAST MAJORITY OF COMMERCIAL AND PUBLIC SKATEPARKS OVER THE COURSE OF THE LATE '70s, '80s, AND '90s.*

The DIY template was arguably set by Burnside Project in Portland, Oregon. Begun in 1990 under the east end of the largely abandoned Burnside Bridge, the project was expanded entirely outside the law by locals with donated cement bags and weekend volunteer work. After a long legal battle ensued to convince city officials of the space's value, Burnside was finally granted amnesty in '98 and continues to flourish today.

Other DIY parks following the Burnside model include FDR Skatepark in Philadelphia and Washington Street in San Diego. Built by the local Philly skaters there in '94, FDR is still a mainstay to the city's scene. Likewise, Washington Street—built by skaters in '99—was given a legal permit in '02.

Channel Street in San Pedro, under the 110 freeway connecting Los Angeles to its port, is another great example of local skaters joining forces to create a positive impact on their community. Originally referred to as Pedroside, Channel Street was born in '02 and expanded piece by piece until it was shut down in 2014 due to the 110 freeway redevelopment. After eight years of community organizing and legal/city government efforts by locals, the beloved DIY skatepark was finally opened and deemed fully legal to fanfare (and a front-page *LA Times* article) in August of 2022.

Portland's Burnside Skatepark, which set the template for all future DIY parks.

* Liability concerns were somewhat solved during the late '90s when skateboarding was officially categorized as a hazardous activity practiced at one's own risk.

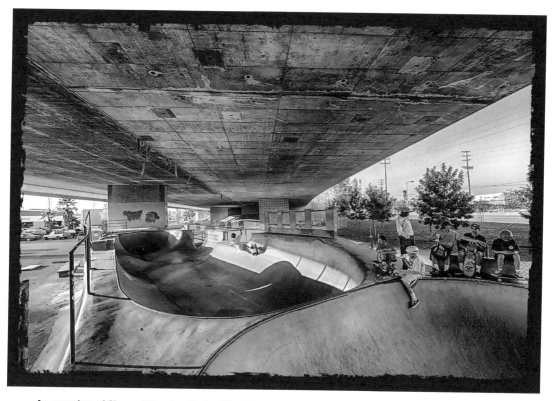

An overview of Channel Street or Pedroside in San Pedro built by local skaters under the 110 freeway and liberated in August 2022.

"I'M BORN AND RAISED IN SAN PEDRO. I HAD SKATED STREET WAY BEFORE, BUT WHEN I WENT AND SAW CHANNEL STREET—AND SAW HOW ROBBIE RUSSO AND THOSE GUYS WOULD JUST CARVE AROUND ALL THE BOWLS—THAT WAS REALLY WHEN I KNEW I WANTED TO GET INTO IT. THAT SKATEPARK IS SOMETHING VERY PRECIOUS TO US ALL."

Ronnie Sandoval

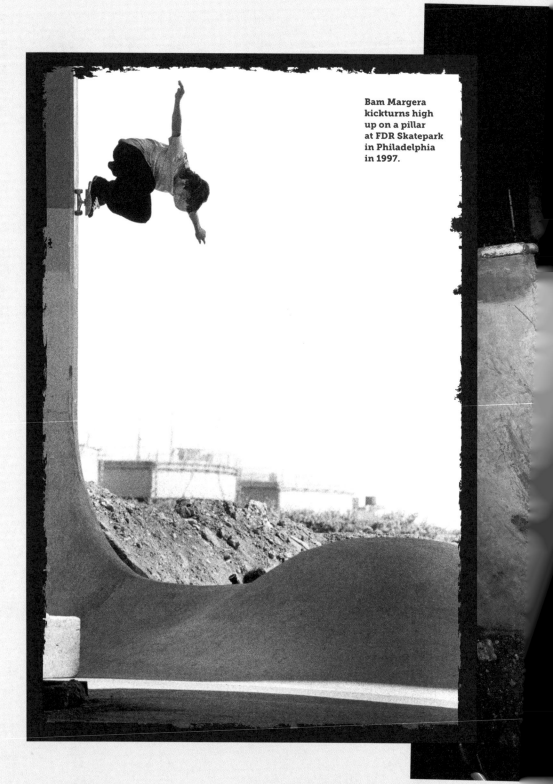

Bam Margera
kickturns high
up on a pillar
at FDR Skatepark
in Philadelphia
in 1997.

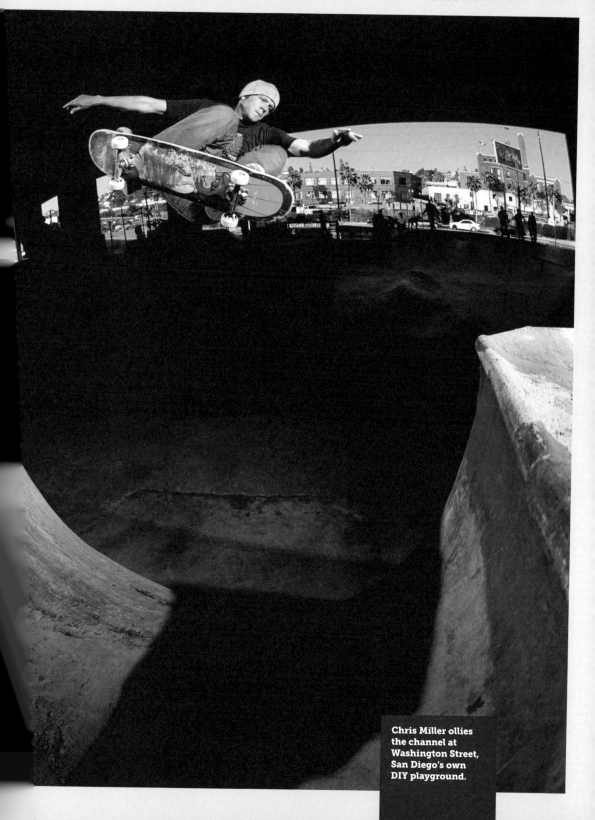

Chris Miller ollies the channel at Washington Street, San Diego's own DIY playground.

WHY SKATEBOARDING? CONCLUSIONS

After showcasing 1000 boards and explaining the broad strokes of its near 70 years of history, the question remains: Why skateboarding?

Skateboarders are all free to answer this question on their own, because skateboarding means something different to all of us. For myself, the best description I have come to embrace is that skateboarding is a form of martial art.

It is too entrenched in subculture, too subjective, and to rule-averse to be called a sport. Yet, too physically demanding and far too dangerous to be considered only a game. It has been taken too seriously by too many for too long to be called a trend. And its industry and influence on culture are too important for it to be called a toy. It is anarchistic but also leans on a deep set of unwritten rules and traditions. It can simultaneously be social or vehemently anti-social. It is certainly an artform to anybody who has ridden one for more than three decades as I have. And I would go as far as saying that like surfing, there is a deep spiritual component. It is almost like Tai chi—intensely physical and meditative at the same time. It is also a whole lot of fun.

Skateboarding will change you for a lifetime. You will forever view the world around you differently. Decades later, staring blankly out of a taxi window in some far off country, you will still be prompted to gawk if a good spot passes you by. Like old surfers watching the sea, old skateboarders never lose there eye for liquid cement.

It is never too late to become an active participant in this lifestyle. Simply head to a local skateshop, buy a new complete, and start a new adventure anywhere at any time. All you need to do is roll. The rest is up to gravity, your push, and your imagination.

"WE MAY NOT KNOW WHAT SKATEBOARDING IS. ~~BUT WE SURE AS FUCK KNOW WHAT IT AIN'T.~~ NO. WE KNOW WHAT IT IS NOW TOO—FALLING DOWN AND GETTING BACK UP."

Julien Stranger

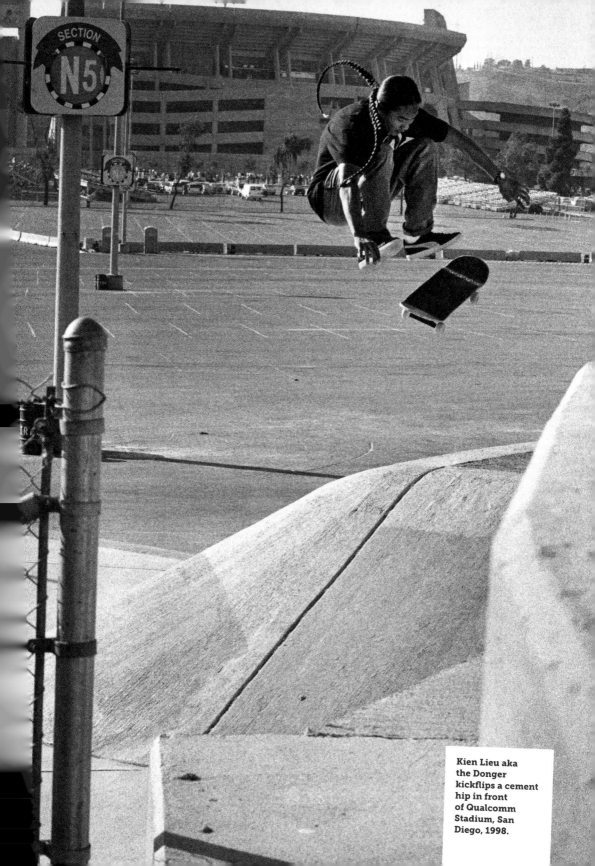

SECTION
N5

Kien Lieu aka
the Donger
kickflips a cement
hip in front
of Qualcomm
Stadium, San
Diego, 1998.

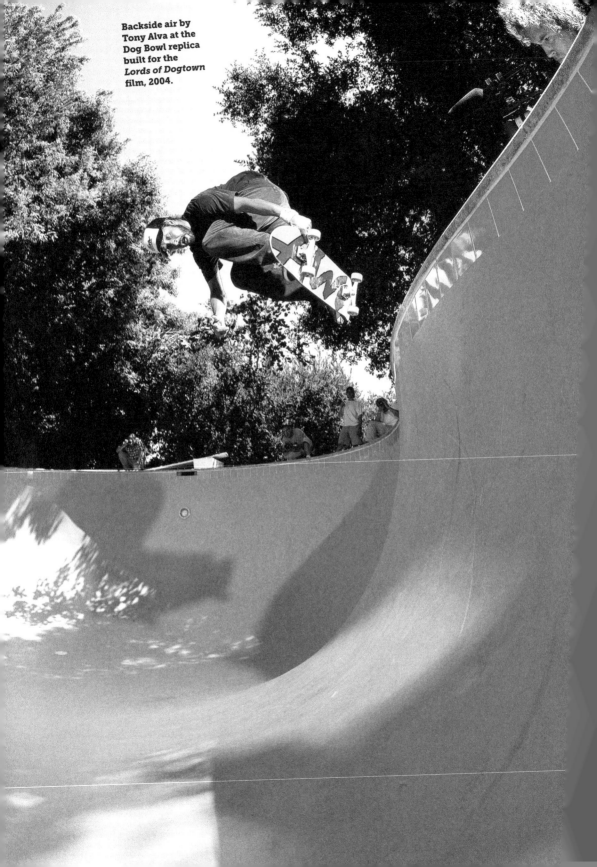

Backside air by Tony Alva at the Dog Bowl replica built for the *Lords of Dogtown* film, 2004.

"IT WAS ALWAYS DIFFERENT BECAUSE SKATEBOARDING WASN'T A TEAM SPORT. YOU DIDN'T HAVE A NUMBER. IT COULD HAVE BEEN A TEAM SPORT BUT IT WASN'T. IT WAS A SOLO SPORT. LIKE SURFING WAS A SOLO SPORT."

CR Stecyk III

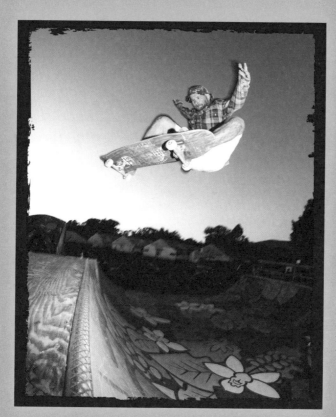

Frontside ollie disaster at the Orchid in Goleta, CA, by your humble author in 2018.

"I HAVE ALWAYS THOUGHT OF SKATEBOARDING AS A PERFORMANCE ART."

Christian Hosoi

BACK TO THE FUTURE

ACCORDING TO *BACK TO THE FUTURE PART II* (1989), THE MATTEL HOVERBOARD SHOULD HAVE BEEN AVAILABLE IN 2015. WHILE THERE ARE HOVERBOARDS ON THE MARKET TODAY, THEY ARE NOTHING LIKE WHAT MARTY MCFLY RODE.

In truth, however, I believe the purist core of skateboarding—the one that created the 1000 skateboards spread throughout the pages of this book—is far too rooted in our analog ways to change, even if a true hoverboard were feasible today.

While our boards and graphics have evolved significantly through the years, the one constant has been the connection forged between urethane wheels and cement. This fundamental point of contact was our point of genesis—fully consummated with the arrival of urethane in the '70s—and has been the basis for everything else in our world since. It is the culture's umbilical cord.

Even beyond the fantasy of hoverboards, most of the newer motorized wheeled contraptions released year after year are passed over by skateboarders no matter how advanced or beneficial their technology. Skateboarders are defiant by nature. And they forever want to be closer to the cement and never farther from it or more disconnected.

I believe the core of skateboarding will continue using the same 7-ply boards, aluminum/steel trucks, and urethane wheels for as long as those materials are available. For now, at least, we go back to the future by continuing to go back to the past.

"WHERE WE'RE GOING WE ~~DON'T~~ [STILL] NEED ROADS."

**Altered version of Dr. Emmett Brown to Marty McFly
in *Back to the Future* (1985)**

"I THINK YOU CAN KEEP SKATING. IF YOU CAN STAND, YOU CAN PROBABLY RIDE A SKATEBOARD. I THINK IT STOPS WHEN YOU CAN'T WALK. TA [TONY ALVA, AGE 65] IS PROOF THAT YOU CAN STILL RIDE. I CAN STILL CARVE AS HARD AS I USED TO, MAYBE EVEN HARDER. YOU CAN CARVE HARD EVEN AT MY AGE."

Steve Olson, age 60, on skating into old age, 2022

Olson making it look good at any age. Encinitas, CA, 2015.

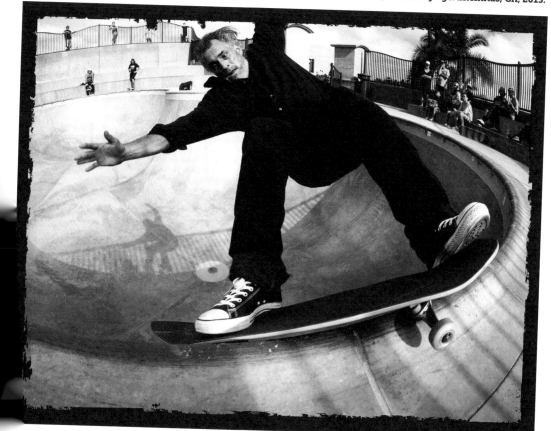

INDEX

ACKNOWLEDGMENTS

Thanks to both my departed parents Inger and Charles and my sister Britt for nurturing and supporting my love affair with skateboarding since 1986.

Thanks to my wife Mary Jane and children Luca and Nicolas for putting up with me still spending all my free time at the skatepark in my 40s.

Thanks to Rizzoli and Olo Editions - Nicolas, Zarko, and Lela for all their hard work on this project.

Thanks to all the artists, photographers, and skateboarders featured in these pages and heartfelt thanks to J. Grant Brittain for a lifetime of motivation and for allowing us to use his historic photography throughout this book.

Thank you skateboarding.

PHOTO CREDITS

All skateboard visuals shown in this book belong to the brands and their authors.

Grant Brittain: pages 9, 21, 22-23, 42, 43, 69, 70, 71, 93, 94-95, 147, 163, 169, 171, 173 left, 177, 183, 189, 190, 191, 193, 194, 195, 197 bottom, 199, 202-203, 205, 211, 215, 217 top, 225, 230, 231, 233, 234-235, 238, 239, 241, 244, 245, 247, 248, 251

Mackenzie Eisenhour: pages 7, 167 bottom, 196

Blair Alley: pages 187, 249

Shutterstock: pages 148 (Ricardo/Shutterstock), 160 top (Flystock/Shutterstock), 160 bottom (FiledImage/Shutterstock, 161 (Fauzi/Shutterstock), 236-237 (Mariakray/Shutterstock)

Rights reserved: pages 11, 13, 15, 16, 17, 41, 125, 126, 127, 149, 158, 159, 167 top, 173 right, 175, 176, 179, 181, 182, 184, 185, 197 top, 217 bottom, 226, 227, 229, 242, 243

Printed in Croatia by GPS Group